the KODAK Workshop Series

Digital Photography

A Basic Guide to New Technology

the KODAK Workshop Series

Digital Photography

A Basic Guide to New Technology

Written by Jenni Bidner

the KODAK Workshop Series
Helping to expand your understanding of photography

Digital Photography
A Basic Guide to New Technology
Written by Jenni Bidner

ISBN 0-87985-797-8
Publication KW-23
Cat. No. E146 3028
Printed in Germany by Kösel Kempten
www.koeselbuch.de

LICENSED PRODUCT

KODAK is a trademark of Eastman Kodak Company used under license.
KODAK PROFESSIONAL, DIGITAL SCIENCE, and PHOTO CD are trademarks of Eastman Kodak Company.

PHOTONET is a trademark of PictureVision, Inc.
PANTONE is a trademark of Pantone, Inc.
All other product names used in this book are trademarks of their respective owners.

Library of Congress Cataloging-in-Publication Data
Bidner, Jenni.
 Digital photography / written by Jenni Bidner.
 p. cm. — (Kodak workshop series)
 Includes index.
 ISBN 0-87985-797-8 (pbk.)
 1. Photography—Digital techniques—Handbooks, manuals, etc.
 2. Image processing—Digital techniques—Handbooks, manuals, etc.
 I. Title. II. Series.
 TR267.B54 1999
 778.3—dc21 98-38214
 CIP

KODAK Books are published under
license from Eastman Kodak Company by
 Silver Pixel Press®
 A Tiffen® Company
 21 Jet View Drive
 Rochester, NY 14624 USA
 Fax: (716) 328-5078

Contents

Crayon, pen, paintbrush, camera, digital camera, and computer—they're all merely tools of artists. In every artistic medium from painting to photography, it is the talent and craftsmanship of the artist that yield great works of art. Certainly the best equipment helps with the task, but it does not insure success. Talent and practice are required. Image by Darryl Bernstein.

Introduction

Digital photography is a wonderful field that combines the best of conventional film photography with new and expanded creative horizons. You can start with your prints, transparencies, or negatives. Or try one of the many digital cameras on the market, ranging in price from a few hundred dollars to tens of thousands of dollars.

If you have dabbled in digital photography in the past and were unimpressed or disappointed, it's time to take a second look. A simple trip to a large computer store to look at their photo-quality printers should change your mind—especially when you consider that these are designed for the *home* market. There are also new products in the professional realm.

When I first got into digital photography, I couldn't help feeling a little despair and dread. I had years of schooling in college, workshops, and independent study, followed by practice, practice, and more practice, using thousands of rolls of film. My bookshelves were crammed with well-worn copies of books on photography and optics. Was it all down the drain?

I'm delighted to tell you that it was not all in vain. The traditionally trained photographer has an enormous advantage in the digital photography field. First of all, if you're a good photographer, you've spent a lot of time developing your image-assessment skills, and creating great digital images requires these skills. Add to that, many of the photo-editing programs are based on conventional photography and photo science. In a program like Adobe Photoshop, you can adjust contrast with plus or minus controls, or go directly into the contrast curve graph and change any part of it (toe, shoulder, etc.) to your heart's content.

I always found a lot of "magic" in conventional darkroom work. Now I can perform the same magic in less time, with greater control, and with no chemical mess to clean up afterwards!

Getting Started

This book begins with an overview section designed to help you get started quickly. If you plan to go beyond the basics, the second chapter will help clarify some of the more confusing aspects of digital photography.

From there, the book follows a logical progression from shooting (input) to processing (software) to printing (output) and finally to storing and sharing your images (transmission and the Internet).

They say in the digital world that every 18 months or so there is a giant technological leap forward, and digital photography is no exception. So whenever practical, I have indicated possible future directions. I've also avoided quoting prices, since they change so quickly and can depend on region. Instead I have tried to compare the relative prices of different equipment categories. The same is true of resolution capabilities. What is considered adequate resolution may be laughably low in three years' time, so shop comparatively.

But most of all, the best advice I can offer is to *enjoy* digital photography. Don't look at it as an enemy to traditional photography but rather as another tool in your quest for great images.

PART I—Getting Started

Overview of Digital Photography

Digital photography is both a simple topic and a very complex one, depending on how far you want to take it. In its easiest form, you can use your standard film camera to take pictures and have a service provider turn them into digital files. From there, you can use software to view, creatively alter, e-mail, or print your images.

You can use the immense power of the digital world to bring photography into both your personal and professional life. You can go beyond traditional photography applications, like photo albums and pictures on the wall, and use digital photography to add a new dimension to your personal correspondence, family's entertainment, business presentations and marketing, and almost every aspect of your life in which interpersonal communication is involved.

The first chapter is a quick overview of digital capabilities. If you're not prepared to read this book cover to cover, use this section to pinpoint what areas you'll need to learn.

The second chapter covers the "science" you'll need in order to understand the basics of digital photography, such as differentiating between pixel resolution and output resolution.

Five Basic Ways of Obtaining Your Digital Photograph

A digital photograph is simply a computer file (just like your MS Word letter is a computer file). There are five basic ways to create a digital photo file:

1. **Scanning a Conventional Photograph, Negative, or Slide**
 A scanner converts a photographic print, negative, or slide into digital information (pixels). You can buy your own scanner or have a service provider scan your images. Scanned images can be saved directly to computer or put on removable storage media such as floppy disk, Kodak Photo CD disc, or SyQuest, SyJet, Zip, or Jaz cartridges.

2. **Original Digital Photograph Shot With Digital Camera**
 This is the most direct method of getting digital images onto your computer. See detailed descriptions of camera types later in this chapter.

3. **Image Received Via Transmission**
 Friends, family, or business associates can send you images via e-mail attachments or modem lines. These digital files can be posted on the Internet where you (and others) can use a password to view, download, e-mail, or print.

4. **Clip Art Photograph or Other Copyright-Free Photograph**
 Clip art photographs are available from many software companies as well as government organizations; simply load them off a floppy disk or CD, or download them from the Internet.

5. **Still Image "Grabbed" Off of Digital Video (DV), Conventional Videotape, TV, or Game Console**
 Many digital video camcorders let you save still images. Video frame grabber hardware enables you to capture still images off of your TV or camcorder.

Photos in the Computer

Once you have a digital photograph in your computer, the opportunities begin. Thousands of different software programs are available that offer you diverse and creative opportunities for using your digital images. In general, they can be divided into several categories that range from traditional photographic and darkroom functions to business applications.

Image Editing and Altering: Alter your digital photograph, pixel by pixel if necessary.

Traditional Photographic: These changes can be of a traditional darkroom nature, like cropping, flopping, inverting, retouching, contrast control, or color/tonal enhancements.

Art World: Enhancements can also be of a traditional artistic nature, such as painting, calligraphy, texturing, or collaging.

Digital Novelties: The computer has added new digital-age capabilities, including morphing, stretching, skewing, and other manipulation functions.

Image Applications: Once you've altered your images, you can use them in any number of different applications that allow you to incorporate digital photographs, such as graphic page design, word processing, spreadsheets, and novelty templates.

Home Applications: Family and recreational applications include e-mail, screen savers, digital photo albums, greeting cards, T-shirt iron-on creations, calendars, insurance records, and family trees/genealogy.

Desktop Publishing: One of the most popular business applications is with desktop publishing programs, which allow the design and production of newsletters, brochures, business presentations, internal memos and communiqués, catalogs, books, and other printed documents. Professional graphics programs are complex but offer the most creative flexibility.

More RAM, higher speeds, and new graphic-friendly computers make digital photography manipulation easier and faster than ever. Image by Jay Stoegbauer, Jay Stoegbauer Photography Inc.

Simpler and specialized programs provide pre-designed templates for quick and easy production.

Other Business Applications: Other applications include Web page design, overheads and graphics to accompany presentations and speeches, ID and security records, personnel records, photo phone books, and much more.

Output Options

There are many different ways to view your digital photos.

Soft viewing: All monitor viewing, including e-mail, Internet postings, screen savers, and slide shows.

Home printers: For snapshots, family entertainment, novelty photo gifts (including T-shirt transfers, calendars, and stickers), and personal correspondence.

Office printers: For presentations, small-run direct mail, overhead transparencies, business cards, and comps for proofing.

Printers at service providers: All printing needs beyond the capabilities of your home or office printer.

Conventional printing press: For printing magazines, newspapers, newsletters, brochures, and other large-run printing needs.

The Pros & Cons of Different Digital Methods

No Digital Camera?

Anyone who takes photographs or has a stack of prints, negatives, or transparencies can get into digital photography *without* a digital camera. It's getting easier to turn your conventional photographs into digital images that can be manipulated on the computer, included in e-mail, or sent via modem to friends, family, and clients. Use a scanner in your home or office to do it yourself, or use the services of a photolab or digital service provider.

Pros:
❏ You don't have to invest in a digital camera; you can use your current camera.
❏ You can convert existing photos to digital files.
❏ You can get both conventional prints (or transparencies) and digital scans at the time of processing.
❏ If you use service providers, you don't have to buy a scanner.
❏ Unless you use very high-end (and expensive) digital cameras, the quality of conventional silver-halide photographs cannot be matched.

Cons:
❏ Sending your images out to a service provider takes time and costs money.
❏ If you scan your own images, you must invest in a scanner, learn to use it properly, and spend the time to make the scans.
❏ You continue to pay for film and processing of your conventional images.

Analysis:
Having your conventional photos scanned into digital form is a great way to try digital photography without having to invest a large sum of money up front. The per-scan costs charged by the service provider are relatively small.

Dedicated Digital Camera/ Printer Combination

In terms of number of steps, the simplest digital photography system does not require a computer. A few digital cameras interface directly with a dedicated printer, enabling you to make prints without owning a computer. The digital camera is linked via cable or direct data port to the dedicated printer. Software in the camera and/or printer makes simple "improvements" before printing the image.

Pros:
❏ Just two pieces of hardware, plus the cable if necessary.
❏ Nice convenience if you want quick prints without a computer.
❏ Faster results than with a conventional camera and film.

Cons:
❏ Very minimal (if any) image enhancement or manipulation is possible.
❏ Images cannot be stored unless the camera offers a computer connection or removable memory card to download pictures.
❏ You're limited as to the size and type of printer that is dedicated to this camera, unless you can add a computer interface.
❏ Currently these types of cameras are only available in low-resolution "point-and-shoot" models.

Analysis:
For most people, this feature should be viewed as somewhat of a gimmick, because without a computer, you lose many of the advantages of digital imaging, such as the ability to enhance, manipulate, and transmit images. If you need small, quick reference prints and permanent image storage is not necessary, this may be a good choice. Examples are convention or event photographs, novelty prints, real estate photographs, or ID cards.

Digital Point-and-Shoot Camera

If you currently use a compact point-and-shoot camera, you'll feel right at home with a point-and-shoot digital camera. Digital point-and-shoot cameras look, feel, and operate much like their conventional film counterparts, offering autofocus, auto-exposure, and auto-flash capabilities. Picture quality continues to improve with the mega-pixel point-and-shoot digital cameras offering high-resolution images of over one million pixels.

Pros:
❏ The speed with which you can view images. Many cameras can display images as soon as they are captured.
❏ User-friendly operation.
❏ Adequate quality for soft viewing applications (e-mail, Web postings, screen savers, and slide shows) and small prints.
❏ Small, compact, lightweight with a relatively low entry price.
❏ The megapixel cameras coming on the market offer a wider variety of features and user-selectable functions.

Cons:
❏ May offer low resolution compared to conventional film prints and prints from high-end digital cameras.
❏ Lower quality in other areas, including dynamic range and color depth.
❏ Higher hardware costs than conventional cameras.
❏ Some do not have removable memory capacity, requiring frequent downloading to a computer or erasing of images.

Analysis:
A great way to enter the digital photography world, especially if your goals are e-mail, Web posting, newsletter reproduction, small prints, and other low-resolution applications. The Internet user's prime motive is to have digital images to share through e-mail

or on a Web site. Monitor resolution is only 72 ppi; high-resolution images are not necessary. Potential users include snapshot photographers, computer enthusiasts, small businesses with low-resolution desktop publishing needs. Already embraced by the former instant film markets, such as real estate, insurance, and ID/security fields where large quantities of pictures are needed quickly and usually only for a short while (i.e., until the house is sold).

Megapixel Point-and-Shoot Cameras

Stuck in between the point-and-shoot category and the high-end category is the growing new megapixel point-and-shoot camera category. Technology is advancing in leaps and bounds, and point-and-shoot cameras are on the market offering one- and two-million-pixel capability. They offer the high resolutions needed for larger enlargements but lack many of the user-controllable functions found on high-end cameras. These functions help advanced photographers control the picture outcome.

The pocket-size megapixel digital camera, the Kodak DC215, features a 2X optical zoom and a compact metal body. Photo courtesy of Eastman Kodak Company.

High-End SLR Digital Camera

If you crave the image control you get from a conventional SLR camera, you'll probably want its digital counterpart. Much of the artistry in high-end conventional photography comes from using the many features and capabilities of an SLR camera. The same is true in the digital realm. A few of the SLR niceties include aperture and shutter speed selection, choice of lens focal lengths, and versatile accessories like off-camera flash and filters. Some digital SLR cameras allow you to use lenses from conventional SLR cameras.

Pros:

❏ Higher-resolution capabilities and image quality than point-and-shoot counterparts.
❏ Image control through traditional SLR functionality.
❏ Most SLR digital cameras use interchangeable lenses and accessories available for conventional SLR cameras.
❏ Removable memory storage media enabling continuous picture taking without the need to download; you can also organize your images on this media.
❏ Ability to review pictures on the camera's LCD panel to make sure you "got the shot."
❏ Voice annotation capabilities on some cameras.
❏ White light balance to improve overall color.

Cons:

❏ The number one disadvantage is the entry price on these cameras, which is much higher than for non-digital SLR cameras.
❏ Not as simple to use as the point-and-shoot variety. Requires some knowledge of SLR photography to achieve maximum creative control.
❏ Larger and heavier to carry.

Analysis:

This is the top of the line for amateur photography and a good choice for professionals who photograph action subjects and do not require ultrahigh-resolution results, such as newspaper publication or general magazine reproduction. This camera type is very widely used among photojournalists. Digital images can be transmitted almost instantaneously using modems, and many newspapers are now using digital printing technology.

Large-Format Digital Cameras and Backs

Bigger is better for film reproduction, and the same is true for digital if large-scale, professional reproduction is the goal. The greater the number of pixels the digital camera records, the bigger you can successfully enlarge the end result. Hence a host of different (and costly) digital cameras and camera backs are available for the professional photographer. Some are integral cameras, while others replace the film back on a medium-format camera or the film sheet holder on a view camera.

Pros:

❑ Digital capture eliminates the extra time and expense of scanning images for printing.

❑ Larger, better CCD (charge-coupled device) image arrays enable the scene to be captured with more pixels, higher dynamic range, and bit depth.

❑ Some enable real-time soft proofing (proofing a digital image on a computer monitor) via cable link, which is a benefit when working with art directors and clients.

Cons:

❑ The price is much higher for these cameras than for the SLR types.

❑ Some scanning technology requires a long triple pass, one for each of the three RGB (red, green, and blue) color channels, meaning only still lifes can be photographed without blurring.

❑ Single-pass cameras can offer slower capture speeds than SLRs due to the larger image arrays and extra information that needs to be gathered.

❑ View camera digital backs obviously require proficiency in view camera shooting techniques.

Analysis:

These have already revolutionized the catalog photography business and are making headway into other areas of studio photography. As image-capture speeds and relative ISO speeds improve, the cameras' use by fashion and other non-still life photographers will increase.

Digital Video (DV)

The latest moving-image recorders are digital video camcorders or DV. DV records hours of motion and sound on DVC (digital video cassettes). Most provide a simple way to save still images from motion clips.

Pros:

❑ Better picture quality, resolution, and sound.

❑ No degradation when the video is copied or edited on the computer.

❑ Still images taken from digital video are usually of better quality than those grabbed off of conventional video.

Cons:

❑ As of this writing, DV camcorders are considerably more expensive than their conventional video counterparts.

Video Frame Grabber

Use images from your conventional video camcorder, videotape, or television screen. Still images from videotape can be digitized for your computer with an inexpensive video "frame grabber." Select that perfect decisive moment from a home video, movie, television program, or game program, and then import it into your computer for printing, inclusion in graphics programs, e-mail, or other applications.

Pros:

❑ Another fresh source of images can be found in your home videos.

❑ Relatively inexpensive.

Cons:

❑ Relatively low resolution.

❑ Camcorders with slow speeds yield somewhat blurry results of moving subjects.

❑ Most movies, TV shows, and game console programs are covered by international copyright protection, limiting your legal usage of their imagery.

Analysis:

Great fun at a low entry cost. Share home video stills with friends and relatives over the Internet. Add news program stills to school reports. Save memorable movie moments and video game scores. Include TV coverage and advertisements in business presentations.

The Personal Communication Device

Some manufacturers are moving toward turning their digital cameras into small computers that take pictures. A new breed of digital cameras is using cross-industry technology to deliver advanced features, including voice recording, motion (movie) recording, datebook/calendar applications, database functions, built-in modems, speed dialing, and more.

Pros:

❑ Non-photographic functions are being added to digital cameras, enabling you to carry one device for many of your communication needs.

Cons:

❑ Extra gadgets add to the price, operational complexity, size, weight, and electronics—often at the sake of photographic functions and capabilities.

Analysis:

If cool gadgets are a must for you, then you'll be attracted to these clever, multipurpose, camera-plus devices. Do you really need all that capability? And do you want it attached to your camera?

Computer Needs

PC vs. Apple Macintosh Computer?

The war is over, for the most part. With a new PC or Macintosh computer, simple software enables easy conversion of files so that either computer can read them. The graphics programs that in the past made the Macintosh computer the must-have of photographers and graphic designers

are now available in PC versions. All but high-level pre-press work (which is still in the Macintosh computer-only realm) have come to an equal playing field. For the best results and the most software choices, you'll want PC Windows capability or Macintosh 7.5 operating system or higher. Users of UNIX operating systems have some imaging choices as well, although many are geared toward photofinishing workstations and industrial applications and are not covered in this book. Translation software for downloading and uploading images from Unix-based FTP sites is readily available.

Random Access Memory (RAM)

You'll need Random Access Memory (RAM) just to run your software programs and have your peripherals (like printers and scanners) functioning. Add to that the rule of thumb for digital photography—have available RAM of *three* to *five* times the file size of the picture you are working on. A nice image on your monitor (in the 300KB file size range) with a simple photo-editing program could require as little as 8MB to 16MB RAM. But for a professional image meant for magazine reproduction (18MB and up for the picture file alone) used with a program like Adobe Photoshop or Live Picture, you won't be happy with less than 64MB and will probably want more.

Don't count on virtual RAM and other memory-adding software, because they can sometimes cause conflicts with graphics and photo-editing programs. Most computers can be upgraded with more RAM up to a certain point. If you're buying a new computer, make sure you buy a unit that will allow you sufficient memory upgrades.

Memory Recommendations:
Bare-bones for limited use:
 16–32MB RAM
Adequate for home hobbyist:
 32–64MB RAM

Professional:
 64+MB RAM for average work,
 200+MB for working with high-resolution images

Hard Disk Space

"Scratch disk" or unused hard disk space is highly recommended for most graphics and photo-editing programs. You should set up a scratch disk three to five times larger than the largest average file size you expect to work on. When determining your hard disk needs, you need to consider this scratch space along with (or as part of) all the memory needed to store your applications, digital photo files, and other files. If your present computer doesn't have enough room, consider an external hard drive peripheral. If you're buying a new computer, think twice before buying anything under several GB.

Clock Speed

Clock speed refers to how fast the system drives the computer's processor. It is measured in megahertz. The higher the clock speed, the faster the computer can process information. Today's computers are getting faster and faster Macintosh computers from the Power Mac forward and the new generation of Pentium products for PCs are all great candidates for digital work. Keep in mind that you'll probably find anything less than a 50MHz processor frustratingly slow. For high-end work, an 80MHz processor for a Macintosh computer is considered slow. Remember that while a fast processor can speed up your work, it will be wasted if you don't have enough RAM.

Monitors

You can get away with your older VGA 256-color (8-bit) monitor, but the colors will be jumpy and nowhere near photographic quality. Most of the new photo software requires a Super VGA monitor capable of 24-bit color and enough VRAM on your computer to run it.

CD Drives—A CD drive will give you access to CD-only software, as well as picture files. While CD-ROM indicates a read-only format (ROM=read-only memory), CD-R (CD-Recordable) format allows you to record data to a compact disc. Using CD-RW (CD ReWriter) format, you can write over data that you've already recorded.

Storage Media—Storage media refers to the means on which you save or store your files. Iomega makes Zip drives; each Zip disc holds 100 MB of information. Jaz drives, also made by Iomega, use small cartridges that hold 1 or 2 GB of information. SyJet cartridges by SyQuest are similar to the Jaz system and can be purchased in different storage capacities. DAT (digital audio tape) drives use tapes similar to small cassette tapes, with each tape holding 4 or more GB of storage.

Modems—For Internet access, you'll need a modem or other telecommunications means. Faster modems will quickly pay for themselves if you subscribe to an hourly Internet service. Cable modems are available in many communities. Check the last chapter for more on the Internet.

Universal Serial Bus (USB) Ports—More and more of the newer computers and digital cameras are offering these peripheral connection ports that provide higher-speed digital connections. If you're buying a new computer, make certain they're included.

Understanding Digital Photography

Digital photography starts with an understanding of input and output resolutions, and pixels, dots, and lines per inch. This will help you choose the kind of digital camera and scanner that will meet your needs. Understanding digital photography can save you time and money and help ensure good results.

The primary mistake most people make is confusing pixels per inch (ppi) with dots per inch (dpi) and lines per inch (lpi). Although they can sometimes be the same number, they have very different meanings relative to your work.

Pixel Resolution

When an image is created by a digital camera or a scanning device, it is recorded as many individual sections. These individual sections are called pixels or picture elements, and each is assigned color and tonal values (limited only by the capability of the input device). The actual size of a digital image in terms of number of pixels or picture elements is the *pixel resolution* (or spatial resolution).

Pixel resolution is a solid figure. It gives the total number of pixels on the vertical side by the number of pixels on the horizontal side, or 300x450, for example. Since the pixels are evenly spaced, the image in this case would be horizontal in the 1:1.5 ratio—or the ratio of a 35mm slide or negative. The total number of pixels recorded would be 300 times 450, or 135,000. So a 300x450 CCD (charge-coupled device) sensor on a camera could capture 135,000 pixels.

These 135,000 pixels could then be printed very closely together, so they would create a small print that looked as perfectly smooth as a conventional photographic print. Or the image could be printed the size of a billboard, causing those 135,000 pixels to be spread out and enlarged into dots the size of a quarter—which might look okay if viewed at 200 yards from a vehicle moving at 55 mph but be unrecognizable close-up.

Unfortunately, many people in the industry have the habit of referring to the pixel resolution of the camera as dpi. This causes infinite confusion, since dpi refers to specific printing specifications that relate to output. In your mind, whenever you see the resolution of a digital camera expressed in a number times a number (300x450), think *pixels*.

The pixel resolution informs you how big you can print (or view) your image at optimal quality on a *given* output device. The chapters in Part IV

go into detail about these devices, which require different numbers of pixels to create each inch of picture.

Bigger is generally better in pixel resolution because you have more choices. You can always print higher-resolution pictures at sizes smaller than their optimums. This is ideally done by "throwing away" extra pixels with downsizing software commands or by "wasting" pixels (and printing time) by sending a larger-than-necessary image file to the printer. The downside is that a high pixel resolution has longer processing times and takes more computer memory space.

Scanning Resolution

Digital cameras "scan" the scene in front of them and create digital files measured in terms of pixel resolution. Most manufacturers list resolution in dpi or dots per inch; you have to add the size of your original into the equation.

THE ENLARGEMENT FACTOR IN SCANNERS

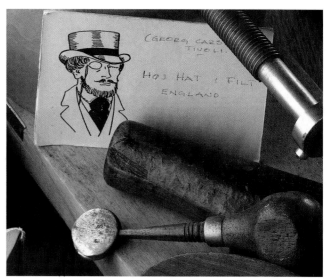

Pixel resolution refers to the number of picture elements that make up the image, or how detailed a digital photograph is. A high-resolution image can be greatly enlarged and offer photographic quality. The image at the right is an enlarged detail from the first photograph, captured with a Phase One digital camera back. Photos courtesy of Phase One.

The key to understanding scanner resolution is the *per inch* part of dpi. At a 300 dpi setting and 100% enlargement (i.e., actual size or true dpi), a scanner will take 300 picture samples per inch, for every inch of the original. If the original is a 4x6-inch print on a flatbed scanner, it would read 300 pixels for each of the print's 4 inches of height, for a total of 1200 (4x300=1200). The scanner head would travel down (or pull the print across) its path for the entire 6 inches of its length, providing a total of 1800 picture samples (6x300=1800). Hence the pixel resolution of this newly created digital picture file would be 1200x1800. It would include a total of 2.16 million pixels (1200x1800= 2,160,000).

However, if the original was a 35mm slide scanned at 300 dpi at 100% with a transparency scanner, the pixel resolution would be much different, *even though the scanning resolution is the same*. The 1x1.5-inch image would have 300 samples taken per inch for its height (1x300=300) and 300 samples per inch for its width (1.5x300=450). The result is a much smaller pixel resolution of 300x450, with a mere 135,000 total pixels (300x450=135,000).

If both these scanned images were then printed on a 300 dpi dye sublimation printer, they would look great at their respective *original* sizes—4x6 and 1x1.5. Since most of us don't want to print our 35m slides at their actual postage-stamp size, much higher resolution scanners are needed for slides than prints.

The Enlargement Factor in Scanners

It can become more confusing when the enlargement factor comes into play. Scanners usually offer you the choice of what dpi to scan at as well as what size enlargement to make. Both these items affect the pixel resolution size.

For the sake of discussion, I'm going to call anything scanned at 100% or life-size as *true dpi*. We've already determined that the pixel resolution can be found by multiplying the size of the original in inches by the true dpi. But what if the image was scanned at 300 dpi and 200%, instead of 100%? The dpi is actually 200% of 300 dpi, or 600 dpi.

You can easily find the percentage of a number by moving the decimal point on the percentage figure two

A fully loaded computer makes digital imaging easier and faster but is by no means a necessity. For the professional, a fast computer (200MHz or faster) with a lot of RAM (128MB+) and a 1-gigabyte-or-more hard drive may be justified. For recreational digital photography, you may get by with an older, less powerful, and less expensive computer, but you'll be spending time waiting for the computer to load images and make calculations. Image by Jay Stoegbauer, Jay Stoegbauer Photography Inc.

From Digital Originals

Reverse the thinking if you're working with a digital original and want to find out how large you can print it. For example, let's suppose your digital camera records at a pixel resolution of 756x504, and the printer has told you for good magazine reproduction, a 200 dpi scan is needed on that particular printing press. Divide the pixel resolution by 200 dpi, and the result is the maximum optimal enlargement—3-3/4x2-1/2 inches. (Compare this to soft viewing: On a monitor screen that displays 72 dpi, this would normally be displayed nicely at 10x7 inches.) In this example, if you're envisioning full-page magazine covers and double-page photographs, you'll need to use professional digital cameras that deliver higher pixel resolutions.

Bit Depth:
All Pixels Are Not the Same

On the subject of pixel resolution, it is important to realize that not all pixels are the same. A picture file may have a pixel resolution of 400x600, but those 240,000 pixels can hold very little or quite a lot of information depending on bit depth (sometimes called color depth or brightness resolution).

The capability of your digital camera, scanner, or other digital capture device determines how smart each pixel is. (See sidebar in this chapter.) A one-bit pixel sees only black (nothing) or white. (This is not black and white as in a black-and-white photograph, which can have 254 or more tones in addition to black and white.)

The next step up is a one-byte system. Eight bits combine to create one byte. Accordingly, an 8-bit pixel contains one byte of information. This gives the pixel 256 options (black, white, and 254 other possibilities).

If you're strictly interested in monochrome images, 256 levels of gray yield an excellent result. But for color, the image will look sadly

spaces to the left (accordingly 200% becomes 2.00 and 50% becomes 0.50 or 1/2) and multiplying it by the original figure. In this example, 300 dpi at 200% is 600 dpi (300x2.00=600).

Therefore, instead of scanning an image at 300 dpi and 200%, you could have simply scanned it at 600 dpi and 100%, or 1200 dpi and 50%. To see this, try scanning a picture at these three rates and check the files sizes of each result. They should be the same or nearly so. (If your scanner doesn't go up to 1200 dpi, try these combinations:

50 dpi at 200%, 100 dpi at 100%, and 200 dpi at 50%.)

Here's another example. You know you want the output to be printed three times larger than the original, or 300% enlargement. The printer has told you for good magazine reproduction, a 200 dpi scan is needed on that particular printing press. You could therefore either set your scanner to 300% and 200 dpi, or 100% and 600 dpi. If the original is a 1x1.5-inch slide, the math would yield a pixel resolution of 600x900, or a total of 540,000 pixels.

Understanding Bits & Bytes

One bit: Has two states or possible options. In computer talk, it is either zero or one, "yes" or "no." In photography, it is black or white.

One byte: This is called an **8-bit system**, because one byte is made up of eight bits. Since each bit has two states or possible options, one byte has 256 options (mathematically derived from 2^8 or $2 \times 2 \times 2 \times 2 \times 2 \times 2 \times 2 \times 2 = 256$). In addition to black and white, this leaves 254 other options. Therefore, a 256-level gray scale is possible, which the human eye sees as a continuous-tone monochromatic image, akin to a conventional black-and-white print. Alternatively, 256 colors can be created, but the human eye sees this as abrupt transitions of color, or a posterized image.

Three bytes: This is a **24-bit system,** since each byte consists of 8 bits (8+8+8=24). In a color system, each primary color (red, green, and blue) would be assigned a byte of information and have any of 256 different levels of brightness. Together they would yield over 16.7 million possible color variations (256x256x256=16,777,216). The human eye sees this as the smooth transition of color (continuous tone) or photographic quality.

Over 24 bits: Once the gold standard, 24-bit systems are quickly being surpassed by 30-, 32-, 36-, and even higher systems. Some manufacturers are using these extra bits to offer billions of colors, while others are maintaining the 16.7 million colors and using the extra information to improve image quality in other ways (such as aiding compositing functions). The only downside is that more bits of information increases file sizes. (A 32-bit system will have files approximately 25% larger than a 24-bit system for an image with the same pixel resolution.)

inadequate. (Granted, just a few years ago, most people were delighted to have 256 colors show up on their computer monitors.)

Today, the minimum standard is 24-bit (3-byte) color. That yields 256 options for each of the three additive colors (red, green, and blue, or RGB), which are the three colors that computer monitors use to create the illusion of continuous full color. Together these 256 variations of RGB yield 16.7 million possible colors (256x256x256). 24-bit color is generally considered to be near-photographic quality, but 30-bit and 32-bit (4-byte) systems are usually better.

How the manufacturers use the extra bits of computing power in 30-bit and larger systems is proprietary. Some are pushing the number of possible colors into the billions, while others are using the extra information as a way to replace "bad information" to eliminate noise and other imperfections.

File Sizes

The color depth of your system (how many bits of information are given to each pixel) also affects the file size of your images. Obviously a 450x600 pixel image will take up less space on your computer than the much larger 1200x2400 high-resolution image. The former contains 270,000 pixels (450x600=270,000), while the latter contains 2,880,000 pixels (1200x2400= 2,880,000). But the bit depth also comes into play.

To calculate the approximate size of a standard uncompressed picture file, multiply the pixel resolution by the number of bytes in the color depth. For a 24-bit system, this would be three bytes (24 divided by 8, since there are 8 bits to a byte). Consequently, a 1200x2400 pixel image on a 24-bit system would contain 8,640,000 bytes of information. Since a kilobyte equals 1000 bytes, this is also equal to 8640KB. Likewise, it is equal to 8.64MB, since there are one million bytes to a megabyte.

Compression and different file formats will affect these file sizes, allowing them to be compressed into considerably smaller sizes with varying quality. Remember the bit depth of your image greatly affects the file size as well.

Output Resolution

Output devices are incredibly varied. Desktop prints can range from rough proofs to high-caliber photo-realistic images. Special printing substrates can create T-shirt transfers and custom mugs. A minilab can digitally print your files onto conventional silver halide-based papers for prints that are indistinguishable from film-derived prints. You can output to screened film that will be printed on a web press and made into magazines or catalogs. Or files can be directly transferred to a computerized press that creates sheet- or web-fed pages without any intermediary steps.

The important thing to realize is that the dpi resolution of a printer can only be compared to the dpi resolution of printers of the *same type*—laser to laser, ink-jet to ink-jet. This is because a 300 dpi dye sublimation printer may be able to produce true photo-quality or near photo-quality images, while a 300 dpi laser printer barely rivals the picture quality of a newspaper. Meanwhile, a 600 dpi ink-jet printer probably can't match the crispness and clean edges of typeface and graphics found on a print from a laser printer with half its resolution. A "tiny" 400x600 pixel digital image may look stunning on your laptop but less than acceptable when printed.

Conventional Printing Presses

The most familiar method of printing for most of us is the black-and-white halftone used in conventional printing, such as for magazines and newspapers. Equally spaced dots of varying sizes are created to fool the eye into seeing shades of gray. Since the dots are equally spaced (center to center, not edge to edge), big, black dots create dark areas, and medium-size dots create a mixture of black and white that we see as gray. No dot is pure white (or at least the color of the paper stock base). To create a darker halftone, you can imagine two dots *growing* outward from their centers until they butt up against each other. Shrink them, and the area of the photo gets lighter.

To see this, look at a newspaper photo with a magnifying glass. The newspaper photo is probably in the range of 65 to 85 lines per inch (lpi), meaning that many dots can fit into a row that is one inch in length.

Magazines are usually created at 133- to 150-line screen. In general, magazine photos look good at normal viewing distances, but when viewed with a loupe, the image changes. To make the point, think of a printed billboard or huge printed poster. It looks great from a distance (like from a moving car on the highway). But if you were to step close to it, it would become an unrecognizable collection of dots.

Color gets more complicated. It is created by using four of these dot grids (all slightly askew so they do not overlap as much), one with black ink and the others with cyan, magenta, and yellow inks. Note that in the theoretical world of color, no black ink would be necessary, since by varying the amounts of cyan, magenta, and yellow, you can create the effect of millions of colors, as well as white and black. However, inks have many imperfections. The combination of 100% cyan, 100% magenta, and 100% yellow should create black but instead creates only a muddy brown. Anywhere cyan, magenta, and yellow show up together, the printer can remove equal amounts and replace with black in a method called Gray Component Replacement. Subsequently, the fourth color in four-color printing became black to correct this imperfection.

Screen Variations

Variations in printing from screens include the spacing (lpi) and shapes of the dots (circles, ellipses, diamonds, etc.), as well as their placement. Halftone screening has a specific patterned order. But screens can also be disordered or random.

For instance, consider stochastic printing, which is increasing in popularity with photographers. Here, the dots are very small and randomly placed. The tonal values are changed by altering the *frequency* (or number) of dots. Since the individual dots are exponentially smaller than variable dots in most halftones, subtle changes in their frequency can be used to record image detail.

Home Printers

Most printers use a halftone dot technique, but in a different form. Ink-jet printers, laser printers, and thermal wax printers use "dithering" techniques to place the colored dots in patterns that simulate the colors in your digital picture.

If the dots are small enough (a high dpi machine), a yellow dot next to a cyan dot can fool the eye into seeing green. No dot leaves a white space (or at least as white as the paper) to lighten the color. Depending on how well the printer does this, the effective line screen and smooth gradations of tones can vary radically, so check sample prints carefully, and don't go by "dpi" alone.

Dye sublimation printers have an incredible advantage over halftone printers in that their dyes are transparent and can therefore be overlaid without the need of dithering patterns. Their density can also be varied by the amount of dye that is vaporized. In this way, dye sublimation printers can get away from halftone dots, thereby eliminating the white gaps inherent in that technique. As such, true continuous tone can be reached on higher-end dye sublimation printers.

Thermal dye-incorporated paper printers use heat to release varying amounts of color from dye already inside the paper or other substrate. The patterns produced are based on the internal capsule structure of the paper substrate.

The chapters in Part IV go into great detail about outputting. The charts and text will help you determine what you're in the market for. This in turn will give you a clue to the pixel resolution you need to accomplish your tasks. This will bring you around full circle to input options—digital cameras, scanners, scanning services, video still cameras, and video frame grabbers. Armed with knowledge of your pixel resolution needs, the choice of what digital camera or other input system you'll need will be much easier.

Raster vs. Vector Files

Another point to clarify is the difference between raster files and vector files. The difference is found in the way these two file types record information that creates digital images. A raster file is a bitmap—a grid of pixel elements, each with its own assigned color and tonal values. A vector image is made up from mathematical commands or equations. These equations describe how a line should look, how an area is to be filled with color and tone, or the exact shape of a curve.

Photographs are usually raster (bitmapped) images. As such, they are

This raster language model, the Kodak Digital Science™ 8650 color printer, can be used for making photo prints from applications such as Adobe Photoshop. Photo courtesy of Eastman Kodak Company.

limited to the number of pixels contained in their files. If they are enlarged too much in printing, you'll get pixelation (the appearance of the picture breaking up into dots, not unlike the appearance of grain from high-speed conventional films). Likewise, bitmapped fonts suffer from "jaggies" (rough, jagged edges) if they are enlarged too much.

Vector files can be created in programs, such as Illustrator, or found in vector or "outline" typefaces. Since the image information is mathematical to start, it can be scaled up and down without affecting the quality. So your vector output can always be as good as what your printer is capable of producing, not limited by pixel resolution.

Printing Starts With the Monitor

In most cases, outputting your digital photographs starts at the computer monitor. For some people, especially ardent Internet surfers, the monitor

screen *is* the final output. Their interest is in soft viewing (no hard copy), with images shared over the Internet or viewed as screen savers and on-screen slide shows. The last chapter will discuss the Internet and transmission methods in more detail.

For the rest of us, the computer is the starting point for what we really want—some kind of output that we can hold in our hands, view at our leisure, share with friends, or hang on the wall. It could be as simple as a print from a $100 ink-jet printer or as complex as a picture printed in a magazine.

Beauty and the Beast

Computer monitors are wonderful machines. Their phosphors display luminous images, the better ones capable of displaying millions of colors. Yet although your photograph looks fantastic on the monitor, you may be in for a surprise when you send it to the printer.

This is because monitors work in the RGB world, meaning the images are made up from phosphors that emit red, green, and blue light. Unfortunately, the world of printing is grounded in CMYK. Varying amounts of cyan, magenta, yellow, and black inks or dyes are placed on the paper or output medium to create four-color printing. The addition of special colors, such as Pantone colors, metallics, fluorescents, or "photo" inks, can result in five-color printing, six-color printing, and so on, depending on how many colors are added. This adds exponentially to the price, because the paper needs to be run through the printing press an additional time for each additional color, plus the specialized inks can be very expensive.

Software in your computer or printer is used to convert the additive RGB scene you see on your monitor into subtractive CMYK colors for your printer to create, either directly or

via the four-color separations needed by the printing press. The mere fact that monitors are based on emitted light, and the prints are seen with reflected light, insures that the images can never be quite the same. It's not unlike the difference between a slide and a print. The slide is going to seem to have more depth, energy, and glow—before you even consider the factors of color depth and color gamut.

Monitor viewing does not require high-resolution images. The output capability of most monitors is about 72 ppi. Thus if you want an image to appear as a 4x6-inch snapshot on the monitor screen, you only need a pixel resolution of approximately 300x450 (72x4=288 and 72x6=432).

Note that printed output of an image with pixel resolution of 300x450 at 4x6 inches would look very rough and about the quality of newspaper photos. More likely, it would be printed at a third that size in a magazine or on a low-resolution ink-jet printer.

This low 72 ppi monitor resolution explains why the image looks "bigger" on a computer screen than if you were to print it. It is, however, a great advantage for viewing purposes. (Note: An exception is the FlashPix file format, which offers six resolutions, with the right monitor resolution automatically picked for screen viewing and image manipulation while still being linked to the higher-resolution versions for printing.)

Looks Great, But....

Your picture may look great on the monitor, but that doesn't mean it will translate well to print. Numerous variables can affect how closely the monitor image matches the printed version or how radically they differ. Among these factors are:

❏ Quality and calibration of your monitor
❏ Viewing conditions of the monitor
❏ Quality and type of printer and its inks, toners, dyes, or pigments
❏ Quality, finish, and color of the output paper or other substrate
❏ Viewing conditions and viewing distance for the output

Remember, too, how color viewing is subject to personal perception. Two people might like very different printed versions of the same photograph. Also, a photograph printed by Minilab A might look great to you until you have it reprinted at Minilab B. After seeing the second print, you might become totally dissatisfied with the first.

Out of Gamut

Every digital input or output device has limitations as to the range of colors it can capture, display, or print. This is called its color gamut. If the color gamut of one instrument in the chain (camera/scanner, monitor, printer) does not match the others, you will be "out of gamut," meaning the devices cannot deliver the same colors, because some colors are beyond the devices' capability. For high-end work, you can use software and gamut mapping to get all devices into sync for predictable results.

Color Management Systems

Consistency, calibration, and a good color management system are the ways to ensure color accuracy. Color management systems work to calibrate your input devices, display monitors, and output devices together so that you will get consistent results. If you need to use outside parties to make color separations or specialty prints, your results will be dependent upon their internal color management and how closely your monitor is calibrated to theirs.

Before you invest in high-end color-correct monitors, software, and measurement devices, analyze your needs honestly. If your prints are for personal use, a little practice should get you pretty close to the results you want.

But for professional ambitions, such as creating your own color separations for magazine publishing, you'll need to be very conscious about the end result. Ensuring color accuracy takes a lot of time in the beginning and is quite an art in and of itself. But using color management software systems can save you a lot of time, frustration, and paper in the long run.

Most color management systems work by profiling each piece of equipment in the chain (from input device to monitor to printer) to learn its capabilities, deficiencies, biases, and color gamut. Usually this involves using a "target" or known color scale by which you judge your cameras, scanners, monitors, printers, etc. By adjusting your equipment so that each reproduces this target accurately, you'll have consistency throughout your chain.

Therefore, to be able to achieve high-end color management, you'll need equipment that can be calibrated and adjusted. You'll also need to pay attention to external factors, like reflections on the monitor screen or the color of the room lighting where you'll be working. Yellowish lighting will change your perception of true color on both the monitor and prints. So replace the bulbs near your workstation with color-correct lights (5000K). This step is important, because the human eye adjusts in seconds to variations in overall lighting, seeing everything as "white." In reality, household lamp bulbs are very yellow, fluorescent lights are greenish, and daylight is comparatively blue. Remember to change 5000K bulbs frequently, because they change color with age.

PART II—Inputting

Digital Cameras

There are numerous ways of getting images into a computer. The simplest and easiest way is with a digital camera. Some cameras are as simple to operate as point, shoot, and download. Others require lengthy acquire times and conversion of files into computer-readable formats.

This chapter discusses their similarities and differences in an effort to help you pick the one that's right for you.

The first question is: "Do I *need* a digital camera?" Next comes a realistic evaluation of what digital cameras can and can't do. From there, you can figure out the true end results and cost benefits. Then, of course, comes the question of which type of digital camera to buy. A low-resolution point-and-shoot? A powerful SLR? Or a high-resolution integrated camera or scanning back?

In many cases, a digital camera can be the perfect tool to get the job done, but it is not for all applications. For example, a digital view camera with a painfully slow exposure time is not going to catch a moving subject, but it can create excellent catalog still lifes ready to go to press moments after creation.

But you may not need a digital camera. With a home or office scanner,

you can digitize your conventional film negatives, transparencies, and prints, although for high-resolution, high-quality scans, the expense of the hardware can be prohibitive for most small operations. Another method is to have your conventional photos converted into digital images at the time of processing. They can be delivered on floppy disk, CD, or by using other storage methods covered in the chapter on image storage and picture file formats. If you didn't have them converted at the time of processing, you can use a service vendor to convert them on a per-image basis from negative, transparency, or print. Still other options enable you to input images from video camcorders, VHS tapes, video games, and television. If you

don't have the image you need in your files or can't shoot it yourself, there are hundreds of thousands of copyright-free photographs that you can purchase in the form of "clip art" or download off the World Wide Web for free or a small fee.

Camera Types

There are several general categories of digital cameras, although more will be introduced as new technologies and new niche markets develop. Categories include point-and-shoot cameras, SLR cameras, view cameras, professional camera backs, hybrid motion-still cameras, and personal communication devices.

20

To create this image, two digital photographs, one for the package under the glass and one for the fruit slices, were combined using Adobe Photoshop software. The border was created by blurring the outer edge of the composite. Image by Katrin Eismann.

The digital cameras are not just coming from traditional camera manufacturers, although these companies bring years of photography experience to their products. You'll also see consumer electronics and computer companies offer digital camera products, often in conjunction with camera manufacturers.

Point-and-Shoot Cameras

Point-and-shoot digital cameras are affordable and fun, not unlike their conventional film counterparts. Some offer many advanced features like removable storage media, while others are no-frills. They tend to be low-resolution units good enough for producing images that will be viewed on a computer monitor (like e-mail attachments) or printed only to a small size.

The point-and-shoot digital cameras are designed to be nonintimidating. This is probably why they *look*

Do I Really Need a Digital Camera?

To determine if you really need a digital camera, you have to analyze your true needs concerning price, quality, and end usage. Then it won't be hard to determine which category of digital camera (if any) is a good fit. Before purchasing a digital camera, answer the following questions. If you have no answer, you may end up buying more (or less) camera than you actually need.

Initial Investment: Can you afford this digital camera? In the low-cost arena, digital cameras cannot beat the quality of much-cheaper film cameras.

Long-Term Savings: At a certain point, will the money saved using the digital camera overtake the initial investment? The elimination of film, processing, and printing costs can add up to big savings. For items going to print, how many intermediate steps can be eliminated with your new digital capability?

Time Savings: Are your needs so immediate that you don't want to wait for film to be processed, printed, and scanned?

Digital Quality: Can the digital camera in your price range deliver a high-enough resolution, color depth, and dynamic range for your intended applications?

Resolution Options: Does this camera offer more than one shooting resolution? This will allow you to choose between quality and quantity in different situations.

Instant Review: Is it important for you to be able to instantly review images in the viewfinder or LCD panel, or can you wait to download them to a computer?

Creative Control: Does the camera offer manual and user-selectable controls to help you reach your creative ideals? These include lens choices, aperture and capture speed selection, manual overrides, accessories, and other traditional photographic features and capabilities.

Shooting Automation: Does the camera offer enough automation to make it easy to use for your level of photographic skill?

Scanning Times: What are your intended subjects? Some digital cameras have scanning times that take several seconds (or even minutes), necessitating the use of a tripod and a still subject.

Internal Memory: How many pictures can the digital camera hold before you need to download?

External Memory: Does this camera use PCMCIA cards, flash cards, or other removable memory storage so that you can reload and continue shooting without having to stop and download?

Interface Automation: Once you have taken the photos, how easy is it to download and access the images?

Types of Digital Camera Users

Home Users: If you're buying a digital camera for home use, the three biggest qualifiers are not much different than those for buying a conventional camera. You first determine what you can afford. Then decide if ease-of-use (point-and-shoot camera) or creative control (SLR camera) is more important to you. Then decide what level of quality you need (low-end, mid-range, or high-end), within your budget range. More often than not, the simplicity and appealing price of low-end, point-and-shoot digital cameras make them the most popular choice of the home user.

"Techno Wizards": If you simply want the latest and greatest technical toys on the market, you're the perfect candidate for the new personal record-keeper-type of digital camera. Look for cameras that add non-photo functions.

Photo Hobbyists: Amateur photographers who currently own and love their 35mm SLR cameras will naturally gravitate toward the SLR variety of digital cameras. The creative controls of SLR photography will already be familiar. Some new CCD digital camera bodies allow you to use conventional SLR lenses that you may already own.

Small Business Users: Depending on your digital goals and the training of your staff, most small-to-midsize businesses will want point-and-shoot digital cameras, SLR cameras, or both.

Professional Photographers: Professional photographers can find digital cameras to meet the same needs met by conventional cameras. Photojournalists will pick SLR digital cameras. Still life photographers will want digital cameras with view camera movements. Those photographers who use medium format will find comparable cameras in the digital realm.

Many high-end digital cameras come with image-capture software that lets you quickly preview your photograph on the computer screen. This allows you to adjust all aspects of the digital image before making a time-consuming high-resolution exposure. Shown here are the software screen and the resulting image, photographed with a Phase One digital camera back. Photos courtesy of Phase One.

like their conventional film counterparts rather than being given a futuristic makeover. The other reason is a cost-savings one. Why redesign the camera body when many of the functions and operations are similar?

Point-and-shoot digital cameras are user-friendly and offer maximum automation in terms of autofocusing, exposure control, flash control, image review, and image transfer. For anyone who has used a conventional camera,

you may not even have to read an instruction manual to get started, but read it anyway. You don't want to miss any key features. Yet this automation has a drawback: There are few manual overrides or user-selectable options.

Megapixel Point-and-Shoot Cameras

The low-resolution point-and-shoot camera is quickly being replaced on the market by the so-called megapixel cameras. These cameras offer over one-million pixels in resolution and some are considerably more. Don't be lured in by pixel-resolution alone, especially if camera controls are important to you. Many of these cameras are point-and-shoot simple—and point-and-shoot limited—in terms of user-selectable features, but some offer features that were previously reserved for the higher-end, SLR-type digital cameras. Scrutinize the features carefully before deciding on a model.

SLR Cameras

SLR digital camera systems are much more expensive but offer the shooting control you'd find in their conventional film counterparts. They also offer much higher resolutions, making them more useful to professionals who need to have their photos published as full-page magazine images, or larger.

SLR digital cameras offer creative control by letting the user select exposure, focusing modes, and interchangeable lenses. Of course, most have automatic options as well.

These cameras have been dubbed "photojournalist" cameras because of the first group of professionals to embrace them. Deadlines are paramount in the news business, and you can imagine the impact of these professional-level cameras which can deliver pictures to a newspaper office halfway around the globe seconds after the images were taken.

Studio Cameras

The more studio-oriented cameras are digital view cameras, digital integrated medium-format cameras, and professional camera backs. These come in many different shapes and forms but are basically in two categories. The first includes either single- or multiple-scan

A simple digital still life image can be easily and artistically enhanced on the computer. By using a digital camera with high-resolution capabilities, the image can be blown up large enough to become artwork for the wall. Image by Katrin Eismann.

Digital SLR cameras are built to function like conventional 35mm SLR cameras, with autofocusing, interchangeable lenses, and a through-the-lens viewfinder. Some digital cameras offer pixel resolutions of over 2 million and LCD monitors for easy picture review. Pictured is the Kodak Professional DCS 620 digital camera, an SLR camera based on the Nikon F5 platform; the camera features a 2-megapixel CCD sensor. Photo courtesy of Eastman Kodak Company.

Digital camera backs are able to provide incredibly high-resolution images, because they have larger CCD arrays. Some use a three-pass scanning system (three separate scans are made to create one final RGB file). The major downside of multiple-scan cameras is the time it takes to capture the image. Photo courtesy of MegaVision.

units—i.e., do they make separate R, G, and B recordings, or are the three colors recorded at the same time, enabling faster image capture? The other main differentiating factor is whether the image-recording device is a linear array that needs to be swept across the "film plane" like a scanner, an area array that captures everything at once, or three arrays that are interlaced together for maximum pixel resolution. These factors obviously have an effect on how quickly the camera is able to make a recording and, consequentially, how still the subject needs to be.

These cameras tend to be very high resolution units, shooting at 3.5x4.5K and higher. For example, at typical magazine reproduction standards, an image taken with a view camera back at 6x7.5K could be produced as a 37-1/2x30-inch magazine centerfold poster.

For the professional studio photographer, the digital camera offers some interesting benefits. The conventional film scenario would have the photographer produce instant test prints with a Polaroid back, so the art director can evaluate the shooting setup in progress and make any necessary artistic changes. In the digital realm, the Polaroid back becomes a high-resolution digital camera back that creates a picture file. The savvy art director can then drop it into a prepared layout and view the image with text and graphics in place. This eliminates guesswork.

The medium- and large-format digital cameras and digital camera backs offer extremely high resolutions, but they are quite expensive. Add the cost of high-performance graphics computers, monitors, and printers, and outfitting the digital photo studio becomes an expensive prospect. For some studios, the cost is quickly recovered in terms of value-added speed and flexibility, as well as the elimination of film and processing expenditures. It is not surprising that the catalog photography field has gone digital in a big way. In this photographic specialty, the amount of film used was massive, the needs are immediate, and the page designs can be done using desktop publishing programs. Colored backgrounds and product colors can be tweaked or completely changed with simple photo-editing commands to jazz up or redesign a catalog.

Digital Video
Digital capture of moving images is beyond the scope of this book, but it does bear mentioning because of the tremendous impact that digital imaging is having on the video field. Some still

Low-resolution, inexpensive digital video cameras make video teleconferencing possible for many small businesses. Faster data transfer services result in smoother action and higher resolution. Photo courtesy of Eastman Kodak Company.

digital cameras offer "burst-of-motion" capability, usually low-resolution clips that last only a few seconds. These clips are saved in various compression formats, such as MPEG, which can usually be viewed on a computer without file conversion. It's a nice capability for the family photographer who wants more versatility.

Digital video or DV is quite different. Moving images can be recorded for longer periods on digital video cassettes (DVC). The advantages of digital video over conventional analog video are considerably better resolution, superior color rendition, improved digital sound, more compact storage, and no degradation when video is copied or edited on the computer. Aside from the lower price tag and compatibility with existing analog equipment, there is little incentive to purchase an analog video system. Digital video offers so many advantages, in fact, consumer DV camcorders rival professional-quality analog video recorders.

Multi-Task Cameras

These cameras have been referred to as metacameras, personal record-keepers, personal communication devices, and even camera-optimized computers! But it's clear that some of the digital units are getting further and further from the classification of "camera."

This type of digital camera is a relatively new phenomenon, and manufacturers will be adding more and more creative bells and whistles to their products. Soon these products will resemble small computers rather than cameras. Current and future capabilities include simultaneous voice recording, after-the-fact memo recording, movie-clip capability, data entry, date-book/calendar functions, built-in modem ports, and infrared or direct-port docking to computers and printers. Usually these add-ons come with a price and limited photography capabilities, since the buyer is probably less interested in still imagery than other factors.

The Basics of Digital Cameras

Despite huge differences among digital cameras, whether point-and-shoot, SLR, view, camera backs, or personal communication devices, there are some underlying similarities. These should be fully understood before you decide which digital camera is the right one for you.

Recording Device

Digital cameras are simply cameras that create images with a recording device rather than conventional film. Most often, it is this image sensor that is the most expensive portion of the camera. Digital cameras can create varied pixel resolutions for images that run the gamut from those adequate for display on a monitor to images with millions of pixels. The prices vary just as radically, with cameras ranging from under $100 to those in the high five figures.

By far the most common digital image recorder is the CCD (charge-coupled device), although other systems are making headway in some digital product groups.

The imaging sensor itself is called an array. Most cameras have area arrays, meaning the actual image-recording sensors are on a grid, usually rectangular in shape, like that of traditional film.

CCD arrays are monochrome devices. In the early days of additive color photography (when James Maxwell demonstrated trichromatic photography in London in 1861), color pictures were produced by shooting tri-color negatives on black-and-white film using red, green, and blue (RGB) filters.

Single-pass digital cameras (a single scan serves to create all the RGB color information) are needed when photographing live subjects. Many professional digital cameras can record the image quickly enough to freeze the action while still offering high resolution. Photo courtesy of MegaVision.

CCDs achieve this same result today by using filters over the sensors (a color filter array or CFA) or a beam splitter. Either method creates separate RGB data channels at the same time. (Note that some high-resolution units actually make three separate recordings for RGB channels and then combine them later. Obviously, this leads to very long exposure times and is thereby relegated to studio cameras.)

The second chapter discussed the critical pixel resolution figure, which is how many pixels (picture elements or sample points) of information a digital picture file contains. A CCD creates pixel information when exposure to light causes the creation of an electrical charge. This charge is then transferred to the CCD and converted to voltage. In the case of an area array, how small and closely together these

lightsampling points are determines the final pixel resolution.

Linear arrays work in a similar fashion, but instead of recording the image all at once, they record only a slice of the scene at a time. The array is then moved slightly, and another slice is recorded until the image is completed. In some cases, separate passes are made for the R, G, and B channels, and they are later interlaced. Their advantage is that they can create extremely high-resolution picture files, especially if they also employ the triple-pass technique.

This type of high-quality image capture can be done remarkably fast for single-pass units, with exposure times in the fractions of seconds—but that's still too slow for most living, breathing subjects. Other systems crawl for literally minutes. In these cases, even the slightest vibration can cause image-degradation

problems, so you have to be careful about even shifting your weight on wooden floors near the camera.

With triple-pass (three-shot) or triple CCD systems, the three color channels are pixel-registered and then interlaced to create the final color picture file. Obviously, this creates a much higher pixel resolution than a single-shot camera with the same-sized CCD.

Three-shot cameras move each color channel (R, G, and B) through a different filter (literally a wheel with optically correct filters on it), while the triple CCD splits the light and directs it to three separate filtered CCDs to record the RGB channels.

For extremely high resolution, critical still life images, these systems can take multiple exposures and then average each color channel to help eliminate any artifacts.

The Kodak DC290 zoom digital camera features a 2.1-megapixel CCD sensor to capture highly detailed images and, for maximum quality, an uncompressed TIFF (Tagged Image File Format) mode. Photo courtesy of Eastman Kodak Company.

The point is that other factors like color depth and dynamic range are extremely important as well. Today, 24-bit color is the minimum you should accept for professional or high-end applications. The available 16.7 million colors might seem like overkill when you read about it on paper, but it really does make a difference when it comes to images that have smooth, lifelike colors numbering into the millions. Higher-bit systems increase the number of colors and provide more information for proprietary solutions to eliminate noise and other image-degradation problems.

Dynamic range, a key factor in scanners as well as cameras, measures the range of tones. A high range distinguishes details in the shadows and highlights that would be lost on a less-capable system. It is measured on a logarithmic scale, with 4.0 being the high point. To give you perspective, consider 3.0 dynamic range adequate for home use and a figure closer to 3.8 adequate for professional publishing.

Resolution

As discussed in the second chapter, pixel resolution makes a huge difference in the quality of your digital picture and the detail captured. Inexpensive cameras tend to have low resolutions that yield images that may look good on a computer monitor but can be printed successfully at only very small sizes. For example, an image with a

The lion's share of the cost of most digital cameras is their image-sensing array. Luckily, as the demand for digital cameras goes up, production costs and prices go down. The technological improvements in imaging arrays and in production techniques make the outlook even better. The downside is that it makes it impractical to quote camera costs, yet the price *relationship* between products as discussed in the book is unlikely to change dramatically.

pixel resolution of 320x240 would look good on a monitor screen at 3x4 inches but would only yield satisfactory prints the size of postage stamps.

Be forewarned that as pixel resolutions go up, the price of the camera and the size of the picture files radically increase. The new buzzword for cameras is *megapixel*, which refers to digital cameras capable of capturing about one million pixels or more.

Quality Factors

Pixel resolution is one of the most important aspects of your digital camera, but it is certainly not the only one. It's theoretically possible to make a camera capable of a 2x3K pixel resolution that only records in archaic posterized 8-bit color—like the 256-color computer monitors so common a decade ago. But a manufacturer would be crazy to commercially produce such a camera.

Digital "Film"

Another extremely important aspect of the digital camera is *where* it saves the image. Many low-end cameras record the image internally on the camera's "hard-drive." This is all right until you reach the memory capacity of the camera. If your desktop or laptop computer is nearby, there is no problem. Simply connect via cable, infrared, or data-port docking; download the images; save them; and start shooting again.

But you may not want to carry your computer with you, or you simply may not have the time to download. In these cases, it's great to have a camera with one of the many types of removable memory cards. In order to gain more storage, some digital cameras even offer side-by-side "twin" slots for two media storage cards. Like film, you load the card into the camera, record your images onto it, remove it when

it's full, and replace it with a blank one to begin shooting again. The advantage is that there is no processing other than dropping the card into a card reader or drive that lets your computer access the information. You can then erase the card and reuse it.

In average situations, with a camera that shoots 640x480 pixel files, you can hold about 20 images on a 2MB card, 40 or so on a 4MB card, and 160+ on a 16MB card. The numbers change dramatically, depending on the bit depth and file-saving method. Higher-resolution images reduce this number, of course, and lower-resolution images increase it. The file sizes can vary as well if the camera does any compression, such as consolidating like color tones. (Hence a photo of blue sky would take up less space than a deeply detailed texture image.)

Removable memory cards are ideal for photographing sporting events. You're not going to want to stop to download midway through the action. You might not even want to take the time to review the images in the viewfinder to decide if they should be kept. Instead, if you purchase several removable memory cards, you can continuously replace full cards with blank cards until you have the opportunity to download. They are more expensive than film, but you can reuse them, and you won't have to pay for processing.

Types of Cards
There are several different types and technologies involved in the field of removable memory cards. Even within a manufacturer's camera lineup, there are models that use different systems. Like almost everything else in digital photography, the decision on what type of data storage to use is a balance between capability (how much memory per card) versus cost. Even within one type of card, there are different choices in terms of memory capacity and physical size.

The three most popular types of cards at the moment are PCMCIA (Personal Computer Memory Card International Association) cards, flash cards, and compact flash cards. All use sturdy solid-state semiconductor technology, with no revolving or moving parts like magnetic media. The cards are used to taxi picture information back and forth between camera and computer.

If you already have an internal or external PC drive for your fax or modem, you may prefer a camera with a PCMCIA card-compatible system to avoid the need for extra drives or adapters. Some flash cards are PCMCIA card size, while others drop into an adapter to allow them to be read by a PCMCIA media drive. The small, postage-stamp-sized compact flash cards have gained great popularity, especially in the point-and-shoot realm.

Beware of SRAM cards if you're not diligent about transferring your photos to permanent storage. SRAM cards have the distinct disadvantage of requiring a battery (albeit a long-life lithium battery) to retain their data. Some SRAM cards are rechargeable.

Motion Capability
The need or desire for motion clips in addition to still images might have a profound effect on your camera choice. Many people believe that the moving image is more powerful than the still (as exemplified by the camcorder phenomenon), so why not have both options? You can even add motion to your e-mail and Web site.

How smooth the motion clip looks is dependent on how fast a frame rate (fps or frames per second) the camera can deliver. This in turn is limited by how fast the camera can process the information and get ready for the next image by clearing the CCD of previous information. Obviously low-resolution, low-quality pictures take less time to process than higher-resolution versions. If the camera offers multi-resolution

options, check frame rates and pixel resolutions at the various resolutions.

Viewfinders and Monitors
In the digital realm, the camera's viewing systems have become an important feature. Instant picture review is possible in many cameras; if the camera has an LCD viewfinder for playback, you can view then erase pictures on the spot and shoot again. Cameras that do not have instant review capability require you to download and view photos on the computer or TV.

There are a few factors you need to be aware of when shopping for a camera. Some viewfinders show the scene through the lens, like an SLR camera. This is great, because what you see is what you get. Other viewfinders show you an approximation of what the camera's lens is seeing. This is why you can have your finger over the picture-taking lens and not see it through the viewfinder.

LCD monitors show you what the imaging sensor is capturing. The monitors can be tiny or several inches large. Some cameras with bigger monitors often let you review images in multiples of four to speed up the process. A few cameras offer monitors that can be rotated for easy viewing, even when you're holding the camera at odd angles, like above your head in a crowd. Some of these LCD monitors let you *review* the images you took. This lets you determine immediately which to keep and which to erase. Probably the best combination is a through-the-lens viewfinder, combined with a larger LCD monitor. Other conveniences include a monitor that can display several images at once.

Single-lens-reflex (SLR) cameras, most medium-format cameras, and view cameras actually have you looking through the picture-taking lens. With SLR cameras, most often a mirror reflects the light into your viewfinder so you can see the image, until the

moment of exposure when the mirror lifts and the light goes instead to the image-recording device (film on a conventional camera, or a CCD or other imaging array in the digital world). This explains why your viewfinder goes black at the moment of exposure.

Other Digital Features

Platform Compatibility. If you're already entrenched in one computer platform, your camera's compatibility will make a big difference.

Pixel Resolution. Obviously top pixel resolution is a prime concern for the digital photographer. But other considerations include the number of resolutions you can choose from and the total number of pictures you can take before downloading or switching removable memory.

Note that there are different ways to change resolutions. The camera can use pixel skipping and just take every other reading on the CCD to produce a lower-resolution version. Better results are obtained if the image is recorded at the higher resolution, and the camera uses algorithms to perform decimation, which weighs side-by-side pixels to create a new single pixel.

The third method is to compress the files in-camera to produce a smaller-sized file, probably with some permanent loss of data caused by the compression itself. Some cameras offer more than one compression choice.

Multiple Resolutions. You might buy a high-resolution, expensive digital camera but not need high-resolution images all the time. For simple record-keeping snapshots, quality might not be as paramount as quantity. The ability to switch between high- and low-resolution pictures quickly is nice.

Image Stabilization. This reduces blurriness caused by camera shake. It works either by computer algorithm or through internal lens element adjustments controlled by electromagnetic sensors.

Sound. Audio capability can be handy. Photojournalists like the ability to attach short voice memos to their photos for caption information. Identifying the subject of the picture by name can eliminate confusion hours or even days later when the picture goes to press. Some cameras offer a choice between simultaneous voice recording or after-the-fact memo recording. Check the quality carefully. Generally it is not as good as a camcorder.

Color Control. In-camera color management can be important. Although a digital camera's CCD is very similar to a scanner's CCD, it lacks a consistent, color-corrected internal light source. Instead, as you shoot under varied lighting conditions, the camera's internal "computer" must make the best sense out of the scene.

Low-Light Capability. If you have specialized needs requiring low-light imaging, you'll want to check the specifications carefully, because digital cameras vary greatly in this aspect. One way low-light capability can be expanded is by making the individual CCD elements larger, not unlike the larger grains of ultrahigh-speed films. But like fast films, the larger pixels reduce the details and are only suited for lower-resolution printing, like newspapers.

USB Port. A Universal Serial Bus (USB) port is a high-speed digital data port for transferring information between computer and camera. This is especially important if you're using a camera with motion capability, which requires the rapid transfer of data for good results.

Digital Zoom. Don't mistake digital zoom with the optical zooms discussed later in the chapter. Digital zoom is just an electronic enlargement of the image coupled with cropping to make it seem like you are "zooming" closer with the lens. In fact you are enlarging or enhancing the pixels to do this. An optical zoom "brings the subject closer" *before* recording the image on

the sensor, giving a higher-quality result.

Scripting Capability. This function enables you to preprogram specialized operations on higher-end cameras so they can be operated in a preplanned point-and-shoot fashion.

Watermarking. Some cameras enable you to superimpose your copyright, logo, or title directly onto the image.

Video-Out Port. A nice feature for hooking your camera to a TV or VCR so you can review images on the large screen or record to tape.

A/C Adapter. This is very handy for conserving battery power when you're near a power outlet, as when you're downloading images to your computer.

Graphic Stylus. Direct graphic input is another option. You can use a graphic stylus pen on the camera's touch screen—not unlike the graphic pad that replaces your computer mouse in some art programs. Granted the camera version is quite crude, but you can add, for example, a handwritten headline on your pictures instantly.

Power Supply. Battery type or the availability of an AC adapter might be important for high-volume users. Some digital cameras require significant battery power.

Future Expansion. You should consider the number of interface ports or free extension slots in terms of future expansion, given the speed at which technology is expanding.

Bundled Software. This is a plus that should be factored into your purchase price, but only if it is software you really want. Be forewarned, often the bundled software is a less powerful, limited version of a popular high-end software package. It could be just a demo.

Other Options. Look for such capabilities as date-book/calendar functions, built-in modem ports, and infrared or direct-port docking to computers and printers.

Traditional Camera Features

In conventional photography, the use of certain camera features and operations depends on your goals. For simplicity, look for automated functions such as autofocusing, auto-flash, and auto-exposure. But if your goal is maximum creative control, manual overrides of automated functions, interchangeable lenses, and professional accessories will be key elements. In digital photography, these same factors come into play, albeit with a few modifications.

Lenses and Focal Lengths

Let's start with lenses. A "normal" 50mm lens on your 35mm camera gives you a particular angle of view that approximates what the average person sees minus the peripheral vision. But this field of view is intimately linked to the film size. On a 6x9 medium-format camera, a 50mm lens is a very wide-angle lens.

Focal lengths work the same way in the digital world. A 50mm lens on a smaller area array will give you a much different view than a larger area array, because the area array is comparable to the film size mentioned above. With most digital cameras, the CCD imaging array is smaller than 35mm format. For

this reason, ask for the focal length in terms of its comparative value in 35mm format. Or look through the viewfinder before buying the digital camera to get a good idea.

Some digital cameras may look like traditional SLR cameras; they're basically conventional camera bodies with digital backs. When you look through the viewfinder, you'll find that the active image area is a much smaller area than you'd expect to see. In other words, the conventional film camera at a given focal length gives a much wider view than the digital version, because the CCD is smaller than the 35mm format. This is great if you like telephoto and long lenses, but it limits the wide-angle capabilities of these digital cameras.

Look for cameras with close-up capability as well. Then you can use your camera like a scanner to make digital pictures of artwork, conventional photographic prints, or other objects you might otherwise put on a flatbed scanner.

Focal Length Choices

Most point-and-shoot digital cameras give you one choice of focal length. If you want the subject to be bigger or smaller in the viewfinder, you have to

move closer or farther away. This may not seem like a problem, but there are two reasons why it might be. The first is obvious. There are occasions when you cannot physically get closer to or farther from your subject. Perhaps a wall or police barricade blocks your way.

The second involves true perspective. Changing your camera angle (up, down, farther from, or closer to your subject) changes the perspective that the camera optically records. The size relationship between near and far objects changes as you move closer or farther away with any one lens. This can be used compositionally to improve the picture, such as moving in close to a foreground flower to make it look huge compared to a mountain. Or it can work against you if you want to show how grand the Grand Canyon is when you photograph your friend in front of it.

Different Focal Lengths

Instead of changing your shooting position (and therefore your perspective), some cameras let you change your focal length. What this essentially does is crop the scene in front of you (in the case of a bigger relative focal-length number) or show a wider view (in the case of a lower focal-length number).

Comparative 35mm Focal Lengths

The following list will give you a general idea of what range of focal lengths is best for what subjects. Of course, great photos have been taken of all these subjects at virtually every other focal length, but this a good starting point. Note that these are the focal lengths for the *35mm film format*. The field of view that your digital camera offers will vary based on the size of the CCD, but it probably will be less wide than its film version.

For comparison purposes, ask the salesperson or camera manufacturer

for the *comparative* 35mm value for your digital camera. Here's a rough guide to the subject types that tend to look best at certain focal-length ranges.

15—20mm: These ultrawide formats correspond to longer focal lengths on most digital cameras; you're not going to find them yet in the digital world in a consumer camera.

28—35mm: Scenics, group photos, interiors with limited space, and anything you want to make appear bigger or distorted by moving in close.

45—55mm: This is considered a

normal lens. It is a good, general all-around lens.

70—90mm: Head and shoulder portraits are usually the most flattering at this range.

135—200mm: A nice intermediate focal length for bringing distant subjects closer, allowing them to fill more of the frame.

Over 200mm: These are often the choice for wildlife, sports, and action photographers.

Macro Lenses: Macro lenses focus closer than normal lenses, allowing you to take a close look at details.

Top point-and-shoot cameras give the photographer a choice of two focal-length settings. A wider setting can be used for group portraits and scenics, while the longer (higher number) focal length is better for head-and-shoulder portraits or subjects at a greater distance.

SLR cameras give you even more options, offering you interchangeable lenses. You physically remove and attach different focal-length lenses. Of course, this is reflected in SLR price tags.

Zoom lenses give you more compositional variety, letting your subject appear bigger or smaller in the picture without moving closer or farther away. Macro capability or macro settings let you focus closer than you'd be able to with a standard lens. Close-focusing capability can be important, especially in specialized applications like medical and industrial photography. Close-focusing allows you a closer-than-normal look at the object. Some digital cameras can focus as closely as an inch or two away from the subject.

Note that a digital zoom should not be confused with an optical zoom. Digital zooms electronically enhance or enlarge the captured pictures to make it seem like the lens is zooming in for a closer look. The resulting quality is inferior when compared to a zoom lens that uses optics to zoom in *before* recording the image on the sensor.

Focusing Systems

Autofocusing systems (or lack thereof) differ among cameras. Focus-free or fixed-focus are at the lowest end of the scale. Don't mistake these for autofocus, because they do *not* have autofocusing capability. Instead, they are designed to produce adequate results as long as your subject is at least four feet or so away from your camera.

Low-end autofocusing (AF) cameras use an *active* system to judge the distance of your main subject, usually by sending an infrared light to bounce off the subject and return. The

lower-end AF cameras offer only two or three autofocusing zones, while the best offer over 100, enabling them to pinpoint the subject distance.

Still better are the AF cameras that use a *passive* autofocusing system, like phase detection. They focus more quickly and accurately than other systems but are generally found only in higher-end digital cameras like SLRs. They're a must if you plan to shoot frame-filling, fast action, such as sports photography. Their main weaknesses are in low-light situations and with low contrast.

These higher-end cameras also benefit from multiple autofocusing points or islands, which help you avoid the bull's eye syndrome and focus on off-center subjects. The AF islands can be user-selected, or the camera uses complex algorithms to determine the best focusing point quickly and automatically, even passing subjects from one island to the next as they move within the frame.

If you have a digital camera with only one centered focusing island, focusing on off-centered subjects (which are often the best compositions) is still possible. The good news is that most autofocusing cameras have a focus-lock feature (initiated by pushing and holding the shutter release button halfway down). Simply aim the focusing island at the subject, push the shutter release button halfway down, "drag" the subject to the edge of the frame while still holding the button down, and then push the button down completely to take the picture. If your pictures are completely out of focus, your subject may be too close or too far away for the AF system to focus correctly. (Note that out-of-focus and blurred images are two different things, one caused by incorrect focusing or lack of depth of field, and the other from camera or subject movement.)

Once you understand the center orientation of your camera's focusing

system, you may find situations where you want to use infinity-lock. This feature is available on a few high-end cameras and is useful if your subject is on the other side of a window (such as in a house) or there are many foreground elements that may fool the autofocus system. Essentially, this function tells the camera to ignore the window or the nearby tree branches and focus at infinity instead. Manual focusing can be used in these situations if your camera offers this high-end function.

Manual-focusing capability or manual-focus override, previously standard, is now an added feature on higher-end cameras. Sometimes it is used to fine-tune critical focus, such as on the eyes of a bird instead of its beak. Another good use of manual focus is when photographing a landmark on a busy street. Every time a pedestrian walks between you and your distant subject, the AF system might try to refocus on the pedestrian; manual focusing allows you to focus on the landmark.

Capture Time

The digital equivalent of shutter speed is the amount of time it takes the camera's imaging device to scan the scene. This is followed by the duration of time needed to process the image and prepare for the next image, which is analogous to the motordrive or film advance system (albeit usually much slower).

The general rule of thumb is that a 1/60 second capture time with a CCD area array is more than adequate for shooting with a handheld camera with a normal lens and no flash. Those with a steady hand can get away with 1/30 second. If the subject is moving a bit, such as a person walking, then 1/125 second is more appropriate. Action requires 1/250 second or faster. Vibrations from car engines or long focal-length lenses also require greater speed.

To get good images with slower speeds, use a tripod, which will steady the camera but do little to stop subject

If you mimic the way photographic optics work, your digital creations will seem more realistic. Here an out-of-focus background imitates the selective use of depth of field traditionally created by setting wide apertures like f/2.8. Image by Darryl Bernstein.

movement (unless you use a panning technique). On some digital cameras, flash will help freeze nearby subjects in action both in daylight and at night. Images can be sharpened to varying degrees in the computer at a later date.

Processing speed—or the equivalent of film advance speed—is related to exposure time. Obviously a digital camera does not need a motordrive, since there is no film to drive forward. But it does need time to process the image. Remember that the CCD or other imaging array must transfer the light-induced electrical charge to be converted to voltage, which is then calculated into a digital picture file. How quickly this task is performed will determine how long the delay is after you take the first picture until the camera is ready to go again.

Exposure Modes

The simplest digital cameras do not offer the user the choice of exposure modes. Some offer only a fixed aperture and automatically adjust the exposure. The camera simply picks what it thinks is the best exposure, with the results dependent on how well the camera's computers analyze the scene. In the worst-case scenario, this could mean the camera doesn't do any thinking and assumes the scene is bright daylight, leaving you to correct exposure deficiencies later on the computer.

A few point-and-shoot cameras offer more control over the exposure system. This lets you customize your exposures for special situations, choosing high-number apertures for pictures that are sharper from foreground to background or low-number apertures for portraits in which the background falls out of focus.

Most SLR cameras let you take full control of selecting exposure for ultimate creativity. This allows you to control the depth of field in the final image or stop action as desired.

Depth of field affects the range or depth of sharp focus (how deep a plane of sharp focus surrounds the subject). A wide (low-number aperture like $f/2.8$) creates a narrow depth of field. This makes the subject the only sharply focused element in the picture, while a distant background falls softly out of the range of sharp focus and becomes a nondistracting blur.

A narrow aperture (high-number aperture like $f/16$) creates a broad depth of field. This gives you as much of the image as possible in sharp focus, for example, a landscape in which foreground, mid-ground, and background are all in sharp focus.

If you don't need to control exposure, you're probably a good candidate for a highly automated digital camera. The traditional photography magazines, photography how-to books, videos, and CDs can help you get started learning more about creative control in capturing an image.

Flash Modes

It is important to remember that the best original digital picture will save you a lot of digital manipulation time and probably give you better results in the long run. Flash, properly used, is a wonderful tool for getting this great first exposure.

The most important thing to learn about flash is its limitations. The tiny flash units designed into compact digital cameras can't work miracles. These small flash units are designed to illuminate close subjects, such as a person standing five to ten feet away. Knowing the strength limitations of your flash, you can laugh the next time you see one go off at a concert or baseball game—the flash can't possibly light up the whole stadium. The result? A

drastically underexposed picture. Instead, you should turn the flash off and hold the camera very steady or even brace it on a solid object.

The higher-end cameras have stronger flashes that work at longer distances, or have a hot shoe or PC connection for synchronization with accessory flashes or larger studio flash units. Since flash is a short burst of light, it is obvious it will only work on cameras with area arrays, since linear arrays must make a line-by-line sweep to create a picture.

Auto-Flash

If your camera has an auto-flash mode, it will automatically fire in low-light conditions or whenever the camera perceives a need. The result will be a well-exposed subject and a nearly black background. Some high-end cameras will also fire if they detect a backlit situation, so your subject doesn't appear as a silhouette.

Other cameras require you use foresight and manually turn the flash on. If your subject is too dark when you review it in the viewfinder or on computer, then try the flash. It will save the frustration of trying to pull details out of the dark areas using a photo-editing software program.

Fill-flash is one of the best features of modern conventional film cameras, because it vastly improves pictures in many different situations. If you take a portrait at high noon, the sun casts harsh, unpleasant black shadows under the eyes and nose. These shadows exaggerate wrinkles and blemishes, and the sun is generally uncomplimentary light for your subject. By adding fill-flash, the picture looks basically the same, except the shadows are now filled, and there are highlights in your subject's eyes. On digital cameras, fill-flash performs the same function, eliminating the need for computer time to lighten shadows and add highlights to the pupils.

Should you decide you want to mix

The red-eye problem can be quickly eliminated in the computer through manual color correction or in a specialized red-eye-elimination function found in photo software programs. Photos courtesy of MGI Software Corp.

neon lights, room lights, or a sunset sky with a well-exposed subject (instead of a backlit silhouette), you can use night-flash or night-portrait mode. This function combines a flash exposure (which records the subject perfectly on film) with a longer capture speed (which records the surrounding background). For optimum results, steady the camera with a tripod or brace it against a solid object. You can substitute fill-flash for night-flash if your camera doesn't have this mode, but the results won't be quite as good. Another viable solution is to take separate pictures of the background and the subject and combine them in the computer.

That annoying red-eye problem often crops up when taking flash pictures in dim light with conventional film cameras. It occurs when your subject's pupils are dilated and the flash is close to the camera's lens. (SLR cameras with detachable accessory flashes don't have this problem, since the flash is so high.) In the digital age, red-eye

happens as well, but it's hardly a concern since retouching a red pupil is a simple task. Some photo-oriented software programs have a red-eye function. You may find a red-eye reduction flash function on some point-and-shoot digital cameras, which emits pre-exposure light through a lamp or pre-flash to narrow the pupil, but it may be easier to do the simple retouching later.

Other Traditional Features

A self-timer allows you to delay the shutter release for about ten seconds so that you can take a self-portrait or include yourself in a group photograph. If you don't own a tripod, the trick becomes finding somewhere to prop the camera or something to hold the camera in the exact position you want it. The handiest self-timers have a light or beep that quickens two seconds before exposure so you can prepare.

A tripod mount is a virtual necessity for advanced photography but should be considered for any camera.

A polarizing filter (right) deepens blue skies and reduces glare. It can significantly improve color saturation. Photos courtesy of The Tiffen Company.

At the simplest level, a tiny tabletop tripod can be attached to the bottom of the camera to hold the camera in place for quick self-portraits with the self-timer. More advanced photographers use full-sized tripods for a variety of reasons. Tripods help steady heavier cameras and can hold them at unusually high or low angles. They allow identical or nearly identical pictures to be taken, such as for time-lapse photography. Certain tripods aid smooth panning, a technique that keeps a moving subject sharp by tracking it, while the background becomes a blur.

Perhaps most importantly, tripods allow the camera to be held motionless for long exposures. This is important in low-light situations, when maximum depth of field (a high *f*-stop) is desired for creative reasons, or with digital cameras that use linear arrays or take tri-color exposures.

Accessory capability and availability should also be considered in your camera choice. The interchangeability of lenses on SLR and view cameras is an enormous creative benefit. Other traditional photographic accessories should not be overlooked, either.

The ability to add filters for creative and scientific reasons is a big plus. A polarizer, for example, can remove unwanted reflections that may hide a portion of a scene on the other side of a window. Filters for minute color corrections are obsolete, since overall color correction is a simple computer function. But color filters for black-and-white images can selectively lighten or darken certain colors in your photograph, saving considerable computer time. Special effects filters are still useful, but most have been replaced by their computer counterparts.

Shooting Tips For Digital Cameras

The most important tip to remember in digital photography is that there is no penalty for practicing and experimenting. In the digital arena, you lose no money in terms of film and processing. You simply erase the picture and take another one over it.

There are certain shooting tips that are true for all cameras, digital or conventional. "I can fix all mistakes later in the computer" might be a very tempting new motto, but resist it. While you can correct mistakes and improve your photos after you've taken them, the very best results in the digital arena start with the very best originals. Spend your computer time doing digital magic that couldn't be done any other way. Make as many of the image corrections as you can in-camera.

Basic Shooting Technique

Good shooting technique begins as mundanely as holding the camera correctly. Grasp the camera with two hands in a firm, comfortable, and steady manner. Then look in the mirror. Are your fingers blocking the flash, lens, or infrared sensors? If so, readjust your hand position. Then put the camera down, pick it up quickly, pretend to shoot, and check the mirror again. If you can do it a dozen times without blocking vital parts, you're ready.

Next you need to carefully read your instruction manual to learn about the various features and options your individual camera has to offer and how to make the best use of them.

Light and Digital Photography

The direction and quality of light has a lot to do with the success (or failure) of your picture, whether or not you decide to add any computer wizardry to the final product.

If you're planning to combine digital photographs in photo-editing or art software, it is critical that you pay attention to the lighting if you want to create a believable final image. There is only one sun shining on earth, so if two outdoor picture elements have shadows falling at even slightly different angles, the image will look unrealistic, although it may not be easy to pinpoint that this is the reason why. Even the change from slight cloud cover to heavy cloud cover can cause noticeably different lighting effects.

The same is true to a lesser extent of man-made lighting, whether it is overhead fluorescent light fixtures or carefully tuned studio flash units. One scene could have a variety of different man-made light sources. For example, someone sitting at an office desk may have a combination of light from an overhead light, a desk lamp, a window, or even the illumination from a monitor screen—all at the same time. Care

The distortions in this photograph were made without spending time on digital manipulation; they were made by placing an old darkroom condenser in front of the digital camera's lens during the exposure. Image by Katrin Eismann.

An important trick to make your digital photos more believable is to match the direction of light in each picture element so the shadows are cast in the same direction with the same amount of diffusion or sharpness. Image by Eric Lindley, Partners Photography.

should be given to achieve a realistic-looking scene in the final photograph. One of the rules of studio photography is to have just one main or dominant light source.

The direction of lighting can make a huge difference. You must decide how you will point light at the subject in comparison to the camera position. Outdoors, you should carefully choose the position of your camera and subject in relation to the sun. For example, sidelighting defines the shape of an object though highlights and shadows. It's a good choice for creating strong edges and emphasizing the texture of the object. By comparison, direct front lighting (like on-camera flash) tends to flatten the subject.

Backlighting can have different effects depending on your exposure and the translucency of the subject. If the subject is somewhat translucent, like a green leaf, it tends to glow, while an opaque object creates a silhouette. Silhouettes can be prevented if you use fill-flash to illuminate the subject, or carefully base your exposure on the subject and not the background light. Whenever your backlit scene includes the sun or a very bright light, watch out for flare that may create unwanted light streaks.

If the sun is not directly behind the subject, you can create a nice framing rimlight around a silhouette. Similarly, backlighting can be used as hairlighting (in the studio or in the sun) to add a fiery glow or simple glint on the hair, thereby framing the face.

The light source itself can be photographed. Neon lights, city lights,

The simplicity of this image is deceiving, because four separate digital images were needed to create the final photograph. Each exposure captured one aspect of the beer glass at its best—the label lit evenly, the liquid glowing from backlighting, the perfect foam head, and the luminous blue background. The images were then combined using Adobe Photoshop software to create the best possible product shot. Image by Katrin Eismann.

fireworks, and even the sun can be both the light source and the subject. To photograph lights, turn your flash off. At nighttime or if the lights are dim, support the camera with a tripod or brace it against a solid, non-vibrating object.

Light Quality

The quality of light is important in creating a feeling for the photograph. Direct, hard light creates sharp-edged shadows and delineates shapes in a hard, forceful manner. The light can be softened through diffusion (a translucent object is positioned between the light source and subject) or reflection (light is bounced off of something). For example, slightly overcast skies soften the sun's light, and a softbox softens a studio flash unit. Diffused light is often called beauty light, because it gently defines the contours of your subject, creating a much smoother transition from light to shadow.

Long before electricity and electronic flash, the painting masters loved northern light—flat, diffuse light that shines into northern-facing windows. It brings out the subtle unique contours of a subject's face without casting harsh shadows or squinting.

The quality of light is hard to recreate digitally, so make certain when combining two or more photographs that you create a realistic composite on the computer.

Conventional photographers spend a lot of energy planning certain effects: razor-sharp images, selective focus, and filters for special effects. On the computer, keep this in mind and vary sharpness and softness, colors and shapes to create the best overall image. Image by Eric Lindley, Partners Photography.

The "Rule of Thirds" is a compositional guideline designed to help you with the placement of the main subject, horizon line, and other important picture elements. Just divide the frame into equal thirds, both vertically and horizontally, with imaginary lines. Then place any of your important picture elements near the intersection points of these lines or along the lines themselves. Image by Bruce A. Landon.

Compositional Helpers

There are a few rules of design and composition that can help any photograph, painting, or digital masterpiece. Of course, rules are made to be broken. But in general, if you follow these pointers (some of them centuries-old from generations of painters), you'll get better results.

The Rule of Thirds

Unless you're using a high-end SLR digital camera, your digital camera probably has its only autofocusing point in the center of the frame, meaning it focuses on whatever is in the bull's-eye

position. Unfortunately, good composition has nothing to do with hitting the bull's-eye; centered images are rarely the best.

Getting away from the bull's-eye syndrome is one of the most difficult things for the beginning photographer (or artist of any kind) to learn. Luckily, there is a simple guideline called the "Rule of Thirds." Simply put, you must imagine a grid superimposed over your viewfinder. The horizontal lines dissect the frame into three equal horizontal bands, and the vertical lines dissect it into three equal vertical bands. The exact shape of this tic-tac-toe board depends upon the size ratio of the digital

camera's files—is it in the 3:2 ratio of conventional 35mm film? It will also change if your picture ratio is altered through later cropping on the computer.

Your goal is to place significant picture elements (like your subject or the horizon) along these lines, especially at the points of intersection. As you become more accomplished as an artist, you will soon start composing instinctually along these lines, moving your subject and horizon lines even more or less off center to achieve your own artistic effects. Experienced photographers often exaggerate the rule by placing key picture elements even further off center than suggested.

Color is a powerful tool. A brightly colored subject draws your eye like a magnet. Beware, however, that a background object can become distracting if it is too colorful. Image by Jay Stoegbauer, Jay Stoegbauer Photography Inc.

distracting background that can ruin the overall effect of your picture. By the same token, you can turn this knowledge to your advantage and use bright colors to draw the viewer's attention toward your subject.

We also associate certain moods with certain colors. To most people, blues feel cool, reds and yellows seem warm, conflicting colors (like blue and yellow) feel disconcerting, and harmonious colors seem more relaxing. If you want to create a certain mood, especially with a portrait, give careful thought to the overall color scheme (clothes, props, and background).

Perspective and Viewpoint
Perspective is a complex subject that is greatly misunderstood. You can change the perspective of your subject drastically by changing your distance from it. For example, if you're taking a photo of a person in front of a mountain, you can exaggerate how big or little they look in relation to each other by changing your physical position. By moving in close to the person, the mountain will look smaller (in relation to the person).

However, if you stand in one position and merely change your focal length (such as switch lenses or use a zoom lens on an SLR digital camera), the true perspective would not change. You'd simply be cropping more or less of the scene in front of you. The good news is you'd be doing this cropping *before* exposure, thereby maximizing your pixel resolution. If you crop the picture later on the computer, you'd be throwing away pixels from the overall pixel resolution.

Cropping
One of the quickest ways to change the shape of your photograph is to crop it. Most prints from conventional cameras are in the 4x6 ratio, but there are no limitations in the digital world. Most photo-editing software lets you crop part of the top, bottom, or both to create a wider-looking panoramic version. This can be very effective for wide scenics or group portraiture, where you don't want to include a lot of wasted space in the form of sky, ceiling, floor, or foreground. Likewise, by cropping the sides you can make a portrait vertical out of a horizontal landscape.

Remember, every time you crop a picture *after the fact,* you're throwing away pixels. When possible, crop in-camera by moving closer to your subject, zooming in, or changing focal lengths (if your camera has these capabilities) and then recompose. That way you'll have a higher resolution.

Using Color
Color is a very strong compositional element. It can make or break your photograph. Since our eye is naturally drawn to bright colors, like reds and yellows, brightly colored objects behind your subject can create a

When you plan the composition of your photograph, think about focus as well. You can use camera techniques to keep only certain areas of the picture in sharp focus. You can also alter the image on the computer using selective masking to blur, blend, or smudge certain portions. Image by Jay Stoegbauer, Jay Stoegbauer Photography Inc.

Your shooting angle and the height at which you shoot also have a great impact on the end result. As a general rule, take portraits at eye-level for the most pleasing results. With kids or pets, this means getting low to the ground.

But scenics often look better and more grandiose with a low viewpoint. Take this to extremes, and you have an ant's-eye view (from the ground looking up), such as a picture of flowers backlit against the sky. Or you have the opposite, a bird's-eye view (straight down) of interesting footprints on the beach.

Foregrounds and Backgrounds
Even though you can digitally "fix" a bad foreground or background after the fact in the computer, it's easy to spend a few seconds getting it right when you photograph it. Good backgrounds for a main subject (especially a portrait) should be either extremely beautiful or totally undistracting. The guideline to finding a beautiful background is to ask yourself if it would be a nice photograph without your main subject. If so, you probably have a winner. Nondistracting backgrounds contain no elements that take the viewer's attention from your portrait subject, elements like brightly colored or shiny objects, or a telephone pole directly behind your subject's head.

When you study your favorite landscape photos, you'll notice that many have interesting foregrounds, too. A powerful foreground element,

Catalog and magazine advertisers use product shots to show consumers what the merchandise looks like. Often the product is placed on seamless paper for a clean, simple, but otherwise boring background. In the digital realm, you can take this standard product shot and be creative. With the help of Painter software, this photograph's background now appeals to the target market. Image by Eric Lindley, Partners Photography.

A good exercise for photographers is to ask, "How little can I show in my picture and still tell the story?" In this classic example, you don't need to show the subjects' faces. Their hands tell the whole story. Image by Jay Stoegbauer, Jay Stoegbauer Photography Inc.

like an interesting rock or batch of flowers, draws your attention into the picture and provides scale for the usually majestic background.

Into the Frame

Motion, or the direction in which your subject is moving or looking, also influences composition. Always leave your subjects room to "walk into" or "look into" the picture by placing them far to the left or right, with most of the picture space in front of them. This might seem minor, but it can make a huge difference.

The same rule goes for graphic page layout and book design. If you review the photos in most magazines and books, almost all of them are placed so that the main subject is looking (or pointing with their body) toward the center binding, rather than to the outside margins. Thus following the "gaze" of the people in a magazine will almost always lead your attention back into the magazine, rather than off the page.

Photographing People

One of the quickest ways to improve pictures of people, especially children, is also the easiest—simply take the photograph at your subject's eye-level. With kids, this means crouching or sitting until the camera is at eye-level with the child. The resulting image will be far more appealing and intimate, and the child won't have to strain his or her neck to look up at you, resulting in an awkward pose. For taller subjects,

you should step up onto a stair or curb. Anything more than slightly above or below eye-level is often disconcerting.

Of course, many professional portrait photographers shoot from slightly lower than eye-level to photograph some people, because it makes subjects look taller and appear more powerful.

Body language and expression can have an enormous impact on the success or failure of your photo as well. Many people feel nervous in front of the camera (perhaps they've seen too many bad pictures of themselves), and their expression and posture will show it. Give them a prop or activity to do while you take the picture. Or explain to them the benefits of digital photography, such as how easy it is to erase the uncomplimentary pictures and take more.

The success of group portraiture relies on two things. The first is simple:

Take a lot of pictures to make sure you have one with everyone's eyes open. Remember, there are no film costs. Just erase the rejects.

The second trick is to creatively pose the group. Beyond the simple line-up-against-the-wall style, you should think in terms of "layering" the group. The team method is the easiest, with a front row of kneeling people and a standing row behind them. The goal is to put the people on different levels so everyone's full face is visible. You can be even more creative by using rocks, fences, or chairs to intertwine people at different levels.

Photographing Children

Children are asked over and over again to smile for the camera and say "cheese." This results in overly posed, forced-smile photographs. To get real,

Start with an idea: "Medicine can be fun and nonthreatening for children." Then let your imagination go, and you can come up with an appropriate digital creation for your client, in this case, a pediatric medicine group. Image by Eric Lindley, Partners Photography.

It's hard to get children to do exactly what you want them to do for a particular photograph. Mimicry, though, works well if you're willing to coach a certain action. Here, a jumping game was initiated to illicit the desired response. Image by Eric Lindley, Partners Photography.

relaxed smiles out of them, use patience, have your camera ready, and wait for those spontaneous moments when the smiles are genuine.

By carrying your camera with you on a regular basis and substituting candid photography for formal photography sessions, your kids will begin to see the camera as a mundane accessory. You must be inconspicuous and un-intrusive. One of the best methods is to watch your kids playing or working on an activity they enjoy. Compose the picture in the viewfinder and then give them a holler or greeting of encouragement. Nine times out of ten, you'll be rewarded with smiles.

Then share the pictures with them. If your digital camera lets you review them in a big LCD viewfinder, show them right on the spot. Or make a family event out of reviewing them on the computer. Children usually become much more enthusiastic if they are allowed to be part of the creative process—picking what goes in the family album and what gets printed, as well as taking some of the pictures themselves.

Most children love photography when you empower them with their own cameras. For toddlers, that means toy cameras. But five-year-olds and up can use one-time-use or child-oriented

conventional cameras (you'll need to have their prints scanned for digital use). Depending on their maturity, once your children enter grade school, they're probably ready to handle the family digital camera with supervision. It's not hard to teach them the basics of camera care and shooting technique, along with plenty of encouragement.

Different Ages

Taking photos of your newborn is easy. The trick is getting your baby comfortable in a photogenic spot. One option is the over-the-shoulder photo with Mom or Dad. By moving closer or farther away (or changing your lens or focal-length setting if possible) and selecting your shooting angle, you can include just the baby or the baby and the adult. Or place your baby in a car seat or in a favorite blanket. Make sure the blanket has a simple pattern so it is not visually distracting. Then position the car seat or blanket near a window for a natural-light portrait or use the flash. If you choose a window, northern light is best, with the child facing the window.

As soon as toddlers begin to walk, photography becomes a little more difficult, because you have to act more quickly. When they see you pointing a camera at them, they'll usually come charging over to see what you're doing. A good trick is to photograph them when they're investigating a new book or toy, or when they're engrossed in an activity, like playing in the sand. You can also ask them to show you something, like a favorite stuffed animal, or perform an activity, like smelling flowers.

Preschool is a fun time for the family photographer, because your youngster now understands the concept of photography but is probably still relatively free of self-consciousness. Children at this age get into a myriad of new games and activities to be photographed.

Once in grade school, you can probably purchase the annual school

pictures of your youngsters, but don't rely on them as the only pictures of your children. Make sure you bring your digital camera to after-school activities, weekend family fun, and holidays. Don't neglect to photograph their friends—years from now your adult children will take great joy in seeing pictures of their childhood buddies.

Photographing teenagers and almost-teens can be a trial for the family photographer. Self-consciousness and rebellion might hamper your results, but keep at it. If you started early and made photography a painless and fun tradition, the process will be easier.

Twenty Quick Compositional Tips

1. **Keep It Simple.** The composition of good pictures is often very simple, including only the subject, a simple background, and no other visual clutter. In the case of party photos, for example, empty glasses and plates in the foreground and crowds of party-goers in the background can clutter the photograph.

2. **Know Your Subject.** Make certain you determine your main subject. Is it the Taj Mahal? The reflection in the pool in front of the Taj Mahal? Or the person posing in the foreground? Once you determine the most important picture element, you can emphasize it compositionally with techniques like the "Rule of Thirds" to produce a stronger overall result.

3. **The Importance of Color.** Color is an extremely important compositional element that can improve or ruin your picture. Avoid bright or clashing colors in the background or foreground that might distract your viewer's attention away from the main subject. Instead, reserve attention-getting bright colors for the subject itself.

4. **Wallpaper.** Since colors give us such strong reactions, we're often

tempted to photograph the colors we see. Think about what your subject is before you take the photograph, or you might end up with just a pretty pattern of colors—good enough as a screen saver, but not much more.

5. **Crop In-Camera.** Move in on your subject (physically or through lens selection) to eliminate picture elements that aren't important. If you wait to edit on the computer, you're throwing away pixels and lowering your overall picture resolution. One of the quickest ways to crop in-camera is to turn the camera sideways and shoot vertical photos of vertical subjects, like trees, skyscrapers, and people standing.

6. **Viewpoint and Perspective.** Stepping closer or farther away from your subject can change the spatial relationship between the foreground and background elements. It can make one object look proportionally larger or smaller than another in the photograph.

7. **Into the Frame.** An elusive but important compositional element is the direction in which the subject is looking, moving, or pointing. Place the subject on the far left or right, pointing or looking toward the center of the frame.

8. **Bull's-Eye Syndrome.** It is human nature to concentrate on your subject as if it were a bull's-eye target, but centered compositions are rarely the best. Try to place the main subject off center. (You may have to use the focus-lock function, if available.)

9. **Add Scale.** When photographing broad landscapes or especially large or small objects, it is important to include something that has a relatively standardized size (such as a person) for scale or comparison. Without people under Delicate Arch in Utah, you'd have no way of knowing how big the arch actually is.

Leading lines don't necessarily have to originate in your photograph. They can be created afterward during the image-manipulation stage. Image by Keith Ewing.

10. Look and Look Again. The first photograph you take might not be your best. Wait a few seconds, re-evaluate your subject, and try again. You might come up with a better idea, the lighting may change, or an element in the picture might move. Look at your subject from different angles.

11. Don't Forget the Details. You don't need to show a tree in its entirety to communicate the concept. A single leaf or patch of bark can sometimes tell the story just as well.

12. Backgrounds. Good portraiture backgrounds should be extremely beautiful (i.e., it would be a nice photograph *without* your portrait subject), offer a sense of the environment where the photograph was taken, or be totally undistracting. You'll generally want to strive for simplicity. Try different shooting angles or lenses until the background is no longer distracting. Distracting picture elements include bright colors, written words (like billboards or store signs), vertical lines (like telephone poles), sunlit highlights, or shiny metal in the background.

13. Foregrounds. Great scenic photos often have interesting foregrounds, backgrounds, and in some cases, mid-grounds. An interesting foreground element, like a rock or batch of flowers, draws your attention and provides scale for a majestic background, such as a mountain.

14. Framing. Compositionally framing your image with foreground elements (in or out of focus) can direct the viewer's attention to the real subject in the mid-ground or background.

15. Good Lines. Use leading lines to draw the viewer into the main subject. Good choices are off-centered fences, sandbars, trees, or winding roads that direct your eye toward important picture elements by "pointing" at them or curving around them. Bad lines would cause your eye to follow them off the edge of the picture or into boring sections of the picture. The best compositions use the subject, lines, and colors to subtly cause your focus to travel around the entire picture. The trick is to distinguish between good lines and bad lines.

16. Bad Lines. Bad lines in your photograph are distracting lines, such as a telephone pole "sprouting" out of your subject's head or a dead-center horizon line that stagnates the picture.

17. Horizons. The horizon line is often an important aspect of the picture. Try to avoid placing the horizon line in the center of the frame, since this is generally a stagnant composition. Instead, decide whether the sky (above the horizon line) or the land (anything below the sky) is the most important. Then include more of the most important element.

18. The Shadow. Good photographers watch the light when they make digital photographs. Great photographers watch the shadows as well. Sometimes a shadow can be the most important compositional element, but at other times, it's a distraction. Notice shadows and use them creatively.

19. Erase. Don't hesitate to erase the bad or embarrassing pictures and record over them. Why dilute the effect of the good photos with a lot of so-so or horrible pictures? You certainly shouldn't waste paper printing them.

20. Have Fun. Even if you bought your camera for business purposes, take pictures just for family memories, too.

Shooting Tips For Specific Situations

AUTUMN
- Find a subject other than the broad expanse of beautiful leaves in front of you, and use the colorful leaves as a backdrop or framing device.
- Move in close on one individual leaf, and make it the subject.
- For maximum color vibrancy, position yourself so the leaves are backlit. Or wait until they are lit by the warm, late afternoon sunlight.
- Don't overlook bad weather days. Wetness tends to saturate the colors, and fog or an early winter snow can be wonderful mood enhancers.

DAWN OR SUNSET
- Dawn skies and sunsets make great backdrops for combined images. On the computer, you can easily take a portrait with a poor background and substitute the sunset. Even if you have no planned usage in mind, photograph pretty sunsets and cloud formations for future use.
- With the sky in the background, you have two basic choices for a person or object in the foreground: The subject can become a silhouette or add flash to illuminate the foreground subject.

HOLIDAYS
- Start a tradition for an annual family portrait on certain holidays like Thanksgiving or Mother's Day.
- Candid photos often capture the most cherished memories of past holidays.
- Create the holiday mood by adding holiday clip art, digital snow, or other computer manipulations (like Santa caps or reindeer antlers for your subjects).

OVERCAST DAYS
- Cloud cover diffuses the sunlight, creating soft, complimentary lighting for portraiture and nature photos. You'll still see shadows, but they are minimal—just enough to show the contours of a face or flower without emphasizing imperfections.
- If colors are dull, you can increase the saturation digitally on the computer.

PEOPLE
- Photograph at eye-level with your subject. With children or seated adults, this means crouching down or getting on your knees.
- See the advice on general portraiture and photographing children given earlier in this chapter.

PETS
- Use all the rules of portraiture, including photographing at eye-level with the pet and trying to get eye contact.

PLANES, TRAINS, AND AUTOMOBILES
- Don't take photographs through glass windows if you can avoid it. The glass is not optically clear, probably has a strong color tint, and could confuse your camera's focusing system.
- Open the window if you can, but be wary of sticking your camera outside. The slip stream on even a slow-moving vehicle will cause camera shake (and therefore blurry pictures) and could cause you to drop the camera.
- If you can't open the window, focus on infinity or select the infinity-lock function (if available) to insure that the camera focuses on the outside scene and not the window.
- Make certain the flash is off when photographing through glass, or you'll end up with a bright white picture of the flash reflected off the window.
- Minimize camera shake in a moving vehicle (and reduce the blurriness in your pictures) by NOT leaning or bracing yourself on the wall or window of the vehicle. The vibrations will be transmitted to your arms and your camera. Instead, move away from the window in a relaxed stance, holding the camera with both hands. If the image does blur, you may be able to improve it on the computer with sharpening functions.

RAINBOWS
- Rainbows are rarely good subjects in and of themselves. Use the rainbow as one element in an otherwise good scenic composition. (In other words, if you removed the rainbow from the composition, you'd still have a nice picture.)
- Enhance the colors on the computer, but be careful to keep them realistic.

SHOWS AND PERFORMANCES
- Stage performers are often far away, dimly lit, and in constant motion, making this type of photography difficult. Do the best you can and digitally enhance the photo later.
- Turn your flash off. It isn't strong enough to light up the whole stadium or theater. Instead, wait for spotlights to hit your subject.
- Be alert, waiting for those peak moments when the performers freeze in a dramatic pose and then shoot.

SUMMERTIME
- High sun often causes harsh, uncomplimentary shadows on people's faces; fill-flash can reduce these shadows, eliminating the need to retouch later.

❏ Extreme changes in temperature can wreak havoc on your digital (and conventional) cameras. In the summertime, this can happen when you step out of your air-conditioned home or car into the blazing heat. One problem with extreme heat is that it can cause interference with the camera's imaging sensor, resulting in "noise" and unwanted artifacts in the image, especially noticeable in the dark areas of the picture.

UNDERWATER AND WATERSIDE

❏ Don't mistake weatherproof cameras for waterproof cameras. Weatherproof cameras merely resist water and are less likely to self-destruct if they get sprayed with rain or mist. They are NOT submersible.

❏ Inexpensive waterproof casings and top-dollar housings are available for many different digital or conventional camera sizes and lens mounts.

❏ You can use film-based 35mm or Advanced Photo System one-time-use cameras designed to photograph underwater and then opt to receive digital picture files in addition to your prints and negatives.

❏ By far the best way to take shallow-depth underwater pictures is on sunny days with a willing subject, such as a friend or hand-fed fish. The closer you are to the surface, the better the colors will be.

VACATION AND TRAVEL

❏ A self-timer and a tripod will enable you to do self-portraits in front of memorable monuments and scenery. Or ask a stranger to take the picture—your digital camera is certain to be an instant icebreaker that could lead to a new friendship.

WEDDINGS-NON-PROFESSIONAL

❏ There are no second chances for photographs at a wedding. Make certain you're ready with fresh batteries and that you have downloaded all old pictures still on the camera's memory. Bring extra removable memory or a laptop to download pictures if you run out of internal memory space.

❏ Find out if flash photography is allowed before you start taking photographs. Many religious sites ban it. Plus, if the service is being videotaped, the flash can create blinding whiteouts on the tape. Check your instruction manual ahead of time to find out how to turn off the flash.

❏ When taking photographs of the altar, angle the camera high, and use the high-soaring ceilings in your composition with the bride and groom at the bottom of the frame. This way, you can avoid including the backs of the heads of the guests in front of you.

❏ Remember that the newlyweds would probably love copies of your pictures, as would other family members. You can even share your images via the Internet (see the last chapter).

WILDLIFE

❏ Be realistic and set your goals on animals that you can get close to safely. Unless you're an outdoorsman, this isn't going to be in the wild, except at a few special viewing areas.

❏ Conventional and petting zoos are nice alternatives for taking "wildlife" pictures, especially with point-and-shoot digital cameras.

WINTER FUN

❏ Sunny days in winter are glorious for taking photographs, because the sun is always low in the sky at an attractive angle. If there is snow on the ground, it bounces the sunlight all around, filling shadows for attractive portraiture.

❏ Whenever the sun gets buried behind clouds, simply turn the flash on (force-flash) when taking a portrait, even if the camera's automatic mode doesn't think you need it. This will pop the colors and bring life to the picture, saving you from having to enhance the photograph later.

❏ When it's actually snowing, you'll usually want to turn the flash off, so it doesn't illuminate the hundreds of snowflakes that are falling between you and your subject.

❏ In winter, condensation quickly forms on the outside of the camera. This can cause fogged pictures if the condensation builds on the lens and can cause internal damage to electronic circuitry. Allow the equipment to warm up slowly inside your camera bag. Better yet, seal your camera in a plastic bag before moving into the colder environment, and leave it in the bag until it has reached the ambient temperature. This will cause the condensation to form on the bag rather than on the camera.

Never underestimate the importance of a person's eyes in your composition. Even in a digital photograph that has been manipulated and altered almost beyond recognition, the eyes still hold the overall composition together. Image by Keith Ewing.

Troubleshooting

Blurry pictures can be caused by three things: the subject is out of focus, the camera moved too much during the exposure, or the subject moved too fast.

Wrong focal point: If your subject looks blurred, it could actually be out of focus. The most common cause of this is an off-center subject, since simple autofocusing systems focus on whatever is in the center of the viewfinder. If you want an off-center composition, start by centering the subject, use the focus-lock function, and then recompose before taking the picture. Or take the picture with the subject centered and digitally crop the image to have the subject off center again.

Blur from camera movement: When the subject and the background are both blurred, the problem is camera movement. Solve it by using a tripod or bracing the camera on a sturdy object.

Only the subject is blurred: If the background is sharp but your subject is blurred, then the subject is moving too fast. Try using a faster speed, turning on the flash, or panning with the subject to blur the background instead of the subject.

Blur from panning: If both the camera and the subject are moving at the same speed (such as on an amusement park ride), the subject will appear sharp, while the background is blurred.

Scanners

Nobody ever said digital photography has to start with a digital camera. Make use of years of prints, negatives, and slides—not to mention the hardware investment you have in your camera—by scanning your conventional film photos to create digital picture files.

Types of Scanners

Using a digital camera to take pictures might be the easiest way to get images into your computer, but it is certainly not the only option. Scanners offer an interesting alternative.

Your conventional film camera is a remarkable tool for capturing images. You've probably spent a lot of money on equipment and film, and spent time learning to take better pictures. Why not consider capitalizing on your older images and hardware investment, and consider scanning your film and print images instead?

Scanners are wonderful tools that convert photographic prints, negatives, or transparencies into digital form. Once in digital form, you can alter the photo on the computer, post it on the Internet, print it at home, or send it via phone lines or other methods to service providers for printing. You can do anything with your scanned image that you can do with an image taken on a digital camera. And you don't have to stop at photographic media—you can digitize artwork, logos, textile patterns, line art, signatures, and other relatively two-dimensional creations from the analog world.

Scanners are designed as external computer peripherals, unless they are integrated into commercial workstations for a minilab or industrial application. In order to work, they need to be hooked into the computer (the brain) with cables (arteries). Software and hardware (and most likely a TWAIN interface) allow the scanner and computer to digitize and work with images. Regardless of what type of imaging device your scanner uses, it will be based in the RGB (red, green, and blue) world of additive color, rather than the CMYK (cyan, magenta, yellow, and black) systems used in printing. Aside from those similarities, scanners run the gamut in features, capabilities, and price.

Two separate film negatives were scanned into digital files and then combined with Adobe Photoshop software. The image of Pegasus was taken in Las Vegas, and the background image was a medium-format picture of the reflections of trees in icy puddles. Image by Katrin Eismann.

CCD vs. PMT

The first factor that divides scanners into different categories is whether they are CCD-based or utilize other imaging sensors, such as PMT (photo multiplier tube) sensors or CMOS imaging technology, which utilizes CIS (contact imaging sensor) modules.

The most common scanner type is the CCD scanner. A CCD imaging sensor creates picture information when exposure to light causes creation of an electrical charge. This charge is then transferred to the CCD and converted to voltage. Unlike most digital cameras, the sensor is usually a line array that reads the picture one line at a time. CCDs are monochrome devices. Most use filters over the sensors (a color filter array or CFA) or a beam splitter to create separate RGB data at the time of the scan. Other scanners use more time-consuming triple passes for the readings.

PMT-based scanners are reserved for the extremely high-priced drum scanners, usually designed to turn small transparencies into huge, high-quality digital scans. They offer the best quality in terms of tones reproduced and relative enlargement sizes. At this point, PMT drum scanners are out of the price league of everyone but service providers, publishing companies, and businesses that do a large volume of high-resolution scans. But watch for top-quality CCD scanners and less expensive "baby drum" scanners to close the gap.

Ever wonder why your 35mm color slides come back from a magazine publisher with their cardboard or plastic mounts slit open? Most likely, the company that published your work made a scan of it. For the best quality, the film needs to be removed from the 2x2-inch slide mount in order to place the image in direct contact with the curved drum of a PMT scanner or flat against the glass of a flatbed scanner.

CMOS Imaging Sensors

CMOS imaging sensor technology and CIS (contact imaging sensor) module technology have been utilized in low-end digital cameras for several years and are now appearing in scanners as well. These sensors have several distinct advantages; one is that they use only a fraction of the power consumed by CCD sensors. CMOS/CIS modules also tend to be considerably slimmer than CCD units. Additionally, signal processing can be integrated onto the chip, meaning analog-to-digital conversion can be performed much quicker. In cameras, for instance, this can result in higher frame-advance rates.

Although top-of-the-line CMOS sensors are capable of going head-to-head with CCD sensors in terms of resolution capacity, most current products utilizing CMOS sensors have considerably lower resolution and poorer dynamic range than their CCD counterparts.

Print-Fed Scanners

Print-fed scanners are very popular because of their simplicity and low entry cost. They're designed for one thing: taking your prints (usually 4x6-inch or 3-1/2x5-inch standard prints) and scanning them.

These scanners are usually very small and can stack on top of other equipment. They connect directly to

This image began with conventional collaging; color prints were cut, pasted, and taped together. The art was then scanned on a flatbed scanner, then altered using Live Picture software. Virtually any relatively two-dimensional object that can be placed on a flatbed scanner can be scanned. Image by Marni Schlifkin.

your computer with cables and usually come bundled with simple photo-editing and manipulating software. Best yet, they're surprisingly inexpensive.

Through simple computer commands, the photograph is fed into the scanner where it is passed in front of a stationary linear CCD array, which scans the image line by line as it goes by. After scanning is complete, the image appears on your computer screen, ready to be saved and used.

Generally these scanners offer only low-resolution scans. This means a quick scanning time but limits the usefulness of the picture files they produce. They're great for producing digital photos to display on your computer screen, posting to the Internet, or small output on an ink-jet printer. For example, a 4x6-inch original scanned at 200 dpi yields an 800x1200 pixel resolution file, would reach the printer's top capability at only a small 2-1/2x4-inch print on a 300 dpi ink-jet printer. If your goal is much larger prints, you'll start to see pixelation and probably not be happy with the results of this type of scanner. If your printer is an even higher caliber 600 dpi unit, these scans would be optimized at only half that size, about 1-1/4x2 inches.

Sheet-Fed Scanners
Larger sheet-fed scanners are usually simple document scanners, designed for optical character recognition (converting printed text into word processing files that can be edited). Optical character recognition (OCR) software does not require high-resolution scans or even color scans, and

monochrome 250 dpi is usually adequate for most applications.

A few document scanners are able to scan items as small as a business card or as large as legal-size documents and can be used as a copy machine when linked directly to your printer.

Flatbed Scanners
Flatbed scanners are more versatile but larger and more cumbersome (and sometimes exponentially more expensive). They're designed to scan *reflective* rather than *translucent* materials, such as photographic prints, artwork, text, fabric, line art, signatures, and other relatively two-dimensional objects. Flatbed scanners can accommodate works up to the dimensions of their glass surfaces, with standard letter, legal, and photos sizes (such as 11x14 inches).

With flatbed scanners, you position your original very much like you

would on a photocopy machine—an easy analogy since you are "copying" your photograph into the digital world. A horizontal light source is passed along the length of the glass to illuminate the art on the scanner and reflect the information onto a long, narrow image sensor. The information is gathered at regular intervals that correspond to the scanner's dpi figure. If the original is smaller than the maximum size of the scanner (such as a 5x7-inch print on a scanner capable of 11x17 inches), the scanner can be programmed to end its pass after five inches to save time.

Today's flatbed scanners are almost all single-pass scanners, meaning they collect RGB information in one swipe, rather than three separate (red, green, and blue) scans that are later combined. For obvious reasons, single-pass scanners offer a considerable time savings, and the demand for them is high.

Capabilities range from low-resolution (200 to 400 dpi) to powerful units above 1200 dpi. When combined with OCR software, even the inexpensive flatbed scanners can convert printed text into text files for your word processing program. These files can be edited and shared, eliminating the need to rekeyboard hard copies of documents. Better OCR software can scan magazine articles or other graphic page designs, allowing you to designate the copy flow as it jumps to different parts of the page and wraps around the photos.

Transparency Adapters

High-end flatbed scanners often have free or optional accessory transparency adapters that enable you to scan transparency material as well. Usually you have to replace the solid cover on the flatbed scanner with the transparency adapter, which includes an illuminated light source. Transparencies, negatives, overheads, or other translucent materials are placed on the glass, but now the illuminating light source is in the cover, so it shines *through* (rather than reflects *off*) the material in relationship to the CCD receptacle.

This may seem like the perfect solution, since you now have the ability to scan negatives and transparencies as easily as printed works. But there is a downside. Since flatbed scanners are designed to scan large originals, most won't have the power to scan relatively small slides at resolutions that allow big enlargements. Although you can easily scan a 9x12-inch photographic print on a flatbed scanner at 100% enlargement/200 dpi setting, to scan a 35mm negative or slide (measuring 1x1-1/2 inches) with a transparency adapter, you'd need to enlarge it nine times (or 900%) to reach the same 9x12-inch size. This would require a scan at 100% enlargement and 1800 dpi (or 900% and 200 dpi) just to achieve the same size output printed at the same dpi.

Though some of today's flatbed scanners come close to that limit, they suffer from poorer dynamic range (the ability to faithfully reproduce subtle tones) than PMT drum scanners and dedicated film scanners. The reason is a matter of economics. Photographic prints are inherently "flatter" and don't reproduce as many tones as original film, so why should manufacturers spend extra money (and therefore have to charge you extra money) to build print scanning machines with more dynamic range than most people need?

If you take only slides, or want to scan only your negatives, put your money in a dedicated film scanner. But if you want to scan all sorts of things, a flatbed scanner with a transparency adapter is a good choice. You'll be very happy using the adapter to create lower resolution output, FPOs (For-Placement-Only scans of photos for initial design purposes), or all but the most critical uses (publishing, big enlargements, or output to silver-halide papers).

Film Scanners

Dedicated film scanners are designed specifically for 35mm film, although a few accept medium format. They tend to be considerably more expensive than the average flatbed scanner, but they can scan at much higher resolution. This is very important for enlarging the small 1x1-1/2-inch 35mm format originals into workable sizes.

These scanners also tend to offer much higher dynamic range, enabling more details to be recorded in the shadows and highlights. Another advantage is their small "footprint," meaning they take up little space on a desk when compared to a flatbed scanner. These machines for professional use often have specialized high-production accessories, such as bulk feeders and strip film accessories.

A dedicated film scanner will usually produce better results than a flatbed scanner with a transparency adapter. If your film scanner needs are sporadic, it will probably be more cost effective to have your images scanned by a service provider on a per-scan basis. Photo courtesy of Eastman Kodak Company.

Film scanners need to scan at a much higher resolution than their flatbed scanner counterparts, since the relatively small transparency or negative size (1x1-1/2 inches for 35mm) usually requires much greater enlargements for the end print. Photo courtesy of Eastman Kodak Company.

APS Scanners

A new breed of scanners were developed for the Advanced Photo System (APS). Like the whole APS concept, they're designed to be easy. These small, box-like scanners have a hole in the front that will only allow you to insert a processed APS cassette. The scanner automatically unthreads the film internally, scans each image,

KODAK PHOTONET Online

If you don't want to invest in or bother with a scanner, a service provider such as Kodak can perform your scanning for you on a per-piece basis.

If your needs are fairly low resolution, like e-mail, monitor-viewing, or computer "slide shows," Kodak can solve your needs conveniently and inexpensively. At the time of processing your film, you simply check the appropriate box on your processing envelope, and for a small charge, you will receive your prints and negatives plus a floppy disk (or two for a 36-exposure roll) with a digital file for each image. The files have approximately 600x400 pixel resolution and are JPEG-compressed. Free software on the disk (or software available at http://www.kodak.com) allows you to view the images on screen, organize them into albums or slide shows, do minor cropping and rotation, and send them to your printer.

rewinds the film, and returns the cartridge. The images then appear on the screen of your computer in the familiar index print form, and you're ready to start working with them.

Incidentally, this is also the concept behind consumer kiosks, where you can take your processed APS cassettes and order prints or create personalized digital creations (like greeting cards or souvenir magazine covers) through easy, touch-screen commands.

Handheld Scanners

These handheld units work like a flatbed scanner, except you manually pull the light source over the original by hand. The results are highly dependent upon your manual dexterity.

You'll still see them offered on

If you have Internet access, a more convenient option is to have these images posted on Kodak PhotoNet™ online. You are given a private password to access your pictures. Simple, interactive e-mail order forms let you purchase prints or photo novelties. For a small monthly membership, you can also use the network as your on-line photo library and permanently store your photos.

You can share your password with friends and relatives, who can look up the pictures and order their own reprints directly. You no longer have to guess which pictures in what sizes they'll want to own. You can even delete the bad or embarrassing images before sharing your password.

Higher Resolution

Kodak Photo CD discs and FlashPix CDs can be ordered for higher resolution. These multi-resolution file formats give you many options, from monitor-viewing to large prints. They're both good choices for photo manipulation and digital artistry.

occasion, but you're better off with a low-priced flatbed scanner, unless you need to do a lot of optical character recognition (converting printed text into word processing files for editing) in a place where the original cannot be removed, such as a library or museum.

Commercial Scanners

There are a variety of expensive, specialized scanners for use by minilabs and service providers. Some scanners are attached to printers for high-speed digital color prints. These units can scan 200 rolls or more an hour for printing purposes. Other commercial scanners can be used to save your image to Kodak Photo CD or FlashPix formats. There are also workstations for image improvement through printing, after scanning.

Service Providers

You can find a service bureau that will do almost any type of scan for you on a per-scan basis. The reasons to use a service bureau instead of investing in your own scanner are many:

❑ Too low a volume to justify buying your own scanner
❑ Needs too varied to buy just one type of scanner
❑ Don't want to have to invest the capital in a scanner
❑ Don't want to relegate the office space to a scanner
❑ Don't want to expend the manpower to create scans
❑ Don't want to invest the time to shop for, set up, or maintain a scanner

If you fall into any of these categories, let the experts do it. Prices can range from a few extra dollars to have Photo CD or FlashPix scans made of an entire roll of film at the time you get it processed, to several hundred dollars for *one* precision drum scan.

You can have your scans delivered on floppy disk, Photo CD disc, FlashPix CD, writable CD, SyQuest cartridge, Iomega Zip, Iomega Jaz, or any other data storage system. Smaller files can be efficiently delivered via modem. Larger pictures can be more economically sent via ISDN or through other commercial data transmissions.

Some vendors will scan and deliver your digital pictures over the Internet. The service provider posts the completed scans on their Web server, and you access them through the Internet with a personal password. If you think a friend, family member, or business associate may want copies of the photos, you just e-mail them the Web address and your password. They can then screen them at their convenience and order their own reprints, which are sent via mail directly to their home or office.

Shop Around

Like any jobs you outsource, there will be good service providers and bad service providers. Shop around, get personal and business referrals, and do some trial and error to find a company you're happy with. Some of the best have excellent client relations, providing you with how-to information on digital imaging that will help them deliver (and you receive) acceptable scans.

Picking a Scanner

Once you've decided on the type of scanner you're interested in, it's time to look at the details. Flip to the back of any computer magazine or digital photo magazine, and you'll be amazed at the number of products available. It's tempting to randomly select one based entirely on the price you have in mind. But unless you're lucky, you won't come out with the best scanner for your needs.

Since technological capabilities for scanners keep improving, what constitutes "poor," "adequate," and "great" changes along with the technological jumps. Hence to make a good purchase decision, it becomes important to understand the underlying factors that differentiate one scanner from another.

Optical Resolution

Optical resolution is often the lead specification in scanner advertisements. After all, it's usually the first concern—as well as one of the more confusing factors—for newcomers. But optical resolution is not the only factor (or even the most reliable clue) as to how the scanner will perform. It is, however, a good start.

Optical resolution is measured in dots per inch (dpi), and the higher the resolution the scanner offers, the larger you can successfully enlarge your

scan for any given application. If you don't fully understand dpi, refer to the second chapter for more details.

In order to decide at what dpi you need to scan your originals, you have to think ahead to your end application. A 300 dpi flatbed scanner isn't what you need if you have professional publishing aspirations, unless you're planning to do a pocket-size book with tiny pictures. But it's great if you just want a scanner for fun and games—like e-mailing pictures, small output to an ink-jet or other color printer, children's artwork, or optical character recognition (which only requires 250 dpi or so). A 2400 dpi unit would be overkill in this case.

However, if you hope to manipulate your digital images, output them, and get photo-realistic quality prints of a reasonable size, you're going to need more powerful optical resolution (not to mention 24-bit color or better). Likewise, the successful scanning of line art (including signatures) requires very high resolution scans to achieve smooth lines without jagged edges.

Interpolated or Enhanced Resolution

One misleading specification is *interpolated* or *enhanced* resolution. Interpolated resolution starts with a hardware optical scan at a lower resolution, followed by a software *guess* at what the higher interpolated resolution should look like. In other words, it bumps up the dpi and estimates the color of the added pixels. Some software guesses are better than others. Regardless, it's always better to have the real optical reading, so judge your scanner by its *optical* claims.

Interpolating Downward

Interpolation, however, can be good in another situation. When the scanner is being used at less than its maximum dpi capability, some scanners simply skip readings. For example, they just

make every other reading when scanning at 600 dpi on a 1200 dpi scanner. This enables the scanning mechanism to cover the distance twice as fast and complete the scan faster.

However, most experts will agree that the best results occur when the scanner takes the maximum reading (1200 dpi) and then uses its computing power to interpolate the data downward rather than just drop every other or every third pixel. This can yield smoother tones and gradations. If your scanner can't achieve this, for top-quality work scan at the maximum setting and then use a professional photo-editing software program to perform the downsizing. In the case of halving the file size, side-by-side pixels would be evaluated to come up with one new pixel value.

Color Depth

If your scanner doesn't capture the subtle differentiations between grays (in black-and-white scans) and between colors (in color scans), then this information from the original is lost. This differentiation ability is called color depth or bit depth. (See the second chapter for more details on bits and bytes.)

In black-and-white photography, a print with 256 shades of gray looks "photographic." It is smooth and seamless to our eyes. But 256 colors (8-bit color) appears posterized and fake. The gradation of colors is jumpy. If we give 256 steps (8 bits) to *each* of the RGB colors that create the color palette, these colors can be mixed in 16.7 million ways (256 x 256 x 256) to create 16.7 million color choices. Thus 24-bit color (8-bit red plus 8-bit green plus 8-bit blue) looks *real* to us.

With a 30-bit or greater system, the extra information can be used for even more colors, or more likely, for advanced functions like creating color information that can be exchanged for noise or other damaged information

bits to create a final, better 24-bit package. In other words, it lets the scanner throw away bad or corrupted information, leaving only the best 24-bit information.

If you have a black-and-white monitor, a black-and-white printer, and no aspirations of using your digitized images in any color applications, an 8-bit system that delivers 256 shades of gray is more than adequate. But for more versatility, you'll probably want a color scanner, which can, of course, also scan in black and white.

Dynamic Range

Being able to differentiate among subtle gradations of tones is a much overlooked factor that can have a huge effect on the printed outcome. If you understand the science of photography, you know the importance of the density range of films and printing papers. The more tones the film or print can potentially show, the more realistic the image will look. Professional conventional photographers still work long and hard to pick the best film, lighting, exposure, and developing combination to give them the tonal variations they hope for in their images. Usually the goal is a large or long density range that holds as much detail as possible in the highlights and shadows. In the digital realm, we strive for the same thing, i.e., a higher dynamic range.

The best scanners are able to differentiate among subtle gradations of tones, giving them a higher dynamic range, which is rated on a logarithmic scale from 0.0 (low) to 4.0 (high). It's no surprise that these scanners are considerably more expensive than scanners with a short dynamic range, which could have trouble giving you good scans of transparencies or negatives that have high overall contrast. If you need to reproduce the whole range of the original, with the ability to distinguish among subtle tones in deep shadows or bright highlights, hold out for a scanner that has a density range of 3.5 and above, or use a service provider.

If you're scanning color prints, you need not worry as much. Most color papers have already flattened out the density range to about 3.0 before starting. This is one of the reasons so many professionals use transparency films.

Drivers and Plug-Ins

Drivers and plug-ins are all about simplicity and, therefore, should not be ignored. Drivers enable the scanner (or other peripherals) to communicate with the computer. Scanning times claimed by the manufacturers may not live up to your expectations if the driver is poor. Plug-ins allow the scanner to be used with the most popular graphic design and photo software, offering easy setup and integration.

DIGITAL ICE Technology

A relatively new technology called Digital ICE (from Applied Science Fiction Inc.) has recently been added to some scanners. Digital Ice technology automatically removes surface and near-surface defects from scanned images without altering the underlying image. This can save considerable time by eliminating the need for painstaking retouching of dust spots and scratches from your scanned negatives, transparencies, and photographic prints. The newest generation can even restore colors on faded images, automatically.

Specialized Needs

Sometimes your scanner choice may be more dependent on special accessories or functions than anything else. If you're going to scan the 20,000 slides in your stock file, a dedicated desktop film scanner with an accessory 50-slide feeder could save you *days* of labor.

Likewise, the ability to easily batch images on a flatbed scanner might be important. Almost any flatbed scanner will allow you to place several wedding proofs on the glass at one time (or 20 35mm slides if it has a transparency adapter) simply because they fit on the glass. But can the software treat them as separate images for easy saving as separate picture files?

Being able to save the scanned image in different picture file formats might seem minor, but it can be a major headache if it doesn't work. Make certain the scanning software (or plug-in for the photo software) allows you to easily save your scanned images in the file formats you most often use. It will save you time and eliminate translation problems when later sharing the images.

Other considerations are specific to the occupation. Can the scanner accommodate chest X-rays or mounted dental X-rays? Are there tethered fiber-optic extensions for remote scanning? Can you program multiple profiles for different scanning functions or multiple users? Read your industry trade journals to find out about the latest and greatest scanners for your particular field of expertise.

Line Art

Black-and-white line art is any image or graphic made up of two tones—black and white or blue and white, etc. Your signature is line art, as are many monochrome logos. Surprisingly, scanning line art requires relatively high resolutions to achieve good results. If you scan under 1200 dpi, your results may not be smooth and sharp. Jagged edges or "jaggies" are the most common problem that occurs from line art scanned at too low a resolution.

Other Factors

Read the specifications carefully before buying your scanner. As mentioned earlier, enhanced or interpolated dpi can be misleading. Likewise,

Things to Consider When Picking a Scanner

Before you start shopping for a scanner, you should first weigh the following items to decide what's best for your specific needs. Be certain to compare technical specifications.

Price

Prices of computer peripherals keep dropping, making it hard to decide when is the right time to invest. Analyze how much money you'll spend on service providers while waiting for the price to drop, and you'll often decide to buy now.

Optical Resolution

Always ask what the optical resolution is, and do not confuse it with enhanced or interpolated resolution. The interpolated resolution is the scanner software's *guess* at what the higher resolution should look like, then it bumps up the dpi and estimates the color of the added pixels. Some software guesses are better than others in any given situation. It's always better to have the real, optical resolution, so make your judgement by your scanner's *optical* claims.

Color Depth

If you want true photographic color quality, don't consider a scanner with less than 24-bit color depth. A 24-bit system reserves 8 bits of information for each of the red, green, and blue channels. Higher-bit systems use the extra bits to improve the final 24-bit sample or to add more colors. If you're scanning slides, negatives, or transparencies, you'll probably want a 30-bit or better system.

Dynamic Range

This is a very important factor, especially if you're scanning film originals that have a wide range of tones from highlight to shadow, and you want to get details in both. Just remember that higher is better when it comes to the dynamic range of the scanner. For optimum quality in extreme situations (and a much bigger price tag to match), you'll want to select a scanner that gets as close to 4.0 as possible. For prints, the range is not as important, since the printing process has already flattened the tonal values.

Scanning Method

There are different types of imaging devices, including PMT, CCD, and CMOS. There are also single-pass and triple-pass scanners. As the name implies, the former collects all RGB information in one swipe, rather than three separate passes. Some scanners are stationary and pull the photograph past their scanning mechanisms (like print-fed systems), while others smoothly swipe past the stationery image with a linear array.

Plug-Ins and Drivers

Make sure your scanner offers easy interface with your computer system of choice.

File Format

Can your scanner's software easily convert your original image into the digital picture file format(s) that you want to use? See the chapter on image storage and picture file formats for more information.

High-Volume Scanning

Are you going to be scanning a lot of images, such as your stock photography files? Look closely at such factors as scanning times, automatic feeders, and batch-scanning capability.

Specialized Functions

You may choose a scanner because of special accessories or capabilities, such as a 50-slide feeder for automated scanning or a fiber-optic scope for the medical community. Check trade journals and associations in your field of expertise to find out about specialized equipment.

your scanner may not match the manufacturer's claims if your computer's processing speeds are slow or if too little computer RAM has been allocated to the scanner.

Software bundling should be factored into the price of your scanner *only* if you need the software being offered. Note that many of the bundles are often scaled down, less powerful versions of big-name software programs. Popular bundling packages can include photo-editing software, OCR software, and software that gives the scanner photocopying or fax capability.

Test Drive

Whenever possible, ask for a test drive by having one of your images scanned. Ask for help and suggestions from associates in your profession or the local camera or computer club. Read the reviews that appear not just in the computer magazines, but in the photography magazines as well. Search the Web for independent reviews of current products.

Don't Overbuy

Pick your scanner based mostly on what you plan to do, and then add in a little extra power for expansion and growth. But the best advice is not to drastically overbuy. You can always farm out the occasional piece that can't be handled by the machine you

select. At the rate prices are falling and capabilities are increasing, the *difference* in price between the scanner you need now and the higher-end scanner might be the entire price of the better scanner in two years.

Don't Underbuy

Yet be careful not to underestimate. The new generation of home-use computers can easily handle FlashPix image files. Near- and true-photo-quality printers are dropping in price so quickly that you may not be able to resist adding one to your collection. These printers handle a lot higher resolution and wider dynamic range than your older (and possibly archaic) 300 dpi ink-jet.

Even if you don't splurge for a photo-quality printer, service providers can print your high-resolution digitally enhanced photos with high-resolution printers, including units that print onto silver-halide paper. So analyze what you honestly *aspire* to do, along with your current needs.

Using Scanners

Every photographer knows how important it is to remove dust and fingerprints from the camera lens, enlarger lens, and negative or slide to get optimum prints. If you scan a dirtied image or use a dirty scanner, you'll see fingerprints, hairs, and dust on your enlargements. If you can skillfully use photo-editing software, you can remove these blemishes after the fact digitally. But why bother, when simple housekeeping can eliminate the problem? Usually an air-blower and an occasional swipe with a chamois cloth will do the trick, but check the instruction manual for the manufacturer's recommendation. An inexpensive dustcover from the computer store will help as well.

To get the best scans of 35mm slides, you need to remove them from

With the click of a mouse, you can scan pictures and documents for printing, faxing, or e-mailing. This Kodak Digital Science color scanner automatically feeds all popular photo sizes, including 8x10s and panoramic prints. Photo courtesy of Eastman Kodak Company.

their mounts so they lie flat against the scanning surface. The exceptions are the desktop film scanners which are calibrated to scan a slide in its mount or negative in a special holder. Unless you're doing FPOs for design purposes, remove the protective sleeves you're probably storing your transparencies in. The sleeves might look clear, but they'll degrade the scan.

Position the scanner on a solid, flat support and minimize vibration, which can jar the delicate scanning mechanism.

Warm-up time varies by scanner. It may seem trivial, but for high-quality results follow the manufacturer's suggestions. It will save frustration later.

Take the time to re-scan images if they are crooked. If you wait until you're in your software program, you may get some image degradation, even though it looks great on the monitor. This is because the pixel scans are created on a grid. If they're

shifted 90°, 180°, or 270°, they're still on a grid. But if they rotated a small amount like 5°, the software has to make calculations to create a new grid for monitor display and printing.

Some software simply does a better job of this than others. If you have no choice but to use software to straighten the image, use a powerful image-manipulation program like Adobe Photoshop, rather than a graphic page-design program.

When scanning a print or drawing on a flatbed scanner, if the original is thin, you may find you are getting ghost images from whatever is printed on the back side, such as a caption scrawled onto the back of the print. The best solution is to cover your image with a piece of white paper before scanning. (Don't use colored paper or a tint of the color may shine through.)

There is also the problem of moiré when scanning pictures that have been

previously printed using halftone methods. This annoying, almost psychedelic pattern can be difficult to eliminate. Before starting, analyze why you are scanning a halftone print. If you own the image, you probably have the original *somewhere*. If it's not your image, you're most likely infringing upon someone's copyright when you scan previously published photos.

Copyright Warnings

Scanners open up an exciting world, because anything you can put under the hood of a flatbed scanner, you can bring into a computer. But just because you are able to scan it, doesn't mean you can legally use it. Images and artwork printed in magazines, books, brochures, or the newspaper are covered by the same copyright laws that the original images are.

You can use these types of images for personal enjoyment, but as soon as you start displaying, distributing, or trying to sell them, you're infringing on the rights of the artists, photographers, and models. To be safe, use only your own images and artwork in your creations. Other options include copyright-free clip art, images in the public domain (such as many government images), or images that you have written permission to use.

Resist the urge to copy wedding and portrait proofs as well. The professional photographer that did such a great job relies on your reprint orders to stay in business. Without reprint orders, he'd have to raise his initial sitting prices exponentially—meaning you'd have to pay a big fee up front, whether you were happy with your results or not. With the reprint method, the photographer has great incentive to produce irresistible portraits that you'll really want to buy.

Improvements in scanners are being made in leaps and bounds, especially at the low end of the scale. Scanners described here as "low quality" could in a matter of months jump to "adequate quality" and again to "true photographic quality." Determine your scanning needs, then use this table as a comparative reference in conjunction with a catalog that lists product specifications. High-speed minilab-oriented scanners and scanners for Photo CD discs are not included here.

Scanning For Magazine Reproduction

Scanners can be very confusing when it comes to setting your scan sizes. The trick is to determine how the image will be used before you make the scan. This involves determining four things:
1) The desired output size
2) The size of the original and its comparative size of enlargement (or reduction) to the desired output size
3) The recommended line screen (lpi) for the printer that is creating the magazine
4) A quality factor (usually between 1.2–2.0) to improve your results

Say an image is to be used in a magazine as a full-page vertical at 12x8 inches with a 133-line screen and a suggested quality factor of 1.5. You can figure out the scanner settings in one of two ways:

Example 1
Start by determining the necessary pixel resolution. In this example, we know that it would be the lpi (133) times a quality factor (1.5) times the reproduction size (12 inches high and 8 inches wide). This would yield a desired pixel resolution of 2400x1600.

133 x 1.5 x 12 = 2394, or approximately 2400
133 x 1.5 x 8 = 1596, or approximately 1600

Next divide the pixel resolution by the original picture size in inches. This will tell you the dpi to which you need to set the scanner at 100% enlargement to achieve optimum results.

In the case of a 4x6-inch print:
1600 ÷ 4 = 400 for height
2400 ÷ 6 = 400 for width

For the 35mm slide or negative:
1600 ÷ 1 = 1600 for height
2400 ÷ 1.5 = 1600 for width

Consequently, a 4x6-inch print would only have to be scanned at 400 dpi, while a 35mm slide or negative would need to be scanned at 1600 dpi.

Example 2
Here you begin by finding out how much the original must be enlarged to be used at 12x8-inch size. Divide the reproduction size by the original size. In the case of a 4x6-inch print used vertically:
12 ÷ 6 = 2 for height
8 ÷ 4 = 2 for width

For 35mm:
12 ÷ 1.5 = 8 for height
8 ÷ 1 = 8 for width

The 4x6-inch print must be enlarged 2 times, or 200%. The 35mm slide or negative must be enlarged 8 times, or 800%. Hence, you could set your scanner to 200 dpi (which is 133 lpi times the quality factor of 1.5) and 200% enlargement for the print, or 800% enlargement for the slide or negative.

The results would be the same either way.

Comparing Scanners

PMT Drum Scanners

Advantages: These are designed to produce high-quality, high-dpi scans of transparencies. They use PMT (photomultiplier tube) imaging technology, rather than the more common CCD. Usually they boast much higher dynamic ranges and overall quality, and can output files in RGB or CMYK, suited for the publishing field.

Disadvantages: They are extremely expensive to purchase and maintain, and require skilled operators. Service bureaus can provide drum scans on an individual basis, but the costs are high.

When to Use: Use drum scans when your needs are beyond the dpi range and quality level of the less-expensive scanners, for example, when a 35mm transparency is being enlarged 20 times to be used in a magazine spread and a scan of about 2200 dpi is needed.

Desktop Film Scanners

Advantages: Time, convenience, and quality are the big pluses of a film scanner for high-resolution digitizations of 35mm slides or negatives. Many offer accessory auto-feeders. These scanners tend to be small, making them easy to fit on already-crowded computer desks or to take with you when traveling to a remote office.

Disadvantages: Can't do flat art. Most of the economical models are limited to 35mm format. Considerably more expensive than the flatbed scanners designed for home and office use.

When to Use: These are the gems of photojournalism, allowing negatives to be sent and received at remote newspaper offices seconds after they come out of the processor. But they work well for anyone who needs higher resolution and better quality than what is generally available on flatbed scanners with transparency adapters, but less quality (and less cost) than a drum scan.

Flatbed Scanners

Advantages: These easy-to-use scanners accommodate large, flat art (photographic prints, letters, drawings, fabric, etc.). They can be used in conjunction with optical character recognition (OCR) software. Some models offer accessory transparency adapters.

Disadvantages: These scanners tend to have lower resolution and dynamic range than desktop film and PMT counterparts. They require a lot of horizontal desk space, especially if they can accommodate large originals, like 11x14-inch prints. They can't be stacked or placed on a low shelf since considerable space is needed to lift their hinged lids to position the original.

When to Use: If you scan a lot of prints, logos, line art, or require optical character recognition.

Transparency Adapters/ Flatbed Scanners

Advantages: Transparency adapters are available for some flatbed scanners, allowing them to scan transparency and negative film of all sizes.

Disadvantages: These adapters are limited to the maximum dpi of the flatbed scanner, which limits the amount of enlargement possible when compared to desktop film scanners.

When to Use: If you need a flatbed scanner for prints or optical character recognition and you want to expand its capabilities to include small enlargements or FPOs of transparencies (including large format) and negatives.

Home-Use APS (Advanced Photo System) Scanners

Advantages: Insert your processed APS film cartridge, and this small scanner accesses the film, digitizes it, and displays a digital index print on your computer, with easy software interface.

Disadvantages: With current models, you can use only APS films. You'll need another scanner for other films, such as 35mm.

When to Use: If your only concerns are APS and your resolution needs are not particularly high, this is a good, convenient choice. Expect prices to fall as the APS market grows and more companies manufacture products.

Print- or Sheet-Fed Scanners

Advantages: Inexpensive and extremely easy to use. They tend to be small and offer simple operation.

Disadvantages: You can only scan prints up to a certain size, often only up to 4x6 inches. The scanning resolution is comparatively low.

When to Use: Choose this type of unit if you want a quick way to scan your 35mm or APS prints for home enjoyment, such as for screen savers, newsletters, low-resolution prints, or for use on the Internet and e-mail.

Handheld Scanners

Once extremely popular, these units are hard to find today. They have been replaced by the better, more consistent scanners mentioned in this table.

Service Providers

Advantages: No equipment capital, training, or time investment is necessary to get virtually anything scanned at the resolution and quality of your choice.

Disadvantages: The price per scan can seem high, since the provider must amortize the hardware expenses and still make a profit to stay in business. Quality can vary from shop to shop depending on the equipment used, how well it is maintained, and the training of the personnel. Shop around.

When to Use: Use if your volume is low or your needs varied.

Digital Cameras

Digital cameras are essentially scanners with lenses, exposure systems, and other fancy features attached.

Other Inputting Methods

In addition to using digital cameras and scanning conventional photographs, there are several other ways to get images into your computer. Still video cameras, camcorders, frame grabbers, clip art, and stock photography can provide you with images you can use for creative purposes.

Digital Video

Digital video (DV) records hours of moving images on digital video cassettes (DVC). Digital video has considerably better resolution and color rendition than most conventional analog video (your VCR tapes, for example). Not only can you play your digital videos on compatible computers, but you can also save still images, fine for low-resolution needs even if they are not the same quality as images from a high-end still digital camera.

Video Frame Grabbers

Video frame grabber hardware and software do exactly what the name implies. They "grab" single still images off of your VCR, TV, or television-played game console. You can save these images in popular picture file formats and use them any way you'd use other digital pictures, including viewing on a monitor, storing, printing, graphic page design, or e-mail. Some video frame grabbers let you create an intervalometer function that captures sequential pictures at a predetermined interval. (This is usually limited to thumbnail-size images because of the time delay required to digitize the images.)

Be aware that your results will depend upon the capabilities of your camcorder and the quality of the taped image. Most camcorder CCDs use an interlacing technique to improve image quality. Two side-by-side frames are interlaced (one pixel row from the first, then one from the second, then back to the first). This can cause definite image degradation if the subject (or camera) moves fast enough to change position between the two frames. For action subjects, you'd be better off with a camcorder that offers high-speed capability.

Much of the popularity of frame grabbers springs from their relatively low price (less than the cheapest digital cameras) and the fact that anyone who has a camcorder probably has a drawer full of tapes with many terrific still images hidden inside.

In addition to your own videotapes, frame grabbers can pull images off of commercial videotapes, laser discs, and anything that appears on

The portable Kodak DVC325 digital video camera has adhesive mounts for attachment just about anywhere—like on a window ledge or laptop. Handheld operation is possible within the range of its 9.8-foot (3m) cable. Photo courtesy of Eastman Kodak Company.

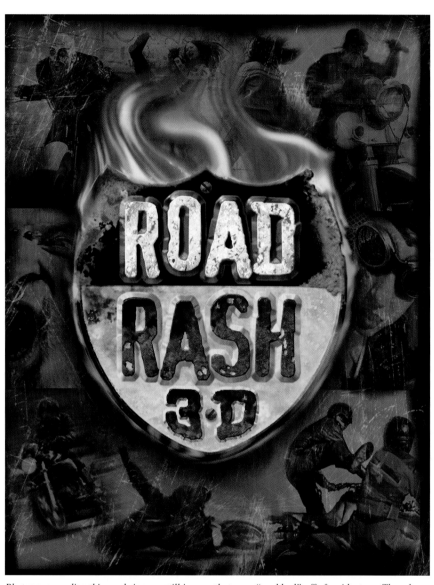

Photos surrounding this road sign are still images that were "grabbed" off of a videotape. Though these images may be secondary (compositionally speaking) to the Road Rash logo, if they were exchanged for a plain gray or black background, the fiery logo would lose its excitement. Image by Keith Ewing, Hamagami/Carroll & Associates.

your television screen, including games. But the ability to grab these images doesn't necessarily give you the right to use them. Most commercial tapes, television programs, and games are covered by international copyright laws. Contact photography trade organizations like the Photo Marketing Association International (3000 Picture Place, Jackson, MI 49201; 800-248-8804) or the Professional Photographers of America (http://www.ppa-world.org or call 800-786-6277) for more information on copyright laws.

Related Technology
Some scanners offer a video output that lets you put your scans directly onto videotape. This way you can add conventional still photographs to your edited videotapes.

There are some printers with a built-in interface for printing still images directly off of a video source, such as a VCR or camcorder. Unfortunately, they don't retain digital picture files. But they're good for instant IDs, last-minute photographs, and for your own entertainment.

Clip Art and Stock Photography

Photographers usually want to use their own photographs in their digital creations because of convenience and artistic pride. But there are times when it is not possible or cost-effective to go out and photograph a particular image.

This is especially true if you start combining images. You may only need a small portion of a photograph of an autumn leaf for a background element, but you don't have one handy in your files and it's the wrong season to photograph it.

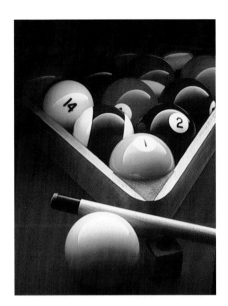

Video frame grabbers let you "grab" still pictures off of videotapes, the television screen, or television-played game consoles. These digital images can then be manipulated, saved to disk, or used in the same ways you use your other digital images. Photos courtesy of Play, Inc.

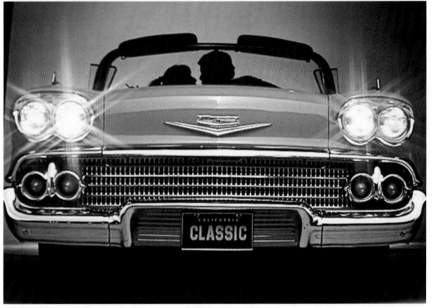

This is where clip art becomes invaluable. Clip art refers to royalty-free photos and artwork that you buy once and can use forever, for any purpose, without fear of infringing on someone's copyright. Many companies compile them and sell them in CD and floppy disk formats.

The downside to clip art is that anyone can buy it, and lots of people do. So hundreds, thousands, or even hundreds of thousands of people could be using the same photograph as you. This won't make a difference in the above example, since the leaf is only a small piece of a much larger digital art project. But if it were the lead photograph in your advertising campaign, it could be embarrassing when it shows up in your competition's advertisement as well.

Stock photography gives you a bit more control, mainly because the higher price limits its use by the masses. Stock photography agencies were created to make life easier for professional photo buyers, like magazine editors and advertising art directors. A stock agency can hold the photos of hundreds of photographers, cataloged like a library. The client

calls or stops by and asks for a certain type of picture by key word—such as a subject (Mount Rushmore), mood or emotion (joy), color, or just about anything else. The agency goes through their files and delivers potential photographs. If the client decides to use them, a usage fee is charged. Fees vary depending on how photos are used (magazine editorials being less expensive than advertising usages) and size, usually with a $250 or so minimum. But the client gladly pays the fee because he won't need to call 100 photographers and ask for photos of Mount Rushmore or pay for a photographer to travel there and incur far greater expenses.

Clearly stock photography is out of the price range of the home user, but keep it in mind for your professional applications. Keep your eyes open. Some stock agencies are contemplating a special home-use consumer rate through their Internet site. This could make stock photos affordable for inclusion in art, homework, and Christmas cards.

Adobe Photoshop software was used to make these subjects more interesting in this photo. The Motion Blur filter was applied to the background, while the foreground colors were enhanced to "jump off" the page. Images by Katrin Eismann.

PART III—Software

Photographic Software

In its simplest form, photographic software is the metaphoric equivalent of the chemistry, papers, and darkroom equipment used in processing film. But it's also far more. Certainly, photo-editing and manipulation software let us do in seconds what used to take minutes or hours in-camera or in the darkroom. But digital capabilities have given us even more tools—many we might never have imagined, such as morphing and stretching capability, integrated copyright protection, and family entertainment. Together, they give us powerful creative control over our photographs and digital art.

Some professionally oriented software lets you apply thousands of different functions to your images and page design. Other software and plug-ins are project-specific, doing only one type of design, control, or alteration.

Professionally oriented software offers optimum creative control; the controls are in the hands of the operator, requiring skill and knowledge (and the instruction book nearby) to operate. Other programs hide the science and put the emphasis on user-friendly software to appeal to the novice or general consumer, usually at the sacrifice of power.

Photographic software runs the gamut from simple consumer products to professional image-manipulation software. Incredibly powerful programs like Adobe Photoshop offer hundreds of functions and cost hundreds of dollars. People who have used them for years are still finding creative new applications by combining functions, adding plug-ins, or using them in conjunction with other software.

If you've studied the science of photography and understand all about dmax and dmin, gamma and contrast, you'll feel right at home with a professional-level program. But for the unindoctrinated, it can be overwhelming.

Luckily there are much easier, user-friendly (although less powerful) versions of this software for the home user. Some streamlined software is designed to perform just one function or one type of task quickly and easily.

New software programs are constantly being developed, and old programs are often upgraded and improved. Based on what you hope to achieve, use these descriptions as a checklist for selecting the best software for your needs.

Software Functions

Many of the time-consuming tasks from darkrooms have been simplified and improved in the digital world. Here's just a sampling of what some of the imaging, editing, and enhancing programs can do for you— often with just a keystroke and always without chemicals or darkrooms.

Brightness: Lighten or darken the overall image without otherwise affecting the color balance or overall contrast range.

Contrast Range: Extending or shrinking the density range from highlights to shadows, allowing you to perceive more or less detail.

Cropping, Enlarging, and Reducing: Simple commands in almost any photo-editing program let you change the shape or printing size of the photograph. Be aware that the pixel resolution of the digital image has a big impact on how well it is printed at a particular size on a particular printer.

Left: With the great number of photo-manipulation and artistic software programs available, digital imaging has become a marriage of traditional artistic media with photography, all intermixing in the computer. Image by Darryl Bernstein.

Right: Every photo-editing software program is different, so collaging capability varies from one to the other. The best enable you to assign percentages or weights to certain images. This allows selected images to pop out (the lottery tickets in this case), while the others fade into the background. Remember that collages can tell stories, so pick your image segments carefully. Image by Darryl Bernstein.

This means that cropping should be done in-camera (or re-scanning done) whenever possible to avoid "throwing away" pixels once you reach this software stage.

Dodging and Burning: Lightening or darkening a portion of a print in the darkroom requires careful dodging and burning, and often results in a lot of wasted photo paper and time. On the computer, you can select the size, shape, and quality of your lightening and darkening tools, as well as their density. If you don't like the result, return to the saved version and try again.

Flipping and Flopping: You flip an image in a vertical direction (around the horizontal axis), and you flop it in a horizontal direction (around the vertical axis). Flopping is like looking in a mirror.

Rotating: Almost all editing software lets you rotate your image in increments of 90° (quarter turns). Better software lets you adjust the rotation in miniscule amounts. Be careful, however, to rotate the image in a photo-editing program rather than in a page design program in order to get better results. But even these programs can cause data loss. Whenever possible, take your digital pictures with a straight horizon, and re-scan crooked scanned images.

Inverting: Turn a negative into a positive or a positive into a negative with one command.

Masking: Although it's common to mask a subject so you can swap the background for a better one, the possibilities of masking are endless, especially when combining all of the other creative tools you have at your disposal. Note that the mask can be a pre-packaged template (such as a heart-shaped mask for a wedding composite), a design element you create, or a portion of a photograph that you define on a pixel-by-pixel basis.

Silhouetting: In the old days, this was done by painting opaque red or

Smog, atmospheric haze, dull skies, and un-cooperative light all work against conventional photographers trying to get the perfect city-scape photograph. But a few quick commands in a photo-editing software program can pump up the colors and contrast where needed to create a more sellable final image. This is the New York City skyline from the Ramapo Mountains. Image ©George M. Aronson.

Historic 4x5-inch glass negatives can be printed right at home. To create this photo, the glass neg-atives were scanned on a flatbed scanner with a transparency adapter hood. Then Adobe Photo-shop software was used to adjust the contrast and density. The period-style oval cropping eliminat-ed much of the distracting background and crea-tively emphasizes the young girl's face. Retouched image ©George M. Aronson.

"dragon's blood" onto the negative to create a white silhouette around your subject when printed. Today, many programs can do this masking function for you automatically. Your success depends on how distinct an outline your subject has and how sophisticated the software program is.

For professional and high-end silhouetting, the "cutting path" is usually chosen by hand on a pixel-by-pixel basis at high magnification.

Collages and Montages: These new collages and montages bear little resemblance to the scissors-and-glue art of your childhood. Dedicated collage programs and templates in general software programs let you quickly and easily combine images, art, and text into complex collages. Professional programs give you amazing control, letting you decide the extent to which the edges are blended between photographs and the transparency of various

65

Most photo-editing software will let you turn a positive image into a negative, or vice versa, with a few simple commands. Usually this is done when you scan a negative and want a positive print. It can, however, also be used for creative effect. Image by Tony Mauro, Hamagami/ Carroll & Associates.

images. This means smooth gradation in your final image, with some elements emphasized and others fading into the background.

Duotones: In the darkroom world, duotones are created by toning black-and-white prints. Black remains black, gray turns the color of the tone (such as sepia or blue), and white stays white. In the printing world, duotones achieve a similar look using two-color printing (black and a second color, such as cyan or a special premixed color). It's a great way to add color to an image without going to four-color printing.

Hand-Coloring: Hand-coloring was popular before the advent of modern color films; today people like to dress up their black-and-white photographs for an olden-day look, and it's never been easier. You simply select your painting tools (such as paintbrush), size, shape, and the exact color, right down to the saturation and hue. Adding color to your subject's eyes or hand-painting just the product in an advertisement makes them jump out at the viewer. Or you can create the effect of a color photograph. You can also hand-color photographs that are already in color,

To alter only a portion of an image, that portion must be identified to the computer. A classic example is when silhouetting a main subject. This can be done manually at high magnification (with the most control) or quickly with automated functions (albeit somewhat less accurately). This Adobe PhotoDeluxe screen shows that a boy and his soccer ball have been selected. The subject can now be copied and pasted onto a different background. Photo courtesy of Adobe Systems Incorporated.

Today's software programs offer a wide variety of collaging options. For example, you can decide where to position image fragments, where to overlap, and what levels of transparency or opacity to use. Image by Darryl Bernstein.

Subtle, simple digital changes in commonplace photographs can create far more interesting images. Two 35mm color negatives (the landscape and the hand) were scanned and then creatively combined using Adobe Photoshop software. Image by Marni Schlifkin.

such as adding saturation to red lipstick or changing its color.

Color Corrections: Color balance, hue, saturation, brightness, and contrast levels can all be adjusted down to minute levels. Certain colors can be identified and replaced with others in every pixel in which they appear—and all with simple commands.

Posterization: Pre-digital imaging, this was an elaborate artistic process with multiple negatives printed at different exposures and contrasts. Then it became a problem of computers before the invention of 24-bit, full-color computer monitors and printers. Now it's an artistic effect again. In the posterization process, the program reduces the number of gray or color values to the number you select and the colors you prefer. Two-color posterization with black and white would be the equivalent of line art. Three levels would add one more level of gray or color tone.

Retouching Software: Retouching is obviously important to wedding and portrait photographers who need to remove distracting picture elements, fix imperfections in wedding gowns, heighten colors, remove hot spots, touch up makeup, soften wrinkles, or even remove or add people to group pictures. This can be achieved with the creative use of the tools mentioned in this chapter, such as silhouetting, painting, stamping, selective blurs, and other functions. Or these functions can be found in simplified form in special dedicated retouching programs.

 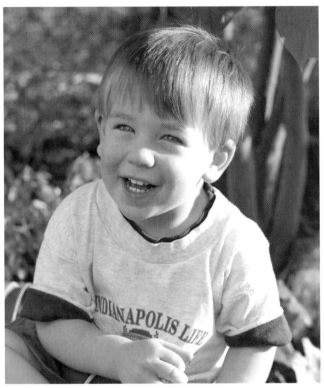

Before the days of color photography, black-and-white portraits were carefully hand-colored for a realistic look. Today, we think of hand-tinted black-and-white photographs as having an appealing vintage or fine-art look. Photo-editing programs let you easily "paint" your monotone images. You can go for realism, for outlandish colors, or for simply an accent of one portion of the image. Image by Eric Lindley, Partners Photography.

Screening: Many top photo-editing and graphics programs enable you to create your own halftone separations (or other printing screens) for your photographs. You can adjust the screen frequency (lpi), type of screen (halftone, random dot, or other specialized screen structures), brightness and contrast, as well as screen angles, dot shapes, and dot gain compensation. Unless you're familiar with pre-press and printing-press publishing, leave halftone conversions to the professionals, or you may end up with disappointing results.

Screen Structures: Halftone screens are not the only screens available. Some specialized screens look much the same as the "textured" screens once popular with darkroom hobbyists. You can add pen and ink patterns, woven textile, wood grain, charcoal, or other textures.

Color Separations: If you're involved in pre-press work, you'll need a high-end software program like Adobe Photoshop, which offers color separation controls in the form of halftone dot shapes, screen angles, trapping, dot gain figures, black ink limits, and CMYK previews.

Camera-like Effects

Even in this digital age, it's always preferable to start with the best possible photograph. Sure, you can use your computer to correct color, composition, design, expression, and just about every other "mistake," but it does take time to learn, time to practice, time to perform, and money to purchase the right computer tools and software.

So take the best photograph you can, and save the digital technology to correct mistakes, to create otherwise impossible imagery, or for when it is more cost-effective to perform the task on the computer, such as complex in-camera masking.

Blur and Focus: Photographers agonize over their shutter speeds and apertures to create that perfect mix of sharpness and focus, some of which can be achieved digitally. Different programs call them different things, but most offer several options. For instance, you can blur the entire image or blur only a selected portion with masking. Blurs come in all types, from random (for an overall fuzzy effect) to motion (which is directional and akin to panning the camera).

Filters: In conventional photography, we put filters over the lens of our cameras to alter the photographs by changing the light before it hits the film. In the world of photo software,

Many software programs make color and image correction easy by showing you a side-by-side comparison of the original and your proposed changes. This lets you experiment visually on a low-resolution version before spending the computer time (and memory) to alter the higher-resolution original. Here is an example of Amiable Technologies PhotoPRINT color correction options window. Photo courtesy of Amiable Technologies, Inc.

A wood duck in breeding plumage is a spectacularly colorful sight, but the quality of light can affect how you capture the color. Adobe Photoshop and other photo software programs can be used to pump up the color saturation to produce a more colorful image. The digital photographer can emphasize or de-emphasize the shadows with darken/lighten, sharpen, or smudging tools. Image ©George M. Aronson.

filters alter the pictures as well, but often in a different fashion. A filter is now a generic term for an effect that can be applied to a digital photograph. Some come with software, others are available from third parties as plug-ins.

Fog and Diffusion: Just like in conventional photography, fog and diffusion achieve two different effects. Fog should soften the image, mute the colors, and lower the contrast. A good diffusion program should combine a sharp and unsharp version of the image without affecting the overall contrast.

Split-Field Lenses and In-Camera Masking: In-camera special effects require precision, experimentation, and a lot of time to create. On the computer, images can be combined with a few keyboard or mouse commands, with a lot more control and options. No planning, tripods, or masks required.

Art World Adventures

Digital photography software has borrowed much from the world of painters and other artists. Traditional art techniques are standard in many photo-oriented programs. Single-function plug-ins and specialized art programs that utilize your photographs are also

available. Note that most painterly features merely *mimic* the effect, such as airbrush, charcoal, or oil effect. It is still up to your printer to deliver the effect in ink, toner, wax, or dye.

Painting Tools: Choose between a pointed brush and a stubble brush, an airbrush and a spray can, or just throw paint around by the bucket like Jackson Pollock. Depending on the program, you're offered dozens of options

in painting tools and types, as well as brush styles and sizes.

Artistic Medium: In addition to paints, some programs offer choices such as pastels, charcoal, pencil, ink, crayon, and chalk.

Erasing: Similar to dodging, erasing lets you remove part of an image like an eraser. The size of the eraser and the pressure you apply to it (how much it erases) is determined by the user.

Images can be altered pixel by pixel, or whole sections can be selected and altered at one time. But like any visual medium, true artistry (in this case undetectable changes) takes skill and practice. Photos courtesy of MGI Software Corp.

In the digital arena, images made with your conventional or digital camera are just the starting points for your final artistic creations. Words, paintings, drawings, or anything that can be digitally scanned or created on a computer are all usable. Digital imaging needs to be viewed as a whole new artistic medium, with photography being one of its major tools. Image by Tony Mauro.

Smudging: Blending or smudging is another ancient art technique, but now you won't even get your fingers dirty. Smudging the edges of silhouetted images is a nice way to smooth things out. It's also an effective tool for retouching wrinkles.

Stamp or Clone: This is a retouching dream, since you can pick up a small or large portion of a scene and rubber stamp (clone) it anywhere else. This is the easiest way to get rid of dust spots and small imperfections.

Eye Dropper: This control allows you to pick a color (usually for painting or pixel-by-pixel retouching elsewhere) by metaphorically sucking it into an eyedropper.

Opacity Control: The transparency or translucency of the photo or a layer in a digital creation can have different opacity (or transparency) factors, usually expressed in a percentage of the original density. It's more than density, though, it's how much you can see *through* it.

Cutouts: Cookie-cutter shapes that let you "make holes" in photographs or shape the perimeter of the photo.

Mosaic or Tiles: Just as the name implies, this filter creates a tiling effect. In this case, a grid is created, each filled with a different level of gray or color based on the pixels it contains. The size of each box on the grid determines how continuous or how tiled the final product looks.

Art effects are software functions that make your photographs look like drawings, paintings, pastels, and other art forms. Your results depend upon the sophistication of the program, the original image, and your creativity. The possibilities are limitless. Photo courtesy of Adobe Systems Incorporated.

 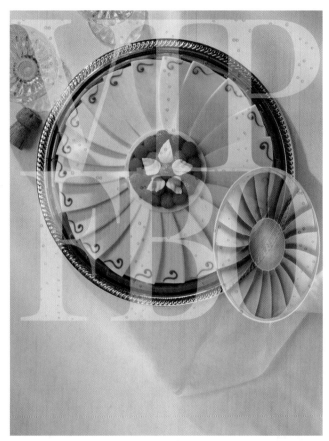

Adding type to your images need not be boring. You can knock out letters (white like a die cut hole), overlay black or colors (like a sticker), or make them transparent as seen in these invitations. Graphically, you can treat text like a caption (under the photo) or use it as another design element in a collage. Images by Darryl Bernstein.

Oil Painting: Of course your ink-jet printer isn't going to start use oil paint, but these functions attempt to make a photograph look like it had been painted. The results vary from program to program and image to image.

Pointillism: With a few keystrokes you can become a pointillist and create masterpieces that mimic the work of Georges Seurat. The best programs let you select dot size, colors of the dots, and how they are distributed. Up close it looks like a chaotic abstract, but as your viewing distance increases, the image begins to take shape.

Line Art Conversions: There may be times when you want to take your 32-bit digital photo with 4.3 billion colors and bring it back into the 1-bit world of black and white.

Contouring: In art class you may have learned that contour drawing involves drawing just the outline contours of your subject. In photo-editing programs, it's much the same idea, although the contouring of existing photographs yields very different results. Often the result looks like a topographical map.

Tracing: Similar to contouring, this option creates a coloring-book-type hollow tracing. Because of the complexity of continuous-tone photographs, the lines will be much more complex than what you'd envision in a coloring book.

Embossing: This filter can make part of your photo look like it is embossed on the paper, rather than printed on paper. Clever embossing techniques are popular with graphic designers who want to subtly include typographic titles or slogans on photos. Instead of knocking out or printing over the type, they can emboss it out of the photograph itself. For example, you can mimic metal stamping by embossing a photo of a copper sheet with a logo or words.

Other Special Effects: There are hundreds of other fun and unusual special effects available to digital photographers. Some are bundled in software programs, while others are stand-alones.

Distortions

With better distortion programs, you can fine-tune the distortion technique

Easy-to-use software filters let you turn an ordinary picture into an artistic creation. Here the new images suggest embossed metal, shuffled tiles, and extreme pixelation. Photos courtesy of MGI Software Corp.

to create very precise results. For instance, you can choose the shape and axes of the distortion, pinpoint the area to be distorted, and control the rate of distortion. Think of a digital photograph as a grid, like threads on a weaving loom. If some of the threads are pulled in different directions, the whole design changes.

Linear: The simplest distortions to understand and to create are linear, such as stretching the image on the horizontal or vertical axis, or slanting it along a diagonal to create a parallelogram.

Pinch: Just like it sounds, you can pinch an hourglass depression into any photo. Also referred to as imploding or thinning.

Spherical: The opposite of pinch, you're "blowing air" into the picture. The center of the distortion can be placed anywhere in the photo, and from there it is pushed outward in a circular pattern. Also called exploding or fat effects.

Photo-enhancement software programs offer many options that let you pointillize, pixelize, or otherwise alter your images. This artistic rendition of a water lily photograph sells as framed fine art. Image ©George M. Aronson.

This image was imported into Live Picture software, where it was distorted into an ominous variation of the original. The image of the boy was added separately. The composite was then imported into Adobe Photoshop software to create the background. Image by Marni Schlifkin.

Shear or Wave: Plot the wave curve, and the distortion follows it automatically.

Ripple or Wrinkle: A simplified version of shear or wave distortion.

Stretch or Goo: In the past, you had to combine different distortions in sequence to create unique and complex distortions. Now some programs let you do freestyle distortions with the click and drag of the mouse.

Other Digital Wonders

The digital world has brought other new and novel applications to photography. Type, and how it relates to photography, can now be easily manipulated. Advanced 3-D design and virtual reality programs have brought new creativity to photography.

Text and Photos: Text and photos have an interesting relationship. Sometimes the photograph dominates the text, such as when a photo is accompanied by a caption. At other times, the photo is just a backdrop on which the text is knocked out (printed white) or printed over (in black or in a color). But the choices are limitless if we consider both text and photos as simple design elements in a greater artistic project. For instance, text can be *filled* with a photograph instead of a color—like a photograph of wood grain to create "wooden" letters. Or a word can be embossed out of a photograph for a subtle effect. With vector drawing programs, text can be twisted and stretched to follow the complex contours of a photograph's main subject. Magazine designers are some of the most inventive, cutting-edge users when it comes to combining text and photos—and one of the first places you'll see new methods used.

Virtual Reality: Software is available that enables you to stitch together still photographs into seamless panoramics or complete virtual environments. From carefully made still photographs, virtual reality movies can be created in which a viewer can navigate around a 360° environment, looking to the right or left and up or down. Complex programming allows viewers to walk around objects, pick them up to take a closer look, and more. This technology is the heart of "virtual stores" on

Photo masks (cutouts) can be any shape or size. In this example, cutout letters were filled with a photograph. Photo courtesy of Amiable Technologies, Inc.

Goo-type special effects can be used to make subtle corrections and alterations in pictures, or you can take it to extremes and come up with some creative, fun imagery. Photos courtesy of MGI Software Corp.

Typefaces or fonts are important tools for the digital image-maker. Literally tens of thousands of different fonts are available, including fonts made from your own handwriting. After you've selected a font, it can be further manipulated in different software programs. Don't overlook the graphic potential of words and type in your overall composition. Image by Keith Ewing.

the Web. Although extremely expensive and complicated, more-affordable versions will likely become available.

3-D Wrapping: Certain art programs let you take your photographs and wrap them (like gift paper) around 3-D objects that you've imported or drawn in a vector-based drawing program. Don't mistake these for *wrapping paper* programs that help you create custom gift wrap.

Special Applications: There are numerous applications that are industry-specific. Trade journals and the Internet are two good ways to find out if any photo software has been created specifically for your needs. Remember, too, that creative use of professional programs like Adobe Photoshop and QuarkXPress can help you design your own graphic templates for stationery, calendars, and more.

Fun and Family Software

There are a lot of excellent software programs and applications geared specifically toward family entertainment and recreation. These consumer-oriented programs are often easier or single-function versions of tasks a seasoned computer user can perform with more complex page-layout and photo-editing programs. But if you don't own these professional programs or don't want to spend the time to learn all their tricks and nuances, dedicated novelty programs are simple and inexpensive alternatives.

Photo Albums

The most traditional use of photographs, in the family album, has a place in the digital world. Terrific software packages create digital albums that look like traditional photo albums. You can select backgrounds, mats, photo sizes, and page layouts. Then you can add headlines, captions, or funny cartoon bubbles. Best yet, it's easy to print multiple copies for relatives and friends, or distribute them on the Internet.

Framed Art and Posters

Care must be taken when picking printing methods for your digital

wall art. Many color printer inks and dyes will fade if exposed to light for even short periods of time. UV lamination and new archival inks are changing that, but make certain you ask about longevity before you spend a lot of money getting pictures printed and framed.

An interesting alternative is the use of large-format ink-jet printers that can print photographs onto watercolor paper, coated canvas, or other art materials.

Collages

Sophisticated collaging software, and collaging functions within other photo

software, allow incredible control and creativity. The best software allows you to treat each individual photo segment separately. You can pick its shape and cropping, such as square, rounded, silhouetted, or freestyle. You can also determine its translucency or density. For example, the most important photo could be full color, normal density, while some of the surrounding images might be faded, filtered, or frosted to de-emphasize them graphically.

E-mail

For business or personal e-mail, it adds impact to attach a photo—as long as it's an appropriate size and in a

You can turn your digital photos into posters by having a service provider print your images into large, framable sizes. Photo courtesy of MGI Software Corp.

common file format. If it's just going to be viewed on the screen, send it in low resolution. If the recipient is going to print it, refer to the chapters in Part IV. Or send it in Photo CD or FlashPix formats to give the recipients all of these options automatically.

Gifts and Novelties

Need a last minute present for a relative or a work associate? Photo gifts have long been popular, but they've never been so diverse and easy to order or make. Options include using your photographs on T-shirt transfers, mugs, key chains, awards and recognitions, quilting patches, fantasy magazine covers, mouse pads, stickers, jigsaw puzzles, neckties, magnets, and crafts of all sorts. You can even create personalized coloring books and comic books for children, based on their own photos with easy-to-use templates.

Some of these gifts can be made at home with special kits and your inkjet, dye sublimation, thermal wax, or laser printer. Others require that you e-mail (or conventionally mail) your digital file to a service provider for production. Many of these services are provided by kiosks in shopping malls and amusement parks.

Screen Savers and Slide Shows

Screen savers are popular both for their entertainment value and for the privacy they afford. The concept behind screen savers is that if you've

been idle on your computer for a certain preprogrammed period of time, the software's animated or still images will pop onto the screen. Now imagine your photos fading in and out instead of the once-popular flying toasters. There are numerous software products that enable you to create screen savers using your images.

Another handy function available on some screen savers is password protection. While most screen savers revert back to your work screen at the touch of a key or click of a mouse, some screen savers require you to enter a password to return to the work screen.

The most sophisticated slide show software programs are audiovisual presentations, allowing you to select different display times, fade options, and multiple-picture displays at one time. Kodak bundles such a program with some of their digital cameras; this software can help you create a custom 20-image slide show on a single floppy disk, for example.

Calendars

Calendar templates are also popular. You can print your own calendar with your pictures and personal dates marked with clever icons. Often these templates allow you to choose between an annual format (one photo), a monthly format (12 photos), or a weekly format (52 photos).

Greeting Cards

You can create greeting cards by adding type to your photographs in the computer. Then print onto art paper or precut greeting cards. Some greeting card papers have fancy die-cut windows, folding guides, perforations, or embossed borders.

Use clip art, available on disk in holiday themes, for decorations, colorful graphic borders, and greetings in ornate typefaces.

Take your family pictures one step further with easy collaging software that lets you combine an assortment of photos and add text, if you like. Photo courtesy of MGI Software Corp.

Kids love to share Little League or fantasy sports cards. Photo software programs bring easy templates into your home computer so you can customize cards. Text can be added to photos easily in word balloons and title blocks, or with more sophisticated photo-filled letters. Photos courtesy of MGI Software Corp.

Screen savers provide privacy and amusement as well as help protect computer screens from damage. Numerous programs are available that let you personalize screen savers with your photos. Usually you can plan the display like a slide show, varying the length of time each image is shown and controlling the fade-in and fade-out functions. Photo courtesy of MGI Software Corp.

The days of slide shows in dark rooms with projectors are over. Today you can create a "slide show" that runs on your computer. You can go one step further by adding a soundtrack. You can use a computer projection system to put on a show for a group of people or make copies of the show for friends. Photo courtesy of MGI Software Corp.

Personal print-sized thermal dye-incorporated printers offer special thick papers that are preprinted with a postcard insignia and address lines on the back. For other printers, special heavy stock perforated papers are available in four-to-a-page postcard formats. Some include embossed boxes to frame your pictures or pre-printed thematic borders.

Gift Wrapping

Assuming your ink-jet or other printer can handle large paper (or your gift is small), you can create custom gift wrapping paper. Design your own pattern in a graphic page design program like QuarkXPress or PageMaker, or purchase software made especially for gift wrap. It includes easy templates based on themes and the recipient's name.

If you use a non-waterproof printer, such as most ink-jets, you may want to give the paper a quick spray with an art fixative before wrapping to avoid the chance of the design smearing or the ink staining.

Family Trees and Genealogy

Genealogy programs are enormously popular and easy to create. They coach you through the process. Most help you create a visual family tree with photos as well as memorabilia. Others give you hints and suggestions for writing diary or autobiographical pages. The best kits include questionnaires for your family members; get contributions from distant as well as close relatives.

Time Capsules

Digital time capsules are great fun and easy to create. Use special time capsule software or your own creative ideas. Usually time capsules try to record what is important to the

You can create your own calendar template in a graphic page-design program like QuarkXPress. But unless you're trying to create a unique design, buying a calendar template is much easier. Many consumer-oriented photo programs now include such templates. Simple commands let you drop your photo or photos into place and customize the calendar. Photos courtesy of MGI Software Corp.

individuals creating it at the time, as well as world events. And it's fun to make predictions about what will happen in the future.

You should include a printed copy as well as the floppy disk or writable CD, and save the text and images in multiple formats. Carefully label it a time capsule, record an opening date (such as 25 years from today), and

store it in a safe environment. As technology changes, you may have to transfer the data from one medium to another. For example, if (or more likely *when*) floppy disks become inconsequential, you should transfer to the new and improved media before you toss out your antiquated computer.

Schoolwork

The same graphic design programs used for designing magazines, newspapers, and brochures can be used by students to create professional-quality term papers, book reports, science projects, and other schoolwork. Even most word processing programs can easily and automatically add photographs with wraparound text and footnotes. Some programs are educational as well as entertaining, teaching children about photography and printing.

School newspapers and yearbooks are also taking advantage of the digital age, with students working in graphic design programs to create amazing results.

Children's Programs

There are numerous photo-related programs designed especially for children. Some help them turn their photographs into greeting cards and stickers. Others are more geared toward teaching youngsters about photography and artwork of all types.

Fantasy Templates

A number of different software programs offer fantasy templates that create fake magazine covers, sports trading cards, calendars, or funny money. They're easy to use and the results make great gifts. Most allow you to simply pick the template you want and to select a digital photograph to use from your files.

Videos

Video images have a place in the new digital realm. Still images can be grabbed off of videotapes, laser

You can use ink-jet printers to print your digital photos onto thick paper or blank cards to create quality custom greeting cards. You can add a logo and other information next to the photo so that when the card is folded, the text appears on the back of the card. Photos courtesy of MGI Software Corp.

discs, or television. Video motion clips can be incorporated into your digital projects, including your Web pages and e-mail.

Wedding Albums

Just like digital photo albums, you can have digital wedding albums. Pages can be printed or viewed on computer. Video stills or motion clips

Digital photography and design is fun and easy. Your children will enjoy integrating pictures into their homework assignments, while learning important computer skills. Photo courtesy of MGI Software Corp.

Wedding thank-you cards need not be boring. Instead, you can create a wonderful memento of any occasion with collaging software. You can create note cards, postcards, or framable posters. Image ©George M. Aronson.

can be added. Professional wedding and portrait photographers may post your wedding proofs on a file server that you access through the World Wide Web using a personal password. You can view the proofs at your leisure, select images to be printed, and design the album. Or you can share your password with friends and family so they can order their own reprints directly.

Digital photography allows you to combine your conventional photographs to create totally new artwork. Image by Darryl Bernstein.

The following photos are just a sampling of the types of manipulations you can make using the hundreds of software packages, filters, and plug-ins available. Most manipulations are initiated with a single computer command. The original photo was chosen for manipulation because it has a mixture of colors, as well as horizontal and vertical lines. Though the end results may not be artistic masterpieces, use your own imagination and artistry to experiment with the various techniques. Images by Jenni Bidner.

Original

Ripple

Charcoal and Chalk

Fresco

Graphic Pen

Extrude

Smudge

Pointillize

Wave

Watercolor

Posterize

Stylize/Mosaic

Business and Desktop Publishing Software

There are many types of software programs, designed for business, that can utilize photographs. Graphic design programs allow you to produce professional-quality brochures, advertisements, newsletters, or magazines for printing at the office or in larger quantities on a printing press. Web design software helps you enter the world of electronic mail. Digital copyright software protects your photographs from theft and accidental usage. Multimedia presentations are easier than ever with today's software programs.

Copyright Protection

There are numerous ways to protect the copyright of your photographs. With formats that allow captioning, copyright information can be keystroked. This, however, relies on the honesty of the recipient and on the understanding of copyright laws. More secure methods utilize encryption and watermarking techniques.

Encryption can be used to lock an image from being opened, viewed, or accessed. Unless the recipient has the password, de-encryption software, or both, the image can't be used. Unfortunately, once the picture usage rights have been granted and the purchaser publishes it on a Web page or in a magazine, it can still be "stolen."

Visible watermarking works in a similar fashion. The visible watermark can be either a blazon copyright symbol over the entire image or a subtle custom watermark with your name and logo in the corner. In order to use the photograph without this watermark, the potential buyer must request an unaltered version of the photo or be supplied with the password that removes the watermark.

One of the most creative methods for protecting your photographs is the use of *invisible* watermarks or fingerprinting. Ownership information or a random digital pattern is embedded into the image. Protective software can see the information, but the viewer can't. This pattern or information can be identified even after it has gone through color separation and into print, making proof of ownership a simple matter. Invisible watermarking is very difficult to identify, remove, or damage.

Most experts recommend using both visible and invisible means to protect your work. Since most thefts of photographer's images often come from naïveté about the copyright laws and not out of conscious dishonesty,

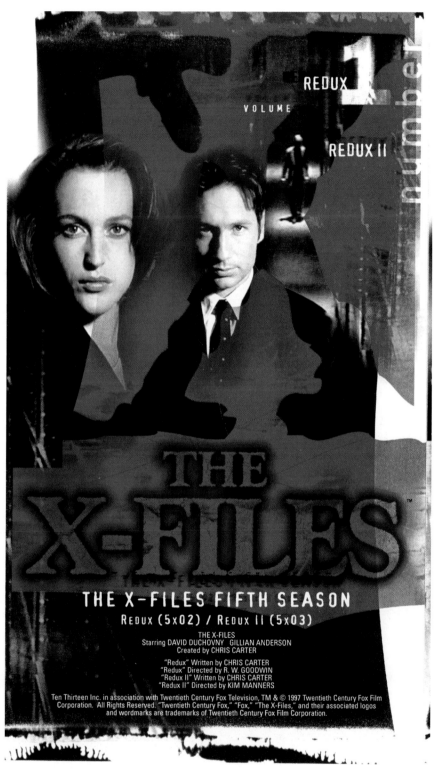

Using software programs like Adobe Illustrator, Live Picture, and Adobe Photoshop, you can design packages (like this X-Files videotape cover), posters, and advertisements on a desktop computer. Image by Keith Ewing, Hamagami/Carroll & Associates.

the quickest form of copyright protection is education. When distributing digital photographs or posting your images on the Internet, include a statement like: "The images included here are protected by international copyright laws. They may not be reproduced or used for any purposes whatsoever without the expressed written permission of the photographer." If you're using encryption or watermarking software, also indicate how the images can be accessed with your approval.

Desktop Publishing

With the revolution in desktop publishing, the layout and production of national magazines, newspapers, and books can now be done with a desktop computer. Even simple word processing programs let you add headlines, graphic elements, wraparound text, and photographs.

Desktop publishing used to be strictly in the realm of the Macintosh computer; all of the early and best software advances were designed for this platform. Today the gap has been virtually closed in all but the high-end pre-press work. QuarkXPress (the giant in graphic page-design programs), PageMaker, Photoshop, and Live Picture are now available for both PC and Mac. New platform-independent picture file formats have allowed the easy interchange between the two systems.

With desktop publishing, you begin by creating templates that form the skeleton of your document, consistent from page to page. You can design the pages (or actually complete printing forms) in every aspect from page size to column width and borders, creating templates into which text automatically flows from page to page and around photos, if that's what you want.

Text can go over, under, around, or through photographs. For typeface

Small businesses can find countless uses for digital images, including show announcements and direct mailing pieces, utilizing home or office printers for limited print runs, or commercial machines for larger print runs. Image ©George M. Aronson.

alone, the font, weight, size, tracking, kerning, color, shade, direction, horizontal and vertical scale, and more can be controlled to precise and minute levels. With special plug-ins or in conjunction with Adobe Illustrator software, type can be arched, twisted, and manipulated as desired. Multiple style sheets can be saved, so different types of text (headlines, subheads, body copy, captions, etc.) will be consistent throughout a book. And this is only the briefest summary of current desktop publishing capabilities.

If you have done traditional page design with typesetters, pasting (or waxing) type into place, and making halftone prints for reproduction, you'll find programs like QuarkXPress easy to use. You're doing the same thing now with keystroke commands, with no wait for typesetting and no sticky wax messes.

For simple letter writing, a stationery template with logo and address in place is easy to create. The text box in which you write the letter can be automatically set up to center the text on the page. You can change the type size and line spacing by any amount, from a fraction of a pica on up, or insert a photo anywhere on the page.

Any picture editing, such as rotating, enlarging, shrinking or cropping images, should be done in a photo-editing program like Adobe Photoshop or Live Picture for optimum quality. Go into your photo-editing program, rework the image, and *then* import it into the page design program.

Those unfamiliar with traditional pasteup techniques and typesetting

✧ *Piscean Beauties* ✧ *Piscean*

Find the perfect gift – for family, friends and yourself – in a peaceful Manhattan setting where you can take your time and get specialized attention.

Choose from hundreds of different necklaces and earrings (that can be converted to clip-ons), designed and hand-crafted by Donna Marie (a Pisces).

♥ COSTUME JEWELRY ♥

All the jewelry was created by combining artistic skill with the spiritual goal of bringing visual joy and emotional enrichment to both the wearer and the observer.

The variety of lengths, styles, and tastes will amaze you. Many are one-of-a-kind! *Average* prices are from $18 to $30 for necklaces and $6 to $15 for earrings.

♥ For appointment
call DONNA MARIE

terms like "picas" or "kerning" may prefer the simpler (but less powerful) programs. Usually these have preset templates so you don't have to spend the time or need the training to create your own.

Small-Run Printing

Newsletters, brochures, presentations, price lists, and other small-volume projects can be printed in the office or through a service provider. Some

service providers have commercial digital printers that take your graphic files and print out mass quantities at high speed. Some machines can even combine database information that labels each document with an individual mailing list or personalized greeting if desired.

In the office, laser printers can do a great job with newsletters and brochures, and deliver sharp, smudge-proof pages. If you want to

If you start to think in terms of design elements, you can create some intriguing images. These capacitors were photographed against a white seamless background, with the result altered to repeat portions of the image in the background. Image by Eric Lindley, Partners Photography.

Large-Run Printing

For large quantities and color work, it is almost always more cost-effective to go to a printer. Unless you're a pro or have studied color management and printing science, leave the color separations to the pre-press professionals or to the printers themselves. It is such an exact science with so many variables that it's simply not wise or cost-effective to do color separations yourself.

Web Design

Entering the world of electronic commerce is easier than ever with all the user-friendly Web-page software that is available today. You used to have to learn the HTML (Hypertext Markup Language) to create a Web page, but now clever software hides all complicated programming languages. You simply design your Web pages much like a graphic page design program and then designate how they are to be linked. The simplicity, power, and design of these programs vary greatly. It's best to read reviews in the computer and Internet magazines to suit your particular needs and expertise. See the last chapter for more information on the Internet and the World Wide Web.

print a newsletter that measures 8-1/2x11 inches when folded, select a printer that can handle 11x17-inch folio paper.

If you only have a black-and-white laser printer, you can use colorful, preprinted newsletter papers that are available from mail-order paper supply stores. Some papers have colorful graphics around which you design your headlines, text, and photos. There are similar options for brochures, business cards, and other business documents.

Business Presentations and Visual Aids

Digital photographs have a place in almost any business presentation, whether it's to show pictures of product, testimonials, or to introduce portraits of corporate officers, new reps, or clients.

Software programs are available that let you produce classic multimedia presentations right on your computer. You become the editor, intermixing still and video images, words and music to create presentations suitable for sales meetings and individual clients. Photo courtesy of MGI Software Corp.

To create an award citation, a full-color photo-graph was turned into a subtle line art image. Type was then overlaid. The certificate was printed on heavy textured paper, laminated with a protective layer, and framed. Had the original color photo been used for the citation instead of the gray line art version, the result would have been far less elegant. Design ©George M. Aronson.

Creative software engineers have come up with numerous options to let you create printed presentation books, overhead transparencies, computer-controlled audiovisual presentations, or presentations with live video links to other offices.

If you're using overhead transpa-rencies, be careful to pick materials designed for your printer. The ex-tremely high temperature output of la-ser printers can melt overhead transpa-rency materials designed for ink-jet and other printers.

New options for business presenta-tions are LCD panels and LCD projec-tors. Both can be considered see-through monitors for your laptop or desktop computer. When placed on an overhead projector, whatever is on the LCD panel screen will be projected onto the wall as if it were an overhead transparency. The LCD projector adds its own light source, so the overhead projector is no longer needed. Usually this light source is so strong that the projections can be seen in normal room lighting, without the need to dim the lights.

Multimedia Presentations
Several top-notch software programs let you play director for a multimedia

After adding text to this photograph using Adobe Photoshop software, the photographer printed the image on a high-resolution ink-jet printer and photographed the print on a copy stand to produce inexpensive title slides for the slide presentation. He was able to reuse the print as a display poster outside the lecture hall. Image ©George M. Aronson.

ᴛʜᴇ
ɴᴇᴡ
ʏᴏʀᴋ
ᴡᴇʟʟᴇꜱʟᴇʏ
ᴄʟᴜʙ

Presents this CITATION *to*

Sara Pendle Stoper

in grateful recognition for her distinguished service
as **President**
and in admiring tribute to her enthusiasm and creativity.

· NON · MINISTRARI · SED · MINISTRARE ·

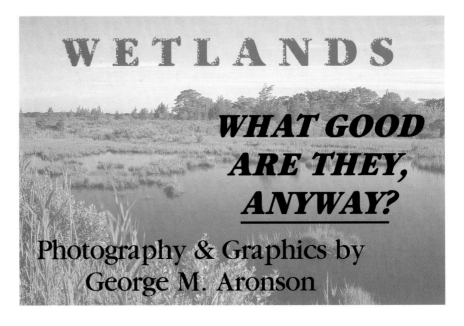

WETLANDS

WHAT GOOD ARE THEY, ANYWAY?

Photography & Graphics by George M. Aronson

You can make your photos look more like drawings with simple functions in most photo-editing software programs. A simple snapshot of an old brick storefront was turned into both a "mezzotint" and an "ink drawing" in Adobe Photoshop. The "mezzotint" was chosen as a logo for the businesses that are housed in the building. The shop owners can drop this logo into their correspondence and newsletters created in programs like WordPerfect and Microsoft Word. Printed materials, including sales receipts, stationery, posters, advertisements, and shopping bags, can be created in graphic design programs like PageMaker and QuarkXpress utilizing this same logo. Retouched images ©George M. Aronson.

presentation, helping you coordinate text, graphics, still photographs, video clips, animation, and sound to create a dramatic and effective presentation. The presentation can be put on disks to be distributed, or simply shown on a computer monitor or computer projection.

CD multimedia productions are strong choices for business presentations, remote sales training, self-serve information kiosks, or to replace the traditional corporate video.

Employee Recognition

Honoring your employees goes a long way toward creating a positive work ethic. Employee of the day, week, month, or year commemorations are easy to create digitally with an inexpensive office printer. Combine the photo with text describing the candidate, and then frame and hang it in a public spot.

Newsletter photos of top achievers are easy to create with a digital camera. Then just drop these pictures into your computer newsletter design, and you're ready to go to press.

Paper supply stores sell pre-printed gilded or engraved certificates that can be personalized by running them through a black-and-white or color printer. A digital camera combined with a dedicated printer can produce nice keepsake photos for each employee at company picnics and other events. With some cameras and printers, you won't even need to bring along your laptop, since the camera can be linked directly to the printer.

Events and Signs

When planning events, you won't need expensive outside sources if you have a good computer, printer, and scanner or camera. For example, if a

new product is being launched, its photograph can be added to signs, press releases, attendee name badges, or commemorative T-shirts.

Likewise, photos can dress up seminar notes. Banners and point-of-purchase (POP) materials that include photographs are far more eye-catching than simple text. Service providers can print your signage and banners (photos and all) onto huge pieces of paper, translucent materials for backlighting, fabrics for banners and flags, all-weather vinyl, magnetic materials, and window-adhering plastics.

Specialized Applications

Almost every type of business can use digital photography to enhance operations. Some industries have software created specifically for them (check local trade magazines for reviews, advertisements, and information). Other

87

Simple retouching can improve an image for marketing reasons. This house looks far more appealing without the telephone pole smack in the middle of the yard. Images by Eric Lindley, Partners Photography.

businesses simply use more general software for particular purposes.

If your business requires large numbers of different photos for short-term needs, a point-and-shoot digital camera and photo-quality printer might be all you need. With higher-resolution applications, even expensive high-end digital cameras in the five-figure range can quickly pay for themselves if your quantities are high enough.

Real Estate
Digital photography has had an enormous impact on the real estate industry. Photographs of a house can be included in computer-based catalogs and Internet advertisements of available properties. Interested parties can have reference pictures taken of important aspects of the property, such as the view from a set of bay windows. These pictures can be printed on-site and attached to prospectuses. When the property is sold, digital files can be erased, with no need for film or print costs.

Insurance
Insurance is another natural application. Instant review of pictures in a digital camera's viewfinder enables agents to be sure they got the pictures

they need, from the correct angle, with all the damage evident—and all without the cost of instant camera prints.

Insurance clients can quickly document their belongings to assure full compensation in case of theft or destruction. Simple software packages coach you through this process, step by step.

Legal and Long-Term Needs
If long-term documentation is necessary, it may be better to go with film originals and a scanner for your digital applications. Even CDs are not as archival as properly stored film. As technology changes, your current digital storage system may be obsolete in a number of years if a new and better storage medium surfaces.

In the fields of legal and police evidence photography, film is still the medium of choice. It is more accepted by the courts and trusted by the jury to be more tamperproof.

Identification and Security
Digital identification (ID) photos can be used for identification cards, business cards, or for part of employees' computer records. Specific applications help design, create, and produce photo ID cards, including add-ons for database integration, bar coding,

magnetic stripe data implantation, and smart chips technology.

Passport photography has long been in the jurisdiction of the instant film market. But the approval of thermal dye-incorporated and other digital papers as a passport medium by the U.S. government should make digital photography a viable method.

Image Archiving
The image-archiving market is a huge business that fuels the bottom line of many digital service providers. Many museums, libraries, and schools are trying to make their holdings more accessible to the general public. Valuable originals can be photographed digitally and cataloged onto CD or other media, or made accessible through the Internet. Delicate textiles, fragile documents, antique books, and other treasures can be safely stowed in archival storage, while the less-destructible digital versions can be shared by millions.

Before-and-After
Any field in which before-and-after photographs are important can utilize digital photography. Plastic surgeons and dentists can show their patients how surgery will improve their looks. House painters can bolster sales by

The ability to combine photographs to create a new reality is one of the most appealing aspects of photo-manipulation software for the business world. Illustrating business concepts or ventures becomes an exercise in imagination. Image by Darryl Bernstein.

demonstrating what customers' houses will look like once painted. You simply need to know how to operate a photo-retouching program.

Other Applications

Small entrepreneurs, like restaurant owners, can use digital photography as well. Daily menus can be printed with photographs of the specials. Some restaurants are creating special souvenirs for their customers. The waiter takes a digital photograph of the diners and the chef, maître d', or owner, inserts it into a template with the restaurant name, date, or other graphics, and prints it out before the dessert is served.

The same type of thing could be done for any special events or to recognize certain customers. Templates can be created in page design software. Or fantasy magazine covers and other novelty templates could be modified for these purposes.

Check-writing programs enable you to create checks right on your computer. You can add your logo or screen photographs into the background design. Some check-writing programs automatically link to accounting programs on your computer.

PART IV—Outputting

Home and Office Printers

Once you know how you intend to use your digital images, choosing the right camera and printer should be much easier.

Before beginning this section, make certain you've reviewed Part I and understand the differences between pixels per inch (ppi), dots per inch (dpi), and lines per inch (lpi), as well as the importance of color management.

The printer descriptions and applications listed in the following chapter will help you quickly identify a printer type based on your interests and intended usage. For example, are you printing for personal enjoyment, pre-press proofing, or small-run professional-quality newsletters? If you want to save the images in a photo album or frame, there are methods that parallel conventional color printing. Then there is printing in the traditional sense, large quantities on printing presses, such as magazines or brochures.

Then the next chapter covers traditional printing on printing presses. Although this book does not aim to fully explain this type of printing or prep you to create your own four-color separations, it provides the foundation for producing digital imagery that can be successfully converted into print.

The scope and quality of today's printers are nothing less than amazing. For example, you don't even need a computer with some printers—just hook them straight into their dedicated digital cameras. More commonly, however, digital files will be transferred to your printer through a computer.

Considerations For Home and Office Printers

For many conventional photographers becoming digital photographers, the primary goal for a printer is to produce photo-quality prints. You'll hear many claims of "near photo quality," "true photo quality," and "photorealistic" printing. Unfortunately, there are currently no industry standards on these claims. Many people were so soured by premature claims of photo quality, they lost interest in digital photography. It's time to take a fresh look.

Other considerations include production time, versatility, and security. For example, if high production speed is important, you'll be frustrated with most ink-jet printers. Or if a laser printer has little internal memory, your RIP time (raster image processing

time, the time it takes to process a page before printing) will be slow, and you may crash your computer.

Print drivers can be important, especially on the high end of printers. They are merely software that allows the computer's operating system to communicate with the printer. However, the best drivers also work like a color management system to make smart decisions about the color of the final output. In an ideal world, this would closely match what you see on your monitor.

The print driver also affects printers that use dot patterns to achieve their

Soft Viewing (the Monitor Screen)

❏ Viewing images on your computer monitor (whether they are your own images or were taken off the Internet) is a legitimate form of output. It is called soft viewing because you have no hard copy.

❏ Like other output devices, computer monitors have an effective dpi. Most Macintosh computer monitors are set for 72 dpi (or phosphors-per-inch, as the case may be), while other screens range between 60 and 120 dpi.

❏ To view a 2x3-inch image on the screen, it should optimally have a total pixel size of about 144x216 (or 2x72 by 3x72). If you want to take advantage of a bigger screen and enlarge the image to 6x9 inches, you'll need a total pixel size of 432x648.

❏ If you're scanning a 4x6-inch print and want to view it on a 72 dpi monitor at this size, scan it at 100% at 72 dpi. If you want to view it at 6x9 inches, determine the ratio of the enlargement. Since 6x9 iches is 150% of 4x6 inches, your scan could either be 150% and 72 dpi or 100% and 108 dpi (since 108 dpi is 150% of 72 dpi).

results. The actual design of those patterns and the way the algorithms place them to create individual colors is proprietary—so they can vary in capability from manufacturer to manufacturer. End result samples are the best way to determine which product produces the results you like best.

A high-level page description language, like Adobe PostScript level 2, is a must if you're printing complex graphics or doing desktop publishing. It will help translate vector (outline) types, page layouts, and bitmapped photos into a rasterized image that the printer can understand. It will eliminate surprises like gappy or disappearing type.

Printer memory is also important. "Smart" printers come with their own RAM to store files waiting to be printed, thereby freeing your computer to work on other functions. Better still, some printers do the raster image processing (RIP) themselves. Without these capabilities, your computer will be forced to do this processing itself before being able to proceed to the next task. Since time is valuable, if you do a lot of printing, you should consider spending the money for a printer with memory and RIP capability.

For business, legal, and personal reasons, investigate print permanence. In other words, will the print fade, smudge, or otherwise deteriorate? If you're just making proofs or comps for temporary viewing, this is not a problem. But if you're printing presentations or legal documents that need to be preserved, you'll need to pay attention to the archival qualities of the output from the printer you select. The output from many of today's ink-jet printers, for example, will smudge when touched with moist fingers or quickly fade when displayed under normal lighting conditions.

The cost of soft goods is a big consideration if you plan to do a lot of printing. Paper, especially high-gloss, heavyweight photo paper, is very expensive. Inks, toner, ribbons, and dyes are not cheap, either. The problem is compounded if the printer does not allow colors to be replaced independently, since in these cases the remaining colors must be thrown away when the first one runs out.

Note the type of specialized papers your printer can handle. Some large-format commercial ink-jet printers can handle watercolor paper and vinyl for store signage. For business

uses, check the printer's ability to handle multiple sizes from unusual envelope sizes to large 11x17-inch folio paper that can be folded into 4-page 8-1/2x11-inch newsletters. Look for the printer's ability to handle materials such as T-shirt transfers, sticker materials, postcard templates, greeting card stocks, or fabrics if that's what you require.

The term "footprint" describes how much space a printer takes up on a desktop. It's something to take into account if your space is limited or if you plan to travel with the unit.

Workload should be considered. A small, portable printer designed for home use is not suitable for high volume. Some high-volume models come equipped with accessories and capabilities that speed up and simplify mass output, like high paper capacity (2000+ pages), two-sided printing, face-down delivery (so that multipage documents are stacked in order), auto-collating of multipage documents, and stapling.

Bigger is better when it comes to parallel interface, because this is how a computer and printer pass information back and forth. A 16-bit parallel interface has a "wider pipe" and thus "better plumbing" than an 8-bit interface, allowing the computer and printer to communicate information more quickly. Look for much faster digital ports in the near future.

A print server is a combination of software and memory that is usually built into higher-end printers. The print server enables your computer to process (spool) your print job and send it to the printer, where it is queued up for printing. This clears your computer so you can work on the next project, even though the current one has not yet been printed. This can be extremely useful if you share a high-powered printer on a local area network (LAN) consisting of several workstations. The print server queues

up the job in order of receipt (or in order of print priority, if so programmed). This frees up your computer to work on other items even if the printer is backlogged with other people's work.

For color printers that require multiple passes, a quality paper-moving mechanism is very important. In ink-jet, dye sublimation, and thermal wax printing, for instance, the paper must be moved over the thermal head three times for CMY, four times for CMYK, and even more when larger color sets are used. If the paper becomes slightly out of line, the results will be out of register.

Keep your eyes open for the hybrid printers as well. These products keep cropping up in new and innovative configurations, combining printing, photocopying, faxing, scanning, telephone, and other capabilities into a single unit. Other printers are incorporating both thermal wax and dye sublimation technologies, allowing you to switch back and forth as your needs change.

Dot Patterns and DPI

Dot patterns and printer dpi are complex subjects, made difficult because different printer types use different methods to create images. Photographs are RGB bitmapped images. This means they are created by breaking up the image into tiny picture samples and assigning red, green, and blue color values to each of these pixels.

Your printer must convert this RGB information into the CMYK colors of the print world. Then it must lay color down to create as close to a continuous-tone (photographic-quality) image as the machine is capable of. Most home printers use a halftone or dither pattern to create an image with uniform-sized dots (the dpi). Each color is laid down slightly askew, with the goal of mimicking the variable-dot, four-color methods of

the conventional printing press. Creative proprietary methods are used to combine dots in an effort to fool our eyes into seeing the millions of colors captured by the digital camera or scanner. The smaller the dots and the better the dot combinations, the more continuous-tone and "photographic" the print begins to look.

Dye-based units stand apart in their ability to achieve continuous tone. By the nature of dye sublimation transparent dyes and their gaseous application, the individual colors can be overlapped and printed to different densities to eliminate the telltale white gaps and dotty feel of halftone printing.

Different manufacturers employ radically different proprietary methods to design their dot patterns, rasterization, and ink distribution. The results yield images that differ in their ability to achieve "photo quality," and the results are subject to personal preference, as well.

Blends and Patterns

It is interesting to note that large sections of smooth, open color (like a blue sky) are among the hardest images for most printers to handle. This is largely because any imperfections are more noticeable, whether they're an individual blip or an overall pattern (such as the uneven pulling of the paper through the machine). Our brains our very adept at picking up patterns, as well as breaks in pattern. This is why grid-based halftone screens are generally placed askew. A tilted screen makes it much harder for our brain to detect the pattern of the grid, making the "continuous-tone" appearance more believable; 45° seems to be the most successful angle.

The Importance of Paper

Glossy photographic papers are designed to make prints look more realistic than standard office paper would. The slick stock holds the ink

better, enabling more detail and more saturated colors—the inks do not spread out and blur as much. Compare a glossy, slick magazine cover to a newspaper. But keep in mind that better paper quality raises the price per print significantly. When combined, special ink packs, glossy photographic papers, and a printer in the 600 dpi range can produce outstanding results.

The paper's color can have as much of an effect on the final image as the colors the printer uses. Most copier papers actually have a gray or yellow tint rather than being pure, bright white. This means that anywhere the printer leaves white gaps to lighten the color, the areas are actually showing up as gray or yellow. The overall results are thus muddy and dull (gray) or too warm (yellow).

Printer Types

Ink-Jet Printers

One of the most economical ways to get into digital printing is with an inexpensive ink-jet printer. Keep in mind, however, that supplies are still on the expensive side. With frequent use, you could quickly surpass the price of the printer in paper and ink costs, especially if you're using glossy photo papers or expensive waterproof and fade-resistant inks.

Ink-jet printers can give excellent results because they are highly controllable, spraying miniscule amounts of ink onto the paper at one time. In most cases, the printer head uses electrical pulses to heat the ink, creating a bubble that forces a tiny jet of ink onto the receiving paper. The more heat created, the more ink applied.

Ink-jet printers come in different dpi capabilities from low to high resolutions. But even within one dpi class, other factors affect print quality.

Since ink-jet printers create colors with individual dots, the sharpness and

Large-format ink-jet printers can make huge prints on a wide variety of display media. Their high cost generally put them in the realm of service providers, who can provide output for you on a per-print basis. Photo courtesy of Eastman Kodak Company.

cleanness of the individual dots will affect the critical sharpness of the end print. Also, how quickly the ink dries will affect how much smudging occurs in the printing process and with subsequent handling.

When selecting an ink-jet printer, avoid CMY printers, since the three colors alone are unable to create a rich black when combined. Instead, select at least a CMYK unit. Since black is the ink most often used (especially with text), a printer with a separate black ink cartridge or trough will save you money in the long run. Better yet, four separate cartridges mean more efficient printing, allowing you to replace dyes independently as needed.

Some manufacturers offer six- and eight-color ink packs to replace the normal CMYK set and enhance the output. Specialty printers designed for photographers get closer still to photographic quality by offering

"photo" ink sets, which include colors such as light cyan and light magenta for smoother gradations. Metallic and fluorescent inks are available for special applications on some printers, providing the equivalent of "spot colors" that traditional web printers have used for decades to add those seemingly impossible colors to magazine covers.

One advantage of ink-jet printers is their ability to use a lot of different papers, including heavyweight, photo-quality papers. A whole new generation of novelty papers are being developed, many with the home user in mind. Some printers allow artists' watercolor paper (depending on the thickness) to be fed through. Heat-sensitive materials, like overhead transparencies, can be fed through most ink-jet printers.

Yet ink-jet printers are not without their disadvantages. The first thing

you'll notice is their slow output. Most ink-jet printers have one head that slides back and forth on a rail, delivering color across the page. This mechanical movement takes time, although larger and multiple heads can speed up the process. Still, the paper comes out agonizingly slow as each section or row is printed. Overhead transparencies can take even longer because of the ink densities needed.

Most inexpensive ink-jet printers currently use inks that are not waterproof and which fade when exposed to light for even short durations. Special UV and waterproof coatings help in this area, but they add to the cost. Waterproof and archival inks that rival the longevity of color found on prints from color negative films have been developed for some printers and will hopefully become more commonplace.

Sharp edges are an inherent problem with ink-jet printers. The size and

93

placement of the dots of ink can affect the smoothness of letters and other graphics. Internal edge-enhancement software can strategically improve this, so ask about it and look at samples. Precision and control of the actual jet mechanism can also make a difference in the sharpness of the output. Smearing affects sharpness if the race for speed through the rollers jumps ahead of ink drying times (especially a problem on rainy days or in humid climates).

Printers that use solid inks can sometimes improve on edge sharpness. The inks are solid blocks at room temperature, but once melted by the thermal head, they act similarly to conventional inks. The difference is that they solidify quicker on the paper, resulting in less bleeding and therefore sharper-edged images. They're also quite handy to load since they don't involve liquid or toner. The colors are individually replenishable.

A poor-quality or damaged paper transport system can affect sharpness. For the application of each color, the paper must be passed over the printer head. If the paper becomes slightly out of line during any of the color passes, the results will be out of register. This is extremely obvious in colored text and graphics with sharp edges.

Carefully check the specs on resolution for your ink-jet printer. Because of the sharpness problems inherent in ink-jet printing, some printers offer a higher resolution with the black ink cartridge (the most common color for text and graphics) than with the colors. It can be misleading if you assume the listed dpi is for all printing applications.

Also question the test prints you are given to view at the store. Check whether they were printed on special (and considerably more expensive) glossy papers and with special inks. The glossy prints will seem sharper than those printed on cheaper, more porous paper.

Superwide printing has always been difficult; the printer heads need to cover more distance, and the larger paper must stay in register without stretching or distortion. Lamination or UV coatings must evenly coat a larger area. For these reasons, wide-format printers are *extremely* expensive, relegating them to a commercial environment. Still, prices are dropping on some wide-format printers, including those that can print on vinyl for displays, canvas for a painterly effect, or art papers for a gallery look. And, regardless of your equipment budget, you can always hire a service provider to furnish an ultrawide ink-jet print at a per-item cost.

Laser Printers

Laser printers use positive/negative electrical attractions to create an image. First, a laser or row of LEDs is used to create an electrostatic image on a photosensitive drum. The charges on this drum then attract the toner. Paper of the opposite charge is brought in contact with the drum andtoner, causing the toner to jump and adhere to the paper. The paper-toner combination is then "cooked" at high heat to fuse the toner to the page.

This heat explains why the sheets come out of the printer warm and why you can't send normal (heat-sensitive) overhead transparency material through a laser printer (to avoid melting onto the rollers). Resist using cheaper, non-laser self-adhesive label materials for the same reason.

The biggest benefits of laser printers are fast printing speeds, quality renditions of text and graphics, the lower costs of soft goods, and versatility. They're fast because the whole page is printed at once, with no printer head painstakingly dragged across the page like with ink-jet printers. Laser printers are perfect for crisp résumés and logos, largely because they use

dry toner that does not bleed like liquid ink, wax, or vaporized dye.

With prices now under a few hundred dollars for a black-and-white low-end unit, choose a laser printer if you don't need to print in color. When compared to a monochrome ink-jet, your results will be faster, crisper, smudge-free, and fade-resistant.

The delay you might experience when printing high-resolution photographs is the raster image processing (RIP) time. Here, the printer and/or computer work to turn page design, vector graphics, and bitmapped photos into a printable raster image. Once the raster image processing is done, however, the page comes out of the printer as quickly as the roller can carry it. Internal RAM and raster image processing in the printer help shorten the time by processing this information at a high speed. It also frees your computer from these tasks. (If the printer doesn't have enough RAM to process the image without getting aid from the computer, the process slows down considerably.) Remember, however, that extra printer RAM adds to the cost—so weigh whether time is more valuable than initial cost. If you decide on lower cost with a lower RAM unit, try to find one that can have RAM added if your needs expand, just like you can often add RAM to your computer if it has additional slots.

If you plan to do page layouts in programs like QuarkXPress or Page-Maker, or desktop publishing work with a laser printer, you'll need a page-description language to translate all the graphic elements on the page (pictures, text, design elements, etc.) into one entity made up of mathematical algorithms. Adobe PostScript is probably the most widely used of these languages and is built into many printers. PostScript enables magazine and book editors to see pages in layout form with text, pictures, and graphics in place.

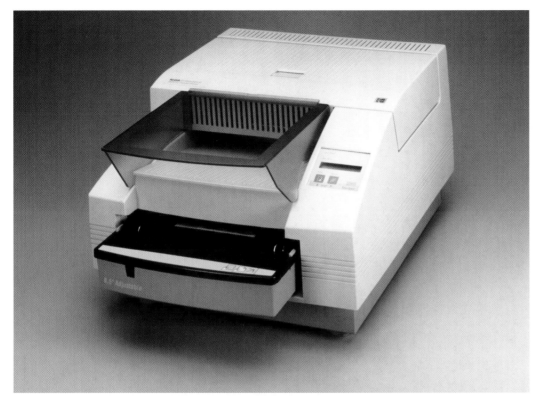

Professional dye sublimation printers are very expensive when compared to ink-jet and laser printers for home use, but they are capable of producing extremely realistic CMYK proofs. This is especially useful for making accurate proof prints of magazine and book pages before they are sent to the printing press. Photo courtesy of Eastman Kodak Company.

Color laser printers are still extremely expensive but not as expensive as they were a few years ago. They require four passes for each of the cyan, magenta, yellow, and black colors.The big advantages of laser printers are light stability and smudge-proof printing, making them more durable than dye sublimation, ink-jet, or other printers. Although they are much more expensive than most ink-jet printers, they are generally less expensive than their dye sublimation counterparts. For all but larger offices and businesses, most people opt for a black-and-white laser printer for their general business needs and utilize a much more affordable ink-jet printer for their color needs.

Dye Sublimation Printers
The key word to remember with dye sublimation printers is the "dye," as opposed to inks or wax. The transparent dyes allow the printer to overlay the colors without opacity. In this way,

halftone or dithered dots can be eliminated, along with the inherent white gaps and pixelation. Thus with top-quality dye sublimation printers, continuous tone and realistic photo-quality can be achieved, especially when combined with slick photographic papers. However, their high prices make them less competitive than ink-jet printers in the home market.

A low-resolution variety of dye sublimation printers is offered at very affordable prices. These shoebox-size printers can make 4x6-inch prints (or two wallet-size prints per 4x6-inch sheet of paper) at 200 dpi or so. Quality varies radically, so check printed samples before buying.

Regardless of whether the printer is an inexpensive unit or a top-of-the-line business printer, soft goods tend to be extremely expensive for this type of machine. Specially coated letter-size sheets can cost as much as several dollars per page.

Another cost for dye sublimation

systems are the dye ribbons. Heat is used to turn the dye on the ribbon into a gaseous state. The more heat the printer head applies, the more dye it vaporizes and subsequently transfers to the paper. The result is an exceptionally smooth transfer with continuous tone.

The dye ribbon is strung together in a roll with alternating full-page layers of dye in each of the printing colors in the order they are applied. The paper is passed over the thermal layer four times, as it is lined up with each of these ribbon colors. Hence a quality paper transportation system is essential.

Obviously this process can be very wasteful, since a full page of each color is rolled out regardless of how much is transferred to the paper. For example, if you printed a document that was mostly cyan, the magenta, yellow, and black portions would be largely wasted. (You can not replenish just the missing color as you can in many ink-jet printers.) Some printers

The Kodak Professional 8660 thermal printer, a raster-based dye sublimation printer with a thermal printer engine and integrated color management technology, can be used for the most demanding color-accurate photographic applications.
Photo courtesy of Eastman Kodak Company.

offer a switchable black ribbon for monochrome work.

Commercial dye sublimation printers are gaining popularity, since they can print onto temperature-sensitive substrates, like synthetic fabrics, plastics, and other products, to create diverse custom products like umbrellas, shower curtains, tent covers, wall tiles, and wallpaper.

High-end dye sublimation "proofers" are designed to check color accuracy before a job goes to the printing press. The prints can often be made on the same or similar paper stock, eliminating the variables of paper tint, texture, and gloss. For fine-tuned accuracy, these printers must have internal color management or be a part of a closely monitored color-management loop.

For the business user, dye sublimation printers produce superb overhead transparencies because of the translucent quality of the dyes (not so with toner-, ink-, or wax-based printers) while still being able to provide deep, saturated colors.

Yet there are disadvantages to dye sublimation printers. In addition to the high price of soft goods, users of these printers can expect tedious printing times, since each page needs to pass over the thermal head four times. Also, as with their multiple-pass counterparts, the paper transport system must be precise, since slight misregistration will greatly affect the outcome.

Also, dye sublimation prints are subject to quick fading and yellowing even under normal viewing conditions. To

address this problem, some manufacturers have added a clear, protective lamination coating to the dye ribbon. Laminates give the print more of the feel of a photographic print and protect the dyes from being stripped when brought into contact with plastic folders and binders that contain plasticizers, such as polyvinyl chloride (PVC). Check Kodak's Web site at http://www.kodak.com for information on protective laminates as well as suggestions for proper storage of all types of images.

Thermal Wax Printers
Thermal wax printing is primarily considered as a way to print comps for designers to check their color layouts and share them with clients. It uses wax ribbons, similar to the dye ribbons of dye sublimation. A thermal

head melts the wax onto the paper, where it is fused with heat.

But unlike dye sublimation, the wax is not transparent, and a four-color dot pattern must be used. Since the dots do not fuse together, it makes "photo quality" harder to achieve.

The waxy feel of the prints also makes them unsuitable for most business documents. However, thermal wax printers can achieve extremely rich colors, which makes them popular in the graphic arts field for comps. They're well suited for T-shirt transfers, jigsaw puzzles, photo mugs, and other novelty products.

Thermal Dye-Incorporated Paper Printers
Several products on the market are based on printer *paper* containing microencapsulated dyes. The dye units are broken when exposed to varying amounts of light or heat. The more dye units that break, the greater the color density. Different temperatures or light levels are set for the cyan, magenta, yellow, and black color layers, so the final color can be controlled very precisely. Before processing is completed, unbroken dye capsules are permanently hardened so the colors won't release during handling later.

There are several advantages and disadvantages to thermal dye-incorporated papers. Compared to ink-jet, dye sublimation, thermal wax, and laser printers, there are no ink or toner cartridges, ribbons, or processing chemicals to buy, change, or dispose. Compared to conventional photography, there are no processing chemicals (except miniscule amounts of water in some cases), and the unexposed paper can be handled in room light. The paper itself has the weight and coated feeling of a traditional photographic print, making it great for photo albums and traditional photo uses.

The purchase price of low-resolution, home-use models is surprisingly small. But we all know that entry price is not the whole picture. The biggest disadvantage is the price per print, because the sheets of paper are quite expensive. For example, the price of 4x6-inch thermal dye-incorporated paper for prints from home printers currently runs about double the price for conventional film reprints at an economy photofinisher.

The second disadvantage is the low resolution on current home models. High-resolution, commercial versions are extremely costly, both in initial purchase price and per sheet of material. But on the plus side, some are hooked to scanners and input devices to create full-service digital printers, making them great for printing near-instant copies of prints or artwork.

Printing Kiosks
Not a home printer and not exactly a service provider, printing kiosks, such as the Kodak picture maker, offer the do-it-yourselfer (who might not own a printer or a computer) the opportunity to make reprints, enlargements, or photo novelty gifts from prints without having to use the negative. You can add enhancements in the process, including cropping, text, creative borders, and other graphics. Some service providers take it further, allowing you to use film originals, such as APS, 35mm, and medium-format negatives and transparencies. These can also be saved as digital picture files.

Silver Halide Printers
Because of the price and high-volume capacity of most silver halide printers, many of which use expensive precision lasers to expose the papers, they are limited to commercial photofinishing labs and other service providers. Much of the appeal of digital printing is that you eliminate the need for darkrooms and chemicals required with photographic papers.

The biggest advantages of silver halide printers are for the photofinishers, in the form of automation and digital enhancements of the prints before exposure. The units can utilize digital originals or automatically scan negatives and transparencies. They eliminate the need for multiple printing chemistries, since both negatives and slides can be inverted for printing on the same type of paper.

Top-of-the-line laser systems can offer high resolutions, sometimes above 2000 dpi. They can be optimized for 4x6-inch prints or 50-inch-wide and larger rolls. On the lower end (both in terms of cost and resolution), some commercial units use CRT and LED devices instead of lasers to convert digital files into exposures on conventional photographic papers.

For the photographer, digitally exposed silver halide prints offer the permanence, familiarity, and quality of traditional photographic papers. Since traditional photographic paper has incredible resolving power, there is virtually no limit for resolution potential. Additionally, the intense competition among manufacturers keeps the silver halide paper prices low and the quality high. The disadvantage for photographers is in having to use a service provider.

Film Recorders
If you need to bypass the digital world and want film again for presentations or distribution, your digital files, along with any modifications you've made, can be converted into a film product using a film recorder. Film recorders print their output on conventional photographic film rather than paper. Some film recorders are incredibly versatile, being able to produce high-resolution, continuous-tone images on transparency film, color negative film, and black-and-white negative film. The expense of high-caliber film recorders usually relegates them to service providers for commercial and industrial applications.

Which Printer is Right For You?

Business Applications

Business Cards: With business cards done on laser printers, address and title changes are easy to make. Laser printer papers come in perforated sheets of business cards in different paper stocks, including some with preprinted four-color design elements. (Note that some office paper companies now offer sheets of precut business cards that are attached with removable tape, giving them a cleaner edge than the perforated kind.) A good graphics program like QuarkXPress will enable you to include scanned logos and other creative graphic elements. The chance of smudging during handling makes ink-jet printers a poor choice for printing business cards.

Business Correspondence, Résumés, and Legal Documents: Select laser printers when sharp type and crisp logo graphics are paramount. Avoid uncoated ink-jet prints unless you're using one of the new waterproof inks or lamination, because spills and moisture could ruin your prints.

Newsletters, Black-and-White: Laser printers can be used to create handsome black-and-white newsletters and brochures, assuming that the printer can handle the paper stock of your choice and has a high enough output dpi to deliver the quality you want. (A 300 dpi laser printer can only deliver the equivalent of a 75 lpi printed document, or about newspaper quality.)

Note that many clever designers have colorful newsletter templates printed ahead of time (with logo and other design elements). In a graphics program, a design template is created, and type and black-and-white photos are added. This is then printed onto colored paper with a laser printer. The same paper can be used for multiple-page issues. (Office paper companies sell pre-designed 8-1/2x11-inch and 11x17-inch four-color newsletter paper and tri-fold brochures.)

Newsletters, Color: Color laser printers can give you extremely crisp graphics, bold color highlights (like graphic lines, red type, or a colored logo), and smudge-free prints. Because of the expense and slow speed of home color printers, you'll probably want to have your four-color brochures and newsletters printed elsewhere.

Overhead Transparencies: Overhead transparency materials are available for ink-jet, dye sublimation, and laser printers. Many people prefer dye sublimation overheads because of the translucent nature of the dyes. Like slide films, they tend to glow more than materials printed using other methods. If you use a laser printer for your overhead transparencies, make certain you use heat-resistant materials specifically for laser printers to avoid a melted mess.

Passport Pictures: Recent approval from the U.S. government may mean that we will soon be seeing passport photos printed on digital printers, such as on thermal dye-incorporated printers.

Photo-Quality Prints from Service Providers: Digital output onto silver halide paper using precision laser exposures produces excellent results, assuming the image is not blown up beyond its optimum enlargement size (based on the digital file's pixel resolution). Other digital printers, including commercial thermal dye-incorporated printers, dye sublimation, and ultrawide ink-jet printers can produce stunning results as well. The output choices, prices, and operator skill levels will vary from vendor to vendor.

Postcards: Although these products are designed for the home market, there are creative applications for them in business, including personalized customer follow-up and short-run direct mail pieces.

Proofs, FPOs: Almost any printer with a page description language that allows you to print your whole document (text and photos) can help you with proofing or FPO needs. For critical pre-press proofing of color, enormous time and money must be spent to create a color management system that matches every device in the loop, from computer monitor to proofing printer to color separation negative (CMYK) to final print.

Art, Fun, and Family Applications

Fine-Art Applications: Right now the gems of fine-art digital printing are the large-format ink-jet printers, because they allow photographers to use watercolor papers and other creative substrates instead of plain paper. Custom inks can also be created to replace the standard set. Printing on canvas is popular for its painterly feeling, and there are many different commercial machines (designed for lab production) that can do this. Some service providers specialize in delivering a "watercolor" or artistic rendition of your photograph, while others try to make it look as much like a silver halide print as possible. Shop around for the quality and style you require.

Gift Wrapping Paper: Design it yourself or use easy software to make custom gift wrapping paper with your ink-jet or other printer. You're only limited by the size of the paper your printer can handle.

Greeting Cards and Paper Frames: Manufacturers are providing numerous choices, with special software templates and creative dye-cut papers. Most are designed for the lucrative home ink-jet market. But you can use insert any printer output into ready-made card-frames designed for conventional 4x6-inch photographs.

Newsletters: Your family can publish its own newsletter. It's a great way to keep friends and relatives up-to-date in less time than it takes to write a stack of individual letters.

Novelties and Photo Gifts: Kits for photo mugs, mousepads, T-shirt transfers, jigsaw puzzles, and other novelties are available. Some are do-it-yourself kits for your home printer, while others require that you send your prints or transmit your digital files, then wait for the product to be delivered.

Oil Paintings: Service providers can turn your photos into actual oil paintings with a very expensive machine that has a computer-guided reproduction system. It uses digital photo files to create a plotting device, which in turn lays down oil paints to produce a painting. Custom color palettes are available.

Photographic Prints at Home: Traditional 4x6-inch snapshots can be mimicked if the output paper has the thickness, quality, and coated feeling of a conventional photograph. Thermal dye-incorporated papers come the closest right now in terms of the *texture* of a photo, but the home versions of these printers suffer from low resolution, and therefore, pixelation. Ink-jet and dye sublimation prints can achieve a photo-quality look, but they are subject to fading, staining, and smudging unless they are coated with protective laminates.

Photo-Realistic Colors at Home: Ink-jet and dye sublimation printers are doing tremendous work in the desktop arena, especially in the 600+ dpi range. High-resolution thermal dye-incorporated printers and silver halide printers will be available for the desktop soon.

Postcards: Heavyweight, glossy, moisture-resistant papers for ink-jet and dye sublimation printers are available in 4x6-inch sizes for postcards. Some are designed to be two-sided, enabling you to put a photo on one side and type the address and message on the other (preferably with a handwriting font, perhaps one based on your own writing). Personal thermal dye-incorporated snapshot printers for home use are also good choices, since they make postcard-sized prints. You could also run perforated sheets of postcards (usually four to a page, available from paper supply stores) through your laser printer. Often they have embossed frames or are pre-printed with foil or four-color decorated borders.

Stickers: Self-adhesive sticker materials are terrific for family projects or bumper stickers—made to order on your own computer. Self-adhesive polyester sticker papers can be run through many home and office printers. They come in novelty sizes and colors, or the standard office selection from file folder labels to address labels to full sheets. With laser printers, be sure to use the special heat-resistant variety.

T-Shirt Transfers: Run this special paper through your ink-jet, thermal wax, or dye sublimation printer to create images that can be transferred to cloth fabric with an iron. Great for T-shirts, quilts, or custom garments.

Wall Display: You might love your ink-jet results, but unless you're using the new archival inks or a special UV coating, they are going to fade in a matter of weeks, if not sooner. You're better off going to a service provider for your enlargements, making certain you ask specifically about long-term archival qualities. As you might expect, silver halide-based digital prints are much more permanent.

Comparing Printers

Dot Matrix

The best of the dot matrix printers can produce near-letter-quality documents.

Advantages: Few, unless you use a lot of preprinted forms or pin-fed paper.

Disadvantages: Limited to simple type (no graphics as we know them today). They're slow and noisy. Skip them if you're considering digital photography.

Ink-Jet

Tiny drops of ink are applied to the paper in accordance with digital information. These printers range from simple home models at very low prices to more expensive, special photo-oriented versions and large-format, ultrawide specialty printers.

Advantages: By varying the pattern of the ink droplets, the printer can create very smooth gradations of color. Low initial costs can make them affordable for home use. Specialized "photo" papers and ink sets further improve the photographic quality. Commercial units can print on special substrates like watercolor paper, canvas, and vinyl.

Disadvantages: Current home ink-jet printers are extremely slow. Prints are susceptible to smudging (most inks aren't waterproof), unless a special coating is applied. Likewise, they quickly fade in normal room light unless a UV coating is added to slow the fading. (Note that archival and waterproof inks will soon be marketed for ink-jet printers; they may be available for your printer by the time you read this.)

Laser

Laser printers get their name from the lasers that use digital information to draw an electrostatic image on a photosensitive drum, which in turn attracts dry toner. The toner is then transferred to the paper and permanently fused with high heat.

Advantages: Produces high-quality text and line-art graphics that are far more resistant to fading in light or to water damage than prints from ink-jet, dye sublimation, or thermal wax printers. Lasers can print at high speeds and capacity. The black-and-white laser printer is the workhorse of the business environment. Color laser printers are great for creating business presentations.

Disadvantages: The price is considerably higher than the average home or office ink-jet printer. For all but larger offices and business, most people opt for a black-and-white laser printer for their general business needs and utilize a much more affordable ink-jet or dye sublimation printer for their color needs. Another disadvantage is that you must spend more for heat-resistant overhead transparencies and self-adhesive materials.

Dye Sublimation

Dye sublimation systems use paper-wide dye ribbon rolls that bring full pages of CMYK dyes in contact with the paper, one after the other. Precision applied heat is used to turn the dye on the ribbon into a gaseous state so it can be transferred to the paper. High-end machines are capable of continuous-tone images.

Advantages: The dyes are more transparent than inks, wax, and toner, allowing them to be overlapped in varying densities, thereby eliminating the telltale white gaps and dots of halftone systems. The gaseous transfer of dye is exceptionally smooth, which often results in excellent photo-quality prints. Some units offer an extra layer in the ribbon that gives the print a protective coating to resist fading, smudging, and staining. Paper stocks for specialized output are available for some devices.

Disadvantages: Since four colors need to be applied one at a time, the printing times are slow. The ribbons are not reusable, and unused dyes on the page-size sections are wasted. The purchase price for soft goods for these units tends to be higher than for ink-jet printers.

Thermal Wax

Heating elements melt tiny amounts of wax, which is transferred to paper or other media. Uses a ribbon system that is very similar to dye sublimation—so much so that some units can switch between the dye and wax ribbons.

Advantages: The opaque qualities of the wax help the printer produce extremely rich colors, which makes the printer popular in the graphic arts field for comps.

Disadvantages: The opacity of the wax requires a halftone dot pattern, so the printers don't achieve the true continuous-tone qualities of dye sublimation. This makes "photo-quality" harder to achieve but mimics the results of a printing press. Some people do not like the waxy feel of the prints and papers.

Thermal Dye-Incorporated

The printing substrate is the key to this type of printer. Dye capsules are embedded in the printing paper in cyan, magenta, and yellow layers. Heat or light is used to break the capsules and produce color. The

individual colors break at different levels of heat or exposure, so the color mix can be minutely controlled. Unbroken capsules are permanently sealed at the end of the printing process.

Advantages: These prints feel like photographic prints and share many of their archival properties. They require no dye cartridges, ribbons, or processing chemicals. Paper can be loaded in daylight.

Disadvantages: Inexpensive "snapshot" models have low resolutions. The price per sheet of paper is high. A 4x6-inch sheet is more than twice the price of a 4x6-inch conventional film reprint at an economy photofinisher.

Silver Halide Digital

Any printer that uses digital picture files to make prints on photographic papers. Precision lasers or CRT and LEDs are used to expose the paper. Many high-speed minilab machines can scan and digitally print conventional negatives. Other machines are designed for custom output, with capabilities of over 2000 pixels per inch.

Advantages: These machines take advantage of the incredible technology and high-resolution capability of silver halide papers. The massive market for these papers in conventional photography helps keeps the cost low. Prints feel like traditional photos because they are on photographic paper. True photographic quality can be achieved with this method.

Disadvantages: High-caliber units are limited to commercial lab work and service providers because of the great equipment cost. Pixel resolution varies greatly depending on the printer.

Printing Kiosk

Self-standing kiosks can be found at many photofinishers, camera stores, and malls. They combine a digital input device (camera for passport photos, scanner for prints, or removable storage driver for digital image files) with a printer and interactive software. Depending on the type of unit, it is either designed to be customer-operated or run by a service staff.

Advantages: Consumers don't need expensive home equipment to make prints from digital cameras, digital files, or print originals. User-operated models can put creative choices (picture sizes, borders, color, and text additions) in their hands through easy touch-screen software. A service staff can perform more complicated applications, like retouching and restoration. Prints are delivered within minutes.

Disadvantages: A trip to the kiosk is necessary. The per-print cost exceeds the per-print cost of a home printer. Although many creative software choices are available, more options are possible with your home computer, a good photo-editing software package, and a photo-quality printer.

Film Recorder

This is a printer that takes digital files and prints them onto film. Exposures are usually made with precision lasers. Output size varies.

Advantages: Make improvements in your scanned images or digital originals, and then output them to conventional film for distribution, slide shows, and traditional film applications. Film has an incredible ability to hold details, and continuous-tone results can be achieved.

Disadvantages: Quality film recorders are extremely expensive, making them practical only for commercial uses. You can, however, pay for output on a per-image basis from a service provider.

Service Provider

Although not exactly a printer type, a service provider, any vendor who offers conventional photography or digital imaging services, can do almost any type of printing you need.

Advantages: No need to buy an expensive machine or learn how to use and maintain it. You're not limited to the output of one type of printer but can instead pick the best option for the particular application.

Disadvantages: On a per-print basis, you will have to pay considerably more than if you did the printing yourself (not including the purchase price of the machine). Some vendors are better than others in price and quality. You may have to shop around until you find one that meets your needs.

Cyan

Green

Blue

Original

Yellow

Magenta

Red

Small changes in overall color balance can make a huge difference in the quality of your printed output, whether it is on a $200 home ink-jet printer or a million-dollar web press. You can correct a color cast using photo-editing software before going to print. Note that to correct a color cast, you can subtract that color from your image or add its opposite to neutralize it. On a home printer, a little practice will help you get excellent results. If your color cast is consistent, you may need to recalibrate your monitor so what you see on the screen will better match what is printed. Image by Jenni Bidner.

The Printing Press

The conventional printing press has a different set of rules from home and office printers. Here's what you need to know to prepare for large-run print jobs.

If you plan to have your images printed in books, magazines, brochures, or anything that is done on a printing press, there is some basic information you need to know.

To create a picture that has the appearance of a photograph, a printing press needs to utilize a line screen that breaks the image up into patterns that fool our eyes into thinking we're seeing continuous tones. The most common screen is the halftone, which uses variable-sized dots. The dots are on a grid, with each dot equally spaced from center to center. The number of dots per inch is referred to as the dpi.

In black-and-white photography, at a given dpi, different tones of gray are created by varying the size of the individual dots. If the dot is big, it is mostly black, so an area with big black dots looks very dark. (Remember that since the center of each dot is fixed, bigger dots simply create more of the dark space.) Hence light areas have very small dots to allow more of the presumably white paper to show through.

Four-color printing means that four colors—cyan, magenta, yellow, and black (also known as CMYK)—are used, each with their own halftone dot pattern. These patterns are then overlaid, each slightly askew. The result is a lot of different colored dots of varying sizes that together create the illusion of a color photograph.

The smaller the line screen (and the more dots per inch), the better the output looks, within the capability of the paper. Newspapers look best at 85 lines per inch (lpi) or less. The photos have large-sized dots compared to the 133 lpi screen of the typical magazine photo, making newspaper photos look a bit rough to us. A smaller line screen does not yield better results, because the porous quality of newsprint makes the dots bleed more than magazine stock. At 85 lpi, you've reached the limits that this paper can handle.

Switch to a mid-grade magazine paper, and the best results are around 133 lpi, the U.S. standard for

Mistakes in exposure can be corrected. Your results will depend upon how badly the image is under- or overexposed, how sophisticated your photo-editing program is, and how well you know how to operate it. This publicity photograph of the New York Chamber Symphony Chorus began as an underexposed snapshot. The image was corrected by the photographer using Photoshop and printed on a high-resolution ink-jet printer. Although the magazine wanted a transparency, deadlines necessitated scanning this ink-jet print to create the final page design. The published photo was a great improvement over the original snapshot. Image ©George M. Aronson.

magazines. Glossier, coated papers and slick cover paper stock yield better results at higher lpi screens because the slick finish holds the ink better.

The halftone is a patterned screen and has many variations, including the shape of the individual dots and size. The stochastic screen is composed of many very tiny, randomly placed dots. Stochastic printing is also called

frequency modulation, because the tonal values are changed by altering the *frequency* of the dots, rather than their individual sizes. Since the individual dots are exponentially smaller than variable dots in most halftones, subtle changes in their frequency can be used to record subtle image detail and smoother color transitions.

From the Past

In the pre-digital days, type was pasted down on a page, along with halftone photographs. This in turn was photographed to create film negatives. In the case of color, four separations had to be made by exposing black-and-white film through tri-color filters. These sheets of film were then manually stripped into place in perfect register.

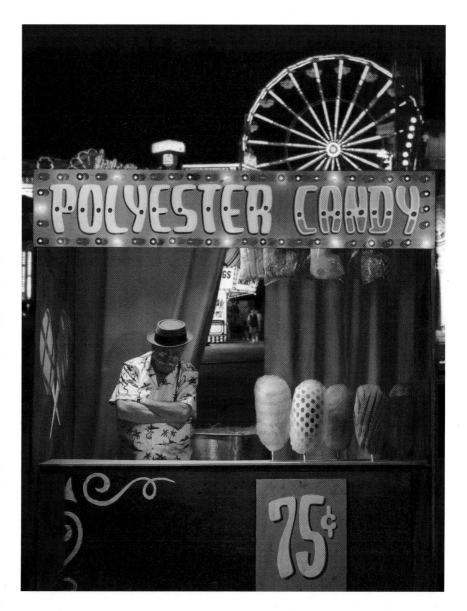

Every aspect of printing has now entered the digital age. This photo was designed digitally on a computer. It was used as a full-page photograph in a two-page layout promoting cotton. If needed, this file could be transmitted directly to a digital printing press, where film negatives are not needed. Even the ink distribution can be controlled by computer. Image by Darryl Bernstein.

Today the computer file can go straight from the computer to the plate or press, with no intermediary products or labor steps. The manual aspects of retouching, pasteups, and color separations have been eliminated.

The amount of digital automation the printing press uses is really a matter of how much of the older equipment has been replaced with new equipment. It may be cheaper and more cost-effective for a printing company to continue using older film-based technology than to replace a five- or six-figure printing press that is still operating well.

The Digital Picture

The most important thing the digital photographer needs to know is how the digital file is converted into dot patterns that a printing press can use. The digital file is actually a bunch of dots in the form of pixels. But each pixel actually holds a lot of information, especially if you're using a 24-bit system or larger, in which case the pixel "knows" which of 16.7 million or more colors it represents.

On your RGB monitor or digital camera viewfinder, it looks great. But for the printing, computer software must evaluate the image and translate the RGB information into four CMYK screens. It is here that color management comes into play (see the second chapter).

Unless you're willing to spend the time to study color management and printing science, it's probably best to leave the actual color separations to the professionals. There are simply too many variables for the novice to control.

Considerations include planning for dot gain, a printing artifact that shows up as an increase in the dot size in most printing systems, especially the web press. If you don't reduce the dot size as a preventative measure, you'll see the effects. Gray Component Replacement (GCR) replaces the overlapping CMY colors that seem to make black (actually muddy brown in reality) with true black. This makes the process easier to control. Black ink limits and total ink levels also need to be set. To the novice, the list seems endless and confusing. You can rely on your printer to recommend a color separator with whom to share printing parameters and needs.

What You Must Know

Whether you do your CMYK conversions yourself or leave them to the

Creating good color separations for four-color printing requires knowledge, skill, and patience. If you have all three, you can retain creative control and save considerable money by creating your own digital color separation files, as the photographer did here with a series of regional postcards featured at left and on the next two pages. Images ©George M. Aronson.

professionals, there are a few things you must know to achieve good results.

In the case of most halftone printing jobs for magazines in the United States, the printer will ask for a line screen of 133 lpi. Most printer and pre-press personnel will agree that to get a good line screen at 133 lpi, you need to have somewhere between 1.2 and 2 times as many pixels per inch (ppi) in the scanned image or digital original. The increase in ppi when compared to lpi figures is called the quality factor.

For example, if a pre-press operator suggests a 133 line screen and 1.5 quality factor, your image should have 200 pixels per inch. Since it's a *per-inch* figure, you need to do some math. If the picture is going to show up in a magazine as a 6x9-inch photograph, you'll need a pixel resolution of approximately 1200x1800 for optimum results. That figure is derived by multiplying the lpi by the quality factor and by the length (133 x 1.5 x 6= 1197) for the width and the height (133 x 1.5 x 9 = 1796) of the printed picture.

If you're using a digital camera, pick the shooting resolution that best corresponds to this number. If you're using an inexpensive point-and-shoot digital camera that can only deliver a maximum picture resolution of 375x500, you're out of luck. Working backwards in this case, with this camera the maximum size you could print the picture in the magazine with optimum results would only be about 1-7/8x2-1/2 inches, since:

375 / (133 x 1.5) = 1.88
500 / (133 x 1.5) = 2.51

With Photo CD or FlashPix picture files, however, you can simply select the resolution that best matches your requirements, since these systems provide multiple resolutions. Using the same example of a 6x9-inch printed photo in a magazine, the 1024x1536 version (Base*4) on an image from a Photo CD disc is somewhat smaller than the desired pixel resolution of 1200x1800 for the 6x9-inch photo. It only offers a quality factor of 1.2. The somewhat larger 2048x3072 version (Base*16) exceeds the needs but assures a good quality factor. With the FlashPix image file format, the 2048x3072 Level 5 resolution would be the best choice.

If you're scanning an image for the magazine, the math does not change much, except now you need to take into account the enlargement factor when scanning. (See the chapter on scanners for more information on scanning your own images.)

Preview Files and FPOs
If you work with a color separator, request a low-resolution preview file that you can use as an FPO (for-placement-only) graphic while you design your book, newsletter, or other document. This saves you the time and frustration of moving a huge digital file around on the screen. The FPO is then swapped with the high-resolution version before going to press. Just make certain the low-resolution FPO isn't accidentally used in the final product. Some software and file formats like FlashPix help you by showing the low-resolution version on the screen but automatically sending the higher-resolution version to print.

You also have to remember that you can't make digital manipulations or enhancements to the FPO (other than positioning) and expect them to show up on the high-resolution version.

Images ©George
M. Aronson.

Images ©George
M. Aronson.

PART V—Storing, Saving, and Sharing Images

Image Storage and Picture File Formats

Beyond the basic needs of creating and printing digital photographs, you will need to know how to store and archive your digital images, and most likely share them with friends, family, and clients.

There are numerous ways to store your images, from saving them on your hard drive to selecting removable media options. Without an archiving system, however, retrieval of these images can be frustrating and timely. And choosing the right file format for your needs will help you along the way.

You can share images by mail, couriers, or removable media, or they can be sent electronically through a number of services, including the Internet. You can also use your photographs to create your own Web page for artistic or commercial purposes.

Once you've taken or scanned your photographs, the question of what to do with them arises. Digital photographs can be stored like any other computer file, assuming you have the memory space. This storage can be on your internal camera memory or removable flash card, internal computer hard drive, external hard drive, floppy disk, writable CD, SyQuest or SyJet cartridge, Zip diskette, Jaz cartridge, magnetic optical, DAT (Digital Audio Tape), or other removable storage. So long as the memory exists after the power is turned off, it can be considered a storage option.

Most digital photographers clear their cameras' internal memories and memory cards as soon as possible to free up more shooting space. Then they leave a few dozen or even a few hundred of their most commonly used digital images in easy access on their computer hard drive and transfer the remainder to removable media. Magnetic, magneto-optical, and optical storage are all viable options. Cartridges, disks, or CDs are certainly cost effective and simple to file. Large-scale backup solutions for businesses with local area networks (LANs) are usually done daily but are designed for the short-term emergency recovery of data, rather than as a permanent storage method.

One of the big concerns when picking a storage method has nothing to do with you, but everything to do with the people with whom you share your images. If you send a client an image on a SyQuest cartridge, you're both out of luck if he or she doesn't have a drive compatible with the SyQuest cartridge—unless the client wants to pay prime dollar and waste time to have it changed to another system by a service provider.

Until recent years, cartridges compatible with the SyQuest system were by far the most popular professional large-capacity writable storage medium, being used by almost every publishing house, advertising agency, and pre-press shop. Zip and Jaz media have made huge inroads recently, gaining popularity among home users because of incredibly low entry prices

Digital photos can be imported into your photo-manipulation software from your hard drive, scanner, digital camera, Photo CD disc, floppy disk, or other storage media. You can even download images off the Internet. Photo courtesy of Adobe Systems Incorporated.

Keeping track of your digital photographs can be easier than keeping track of conventional photographs if you take time to set up a good management and display system with the appropriate software like Cumulus from Canto.

(per MB of information). Now most professionals have drives compatible with Zip drives as well. Since CD drives are so common, a writable CD system is very appealing, especially since prices have dropped, allowing competition with other removable storage media.

Storage capabilities have greatly increased. 100MB Zip drives are being replaced with 250MB Zip drives. SyJet and Jaz removable hard drives boast 1.5GB and 2GB storage respectively. With prices dropping to just pennies a megabyte, it's hard to justify not having that kind of storage capability if you're serious about photo imaging.

When figuring pricing on your options, pay attention to the per-disk and per-megabyte costs. Floppy disks seem so inexpensive until you remember that they only store a fraction of what the other systems store. If you frequently send 90MB files, you may be wasting a lot of space on a 1GB system.

Data Management

What good is having terrific digital photos if you can't find them when you need them? Whether your digital pictures are stored on your hard drive or removable media, they should be organized with a filing or database system that works like a library's catalog system, and they should be easy to access.

If you regularly use business-oriented database or filing programs, you can easily come up with a custom system for cataloging your images. Databases that enable the addition of thumbnail (low-resolution) pictures for reference are the best.

You can find filing software designed specifically for photography. Read the product information carefully to find the right software for your needs. Some are geared to stock photography agencies that need to organize thousands or *millions* of photos by keyword searches and other information. Others are designed for the family photographer who simply wants to create a chronological picture album with point-and-click simplicity. Still others are somewhere in the middle. Photography magazines regularly review this type of software, so check them before shopping.

Things to look for in a database: searching and sorting capabilities, multiple-image retrieval, "drag and drop" arranging, thumbnail viewing, and keyword searches. Some amateur databases are photo albums for your computer, complete with handsome graphics and slide shows with zooms, fades, and blends.

In more complex database systems, your ability to access the right images is dependent on how well you caption or code your images. For the family archives, the simplest retrieval system may be chronological captions. By filing by date, it is easy to access holiday and vacation photos, as well as determine a child's age.

But for professional work, the date is usually irrelevant. If you need to retrieve sunsets, it's doubtful you'll be able to recall the dates of all the sunsets you've photographed. Instead, it's more important to know that it's an ocean sunset with a silhouette of a palm tree. Keywords let you describe photos that can be accessed by a search engine. In this example, you'd choose *sunset, ocean,* and *palm tree* as the keywords, probably in that order. The best keyword systems let you assign weights or levels of importance to individual words.

When writing keyword captions, you must use foresight. Keywords

Retrieving your photographs should be a simple task. If you know the name of the desired photograph, it is quickest (in terms of computing time) to look it up alphabetically without seeing a picture preview. But if you need a refresher or just want to browse, there are systems available that make retrieval a simple point-and-click task. Photo courtesy of Jasc Software, Inc.

▼After

▲ Before

Photographers tend to be visually oriented, so a thumbnail filing system of photos rather than alphanumeric listings is often preferred. If you find that the photos you're accumulating take up too much file space, consider cataloging your images in a database program and placing the actual images in external memory storage. Photos courtesy of MGI Software Corp.

can cover date, place, general subject type, time of day, season, weather, color, or mood. Information such as photographer, pixel resolution, horizontal/vertical formatting, availability of model releases, usage restrictions, and copyright information can also be important.

For instance, the keyword caption for a photo might read: *skier, female, solitude, tranquility*. Note that some of the information is factual, such as *skier* and *female*. *Solitude* and *tranquility* are subjective, since the photo merely evokes those feelings to you.

The more information you key in at the beginning, the more likely the image will be accessed by the search engine when it is needed. Be as subjective as possible when coming up with your keywords. Use both broad and narrow subject categories. Ideally, someone who has never seen your photos should be able to think up descriptive words and have a search engine find an image.

If your business is global, be aware of cultural differences when you create keyword captions. For example, white flowers, the vision of spring in the United States, are the symbol of death in parts of Asia.

On database systems, after including your keyword information (and in some cases assigning weight to the most important keywords), you need to provide an address for locating the image. Most people simply use a numerical system, starting with a low number, sequentially numbering each image. For business applications, you may choose to further subdivide on a job-by-job basis. One hard drive folder or disk could include jobs from only one client. Back up the most valuable images on CD or other removable media in case you encounter disk errors or physical dangers, such as fires.

Picture File Formats

In essence, a file format puts a picture into a code that requires software to recognize it. There are many different picture file formats.

Many digital cameras offer more than one file format. Some offer compression levels, which reduce the file size for more efficient storage and transmission. Compression, however, can cause permanent, irrecoverable image degradation, and it takes extra computer time to perform the compression and eventual decompression.

Certain file formats are platform-independent, meaning they can be opened as easily with a PC as a Mac. Others are linked to specific photo software. Luckily, most file-translation software comes bundled with photo software or is available free of charge downloaded from the Internet.

File formats go in and out of vogue as different technology is introduced and as consumer and professional needs change. In the past, photos on the Internet were almost always GIF (Graphics Interchange Format), a picture format embraced by CompuServe, which quickly became the norm of net surfers. Of course back then most people were lucky to have an 8-bit computer system, which offered a whopping 256 colors and maxed out the capabilities of GIF.

Despite its obvious weakness of only 256 colors, GIF excelled in compressing line art, such as signatures and other black-and-white graphics.

Though the GIF has been by-passed as the Internet file format of choice, the term is still often used to mean "photo" in net-slang. "Send GIF" still means "attach your photo," instead of necessarily denoting a particular file format.

GIF is a *lossy* format, which means an image loses detail and gains unwanted artifacts during the compression/decompression process. For photographers who strive for quality, a lossy format should be avoided whenever possible, unless the images are for proofing purposes or purely recreational snapshots.

Once data has been lost in a lossy compression, it's gone forever—unless you have a copy of the original version hidden away somewhere. No amount of decompression will bring back this lost data, al-though problems can sometimes be corrected with painstaking photo correction.

JPEG

Today one of the most popular Internet formats is the Joint Photographic Experts Group format or JPEG. As the name implies, it was created by a group of experts and is non-proprietary. This means it is used freely. One reason behind its popularity is how it addresses the compression, color, and lossy problems associated with formats like GIF.

The big benefit is that JPEG can be compressed to very high ratios, though it becomes more lossy the higher the compression. For home purposes, compression of 10:1 is considered acceptable (with few visible artifacts), though some claim that 30:1 is just fine. Purists and some professionals feel that any loss through compression is unacceptable.

How much loss is acceptable depends on how the output will be viewed or printed. For soft viewing or low-quality printing, considerable loss may not be noticeable. But remember that once the data is lost or damaged, it can't be retrieved.

Color reproduction is no problem with JPEG. It is designed for today's 24- and 32-bit color photography, offering a choice from 4 bits (16 colors) to 32 bits (4.3 billion colors).

JPEG's main weakness is with sharp edges, like text, line art, and signatures, where loss from compression is the greatest. This is actually where GIF is stronger. If you're deciding between GIF and JPEG, go with GIF for line art and JPEG for photos.

KODAK PHOTO CD System

The Kodak Photo CD system is now widely used in professional imaging. Like music and video CDs, the Kodak Photo CD disc is not subject to magnetic degradation like floppy disks and many other removable storage media. It is very small, easy to store, and can hold a lot of information (for example, 100 images each with five resolutions or 25 images if you jump to the Kodak pro Photo CD system with a sixth higher resolution).

The Kodak Photo CD image pac file format is a *multi-resolution* format, like the FlashPix format, offering five or six resolutions in each image pac file, depending on whether it is a Kodak Digital Science Photo CD master disc or Kodak Digital Science Photo CD pro master disc. The resolutions are 128x192 (called Base/16 or thumbnail size), 256x384 (Base/4), 512x768 (Base or TV/monitor size), 1024x3072 (4*Base or High Definition TV size), and 2048x3072 (16*Base) for the master disc. The pro master disc includes these five resolutions and adds an even higher resolution version at 4096x6144 (64*Base). Pro master discs can scan film sizes larger than the 35mm format, up to 4x5 inches.

KODAK DIGITAL SCIENCE PHOTO CD Portfolio II Disc

There is a third type of Photo CD disc that many photographers overlook. The Kodak Digital Science Photo CD portfolio II disc can store image pac files as well as text, graphics, QuickTime movies, video clips, and audio. Images and pages from many software programs like Lotus or Photoshop can be imported. Or the images and graphics can originate from a digital camera or just about anything that can be scanned.

In this way, multimedia presentations can be created. Since they are designed for soft viewing, the resolutions are the Base size (512x768) designed for optimum monitor presentation. About 700 images or one hour of digital audio can be held on each disc, or any combination that fills the space.

Obviously, the Photo CD portfolio II disc has become popular with professional photographers as a way to distribute a portfolio and sales pitch in one neat package.

The multiple-resolution image pac files are an important feature. As you've read in previous chapters, the pixel resolution of the image affects how large it can be printed on any individual device. Accordingly, before printing an image, the photographer must determine the minimum printing requirements and have the image taken or scanned at least at that resolution. The five or six options inherent in the Photo CD format automatically alleviates the need to predetermine how large the picture will need to be before you have it scanned. The format can be used for many different purposes, from small ink-jet prints to magazine covers.

The highest resolution on a master disc will create a good-quality

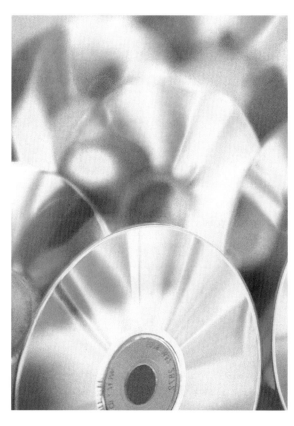

In addition to storing digital picture files, Kodak Photo CD discs can create an interesting subject, as seen in photographer's Jody Dole's image, taken with a Phase One digital camera back. Image ©Jody Dole, photo courtesy of Phase One.

reproduction with 133 line screen at 10x15 size (based on the 1.5 quality format discussed in the previous chapter). The 64*Base high-resolution portion of a pro master disc can easily be printed to 20x30-inch size at the same line screen—big enough for a double-page magazine spread, even after cropping much of the image.

Another advantage is that when an image is scanned to a Photo CD disc, an automatic scene balancing function is usually applied, which corrects color and tone in the same way a good photofinishing machine makes adjustments to a print. If you don't want this service, specifically ask for it to be omitted, such as when you're doing color tests or portraiture in a controlled environment like a studio. Also, the Photo CD format is uncompressed, thereby maintaining the details and tonal quality.

Photo CD discs are fairly economical. A Photo CD disc can be ordered for a whole roll of film at the time of processing (the most cost-effective method) or after. You can keep adding pictures until the entire disc is full. If you scan images from individual negatives and slides, you can request that they be placed in a particular order on the disc, so long as they're done at one time. Since the file format itself is not linked to the CD, you can use a computer to copy the file to another type of removable media.

The master disc is capable of storing over 650 megabytes of information, though the number of images you can save on one disc varies somewhat. As mentioned, the master disc holds about 100 of the five-resolution images. The pro master disc holds only 25 images, due to the larger file size of the six-resolution format.

Sometimes these numbers vary, because the individual image pac files have different file sizes based on a compression technique called chroma decimation. It creates smaller files by discarding unimportant or redundant color information. Therefore, a picture with a big, detailess blue sky can be compressed to take up less space than a picture that includes a lot of highly detailed textures and colors.

If you fill your CD gradually in different scanning sessions, you'll also get fewer scans because about 18MB are wasted for the protocols of each recording session.

Filing and storage is made simpler by the creation of index prints at the time of processing. These index prints are thumbnails of the images on the disc, allowing quick visual identification of the photographs. The index print slips inside the protective CD jewel case, creating the cover for the case.

FlashPix

FlashPix is a relatively new picture file format that is likely to surpass other formats in popularity. It was designed as a follow-up to the Photo CD format but with an eye toward personal computer image processing and networking. FlashPix format was introduced by a consortium of major players—Eastman Kodak Company, Hewlett Packard, Live Picture, and Microsoft. It offers some major improvements and has some definite advantages over other formats.

The two biggest advantages of FlashPix is that it has six file formats to choose from and is very efficient in terms of file size. With a choice of different resolutions, images can be printed on a lot of different devices at a lot of different sizes. This is especially important for the home user, since the format requires a less powerful computer than you'd imagine for the resolutions it delivers. Though the uncompressed FlashPix file format takes about one-third more disk space than a TIFF file (Tagged Image File Format, detailed later in the chapter), it comes up on the computer screen

Care of Your PHOTO CD Disc or FLASHPIX CD

If you follow these simple rules, your Photo CD disc, FlashPix CD, or other writable CD should last for at least 100 years.

1) Start by buying a high-end CD, such as those manufactured by Kodak. Bargain CDs may have inferior coatings, making them more susceptible to oxidation damage (which leads to misreadings and lost data).

2) Store the CD in its jewel case. If you must use plastic sleeves for space reasons, make sure they are archival and contain no plasticizers (like PVC). Select archival lint-free paper or Tyvek sleeves from a conservation supplier.

3) If you absolutely must clean your CD, use photo lens cleaning products and work outward in a radial direction.

4) Do not leave writable CDs in the sunlight for long periods of time. This will shorten its life.

5) Never flex a CD. This is where they are most vulnerable.

6) Do not write on a CD with ballpoint pens, since the pressure can cause damage.

7) Do not apply adhesive labels to your CDs, since they can change the delicate weight distribution of the CD as it spins (or tries to spin) in the drive.

8) If the label is already on the CD, don't try to remove it. Peeling it off can create a lever action that concentrates stress in a small area of the CD.

9) If you must label your CD, use an archival felt-tip pen on the CD's top (non-logo) side only. Non-archival pens, like most permanent markers, can cause premature deterioration of the CD's coatings.

10) Do not freeze your CDs, but try to keep them at temperatures under 77°F and at low humidity.

faster and drains less RAM. Remember, too, that for this larger-size file, you get six resolutions to choose from, instead of the single TIFF size.

You can also reduce file size with JPEG compression. At 10:1 JPEG compression, the entire six-resolution FlashPix file format drops from 12.6MB to 1.3MB (with the top resolution of 9437KB dropping to 943KB). Likewise, single color compression can greatly reduce the file size of some pictures by grouping pixel color information when the image includes a big expanse of one color (such as a big blue sky).

Part of the lower computer power requirements springs from the FlashPix tiling system. Compound Object Storage Tiling breaks the image into 64x64 pixel tiles. When working on just one section of the image, the individual tile or tiles in question are the only ones accessed by the computer. Plus for the low requirements of monitor display (72 dpi), the highest resolution need never be brought onto the screen, unless you are zooming in to have a closer look.

Anyone who has used older versions of Adobe Photoshop and Live Picture software will understand one of the biggest advances of the FlashPix format. Early Photoshop software versions required an entire high-resolution photograph be brought up on your screen (and held in the computer memory) while you worked on a small portion of it. Any changes made were physically recorded and both the before and after versions were held in active memory. Unless your computer

was extremely powerful, this resulted in long delays and sometimes crashes. Then at some point a choice would have to be made—save both versions or just one? This was both memory- and time-intensive.

Live Picture solved this problem with FITS (Functional Interpolating Transformational System) technology, saving image changes as mathematical commands, without permanently changing the original photograph. This means the new picture would be recorded as a series of *viewing parameters* that would take the image from A to B without physically altering the original. This required a lot less computer power. It's analogous to vector images when compared to bit-mapped images—one is drawn by algorithms and the other is a map of actual dots.

This is incredibly important when manipulating high-resolution images. Instead of having to read a new set of pixels into memory after each change, the FlashPix format merely applies a geometric matrix transformation to the image—a set of overall commands.

The FlashPix format takes this concept one step further, by turning the image into a tiled, multiple-resolution (sometimes called "multitiered") file. It offers six different file resolutions, ranging from high resolution at 2048x1536 to increments that are 1/2, 1/4, 1/8, 1/16, and 1/64 the size, respectively. So you can bring up the low-resolution version for quick viewing but instantly access the higher resolutions if more detail is needed. The lower-resolution versions (such as Level 3, 512x384 pixel resolution) can be displayed over the Internet in seconds, whereas the higher-resolution image could take minutes or longer.

On the Internet, you can quickly access a low-resolution version of the picture. But if you want to see more detail, you use simple commands (available on free software) to zoom in

The PHOTO CD Format

Image Pac File	Pixel Resolution	File Size*	Comp/10:1	85 lpi[†]	133 lpi[†]	200 lpi[†]
Base/16	128x192	72K	7.2K	1x1.5″	thumbnail	thumbnail
Base/4	256x384	288K	28.8K	2x3″	1.3x1.9″	thumbnail
Base	512x768	1.1MB	110K	4x6″	2.6x3.8″	1.7x2.6″
4*Base	1024x1536	4.5MB	450K	8x12″	5.1x7.7″	3.4x5.1″
16*Base	2048x3072	18MB	1.8MB	16x24″	10.2x15.4″	6.8x10.2″
64*Base	4096x6144	72MB	7.2MB	32.1x48.2″	20.5x30.7″	3.7x20.5″

Total size for average master disc image pac file is 24MB; for pro master disc is 96MB
At 10:1 JPEG compression, the figures are 2.4MB and 9.6MB
***File sizes are approximate**
[†]Maximum print sizes listed take into account a quality factor of 1.5

The FLASHPIX Format

Image Pac File	Pixel Resolution	File Size*	Comp/10:1	85 lpi[†]	133 lpi[†]	200 lpi[†]
Level 0	64x48	12K	1.2K	very small thumbnail		
Level 1	128x96	49K	4.9K	very small thumbnail		
Level 2	256x192	147K	14.7K	2x1.5″	1.3x1″	thumbnail
Level 3	512x384	590K	5.9K	4x3″	2.6x1.9″	1.7x1.3″
Level 4	1024x768	2.3MB	235.9K	8x6″	5.1x3.8″	3.4x2.6″
Level 5	2048x1536	9.4MB	943.7K	16x12″	10.2x7.7″	6.8x5.1″

Total size for average FlashPix image pac file is 12.6MB uncompressed
At 10:1 JPEG compression, the figure is 1.26MB
***File sizes are approximate**
[†]Maximum print sizes listed take into account a quality factor of 1.5

and have a closer look. You can do this all the way up the scale to the highest resolution image on the six-tier set. Or you can download just the resolution you need to make a good print and not waste time waiting for more information than you need.

If you plan to do any major photo manipulations, the FlashPix format excels. Each version of the image is tiled, broken into blocks that are 64x64 pixels apiece. So if you're working on the high-resolution version and want to remove a small imperfection, you don't have to access the entire, mammoth 2K x 1.5K file—just the individual tile or tiles that are affected. Hence you can perform the changes at an extremely fast pace.

Combine this format with FITS technology mentioned earlier, in which image changes are saved as lists of commands or viewing parameters, rather than as changes to the original. With this technology, it often takes a lot less space to save a whole list of command changes (i.e., image variations) *and* the unaltered original, rather than just two complete versions of a high-resolution image.

Memory is saved when soft viewing as well. The picture format automatically selects the best resolution for displaying on your screen, regardless of your screen size, from tiny laptop to mammoth graphic arts monitor.

Another FlashPix format advantage is OLE (Object Linking and Embedding) structured-storage property sets. The manufacturers describe it as a "standardized wrapper" that allows software developers to add proprietary features and commands without affecting the image file format. One such application enables the user to code the image with alphanumeric caption information that will always be linked to the photo. Use this for keyword information, copyright clauses, color management, technical information, or simply a descriptive caption. When combined with a good database system, your images can easily be retrieved.

The beauty of the FlashPix format is that this technology is *invisible*. It is designed to work silently with applications to automatically optimize each activity, giving the user quicker responses and better results.

The FlashPix format is rapidly becoming important for Internet applications. Plug-ins for Netscape Navigator, Microsoft Internet Explorer, and other browsers allow users to view and print using the FlashPix format from within Internet browsers. When

the format is used to its fullest, the viewer can go to a Web page and interactively zoom, pan, return, and print images with simple icon tools.

Picture disk software allows you to access FlashPix format photos without any other software. It comes on your FlashPix CD or is available free of charge from Kodak's Web site (http://www.kodak.com). The number of photo-editing and other software that recognizes FlashPix is growing quickly, and some digital cameras are beginning to save digital photographs in this format.

Almost any computer purchased in the United States in the past few years with at least 8MB RAM (but preferably at least 16MB RAM), a 50+MHz clock speed, and CD drive will get you moving with FlashPix.

Like with the Photo CD format, you can have a roll of film converted to FlashPix format when you take it in for processing and have it delivered in FlashPix CD format readable on your computer's CD drive. If you haven't planned ahead, you can convert images on a per-photo basis, usually at higher prices. Specialty shops can save images to other removable data storage systems like floppy disk and Zip or SyQuest cartridge if requested.

TIFF

The TIFF format (Tagged Image File Format) is another very popular format for photographs. It has long been the cornerstone of QuarkXPress graphic page design software and used extensively in desktop publishing for the last decade. Being platform-independent (PC or Mac), it is used in numerous software applications, as well as in many digital cameras. The majority of major photo manipulation and art software programs recognize TIFF files and are able to open them. One of its weak points is compression, which is only acceptable up to about 3:1.

EPS

Encapsulated PostScript (EPS) is a vector-based format. The image is composed not of dots, but of mathematical commands that describe it. The result is a resolution-independent graphic that will automatically print at the highest capacity of the printer. EPS images are usually drawings or line art. Note that they can be used in conjunction with photographs.

PDF

Portable Document Format (PDF) enables digital files to be distributed and displayed as originally designed with the formatting, typography, and graphics remaining intact. The page can be viewed and printed across any platform using free, widely distributed software such as Adobe Acrobat. You don't need the application that created the document (graphic design software is usually very expensive), and PDF files are much smaller than the files they are created from, making them better suited for e-mail and Web site uses. Also, PDF files can be widely distributed with safeguards to prevent access to fonts, which can not be freely distributed. Copyrighted material, such as photos, page design, and text, can be locked, making them able to be viewed but not copied.

Other Formats

PICT is a format on the Macintosh platform able to hold both bitmapped sections and vector graphics. TARGA is primarily a multimedia and video picture file. There are scores of other formats. Many are exclusive to particular software programs or families of programs. Read your software or camera's instruction manual carefully. If you have the option to save your pictures in different picture file formats, select the most common and universal, such as those mentioned in this chapter. This will make sharing your pictures easier.

Image Transmission

It is obviously important to the digital photographer to be able to share images quickly with friends, family, clients, vendors, and others. One method to deliver images is on a removable medium, such as a floppy disk, Photo CD disc, FlashPix CD, or SyQuest cartridge. A more convenient and faster method is to transmit the information from one computer to another. Either way, two details must be addressed to share digital files successfully: The recipient must have compatible equipment to receive the information and must be able to read the picture format (see the previous chapter).

Local Area Networks

With a local area network (LAN), sharing information is simple. Two or more computers are linked (usually by cables) to create a LAN. With the proper hardware and software, these individual computer workstations can share printers, scanners, software programs, files, and internal e-mail. But if you want to communicate outside the network, one of the other methods of transmission must be considered.

Modems

Modems are the most common way for computers to communicate. They allow your computer to "talk" to another computer over ordinary telephone lines. Modems can be used to access the Internet and send e-mail with attached photographs. They are inexpensive, small, and portable, and can be used almost anywhere you find a telephone line.

Keep in mind modems are very slow to transmit large files, though today's modems are exponentially faster than just a few years ago. Select the fastest speed your Internet service provider can handle, preferably 56K or faster, or consider one of the other methods discussed in this chapter.

A big problem with modems is that one small glitch on the phone line could bring the process of uploading (sending data) or downloading (receiving data) to a full stop, regardless of how much of the file has already been transferred. Watching a file transfer fail after 95% has already been transmitted can test your patience.

Early modem uses will remember the frustration of trying to link with an incompatible or semi-compatible modem belonging to the other party. More universal interfaces now make translation totally invisible for smoother and quicker transfers between virtually any modern modems.

Other Telecommunications Solutions

The field of telecommunications is in a period of rapid expansion. There are many new types of phone and data-transfer services that will have a profound impact on how data is shared and how the Internet is accessed. It is hard to predict which of the new technologies are here to stay and which are already on their way to obsolescence. For more up-to-date information, do a search on the Internet and in computer magazines, or check with your phone company, cable company, or other local service providers to learn about the latest technology.

One thing that will not change is the importance of speed and reliability, but they often come at a price. Yet this may be money well spent, since faster transfer makes you more inclined to send images uncompressed, resulting in less loss of quality. In the business world where time is money, speed could pay off.

For transmission of files less than one or two megabytes, modems are probably fine. Be aware that some technologies, like cable modems, may not be available at all locations. If your business needs to transfer large amounts of information on a regular basis, a simple modem won't be practical. Your phone line will be tied up for hours at a time, even with a "fast" 90K modem. If you regularly transmit large files over long-distance telephone lines or send removable media disks via express overnight mailing, you'll certainly want to investigate some of the newer options.

The newest options are numerous and sometimes confusing to understand. (Be aware that some technologies, like cable modems, may not be available at all locations.) The faster (sometimes exponentially faster) transfer times make these options worth investigating. They include:

❏ Standard telephone wire options, such as digital subscriber loops (DSL), including asymmetrical digital subscriber loops (ADSL). The advantage of these systems is that they provide a constant connection on your phone line without interfering with your telephone, fax, or modem usage.
❏ Cable systems offer access using the same technologies that deliver cable TV to your home. This can mean fast connection speeds and download times, and is popular for Internet access.
❏ Satellite technologies offer a solution for businesses and individuals who do not have access to DSL and cable modem services.
❏ Older specialized services including ISDN and T1.

When shopping for a service, be sure to check specs for download and upload times, which can vary greatly even when comparing like services (such as one cable company versus another). Note that download times are usually considerably faster than upload times. Also check for hardware and software costs. Spend the time to get competitive proposals if more than one provider or type of service is available.

If your needs are great, it may be wise to see a telecommunications or data transfer consultant to set up your own system. You may choose to sign with a company that specializes in data transfer on a per-megabyte basis—often with a high monthly minimum. You might need to combine different types of systems. Whatever the solution, it will be unique to your needs. For example, security might be key for one company, while speed would be the prime concern for, say, newspaper publishing. One big advantage of outsourcing your data transfer is that you can rely on the expertise of the company you've hired; these professionals can choose the best options and upgrade methods and hardware as new technologies become available.

The Internet

The Internet is great for recreation, useful for research, and through the commercial branch (the World Wide Web, a.k.a. the Web), an efficient way to do business and expand your market.

Accessing the Internet is simple if you have a computer and a modem. Your Internet service provider could be your local phone company or a private enterprise. They provide you with software that enables you to dial a local telephone number where a modem answers your modem, at which point you've reached an Internet server. This is called logging on and usually requires you to use a password to prevent unauthorized usage.

How you access the Internet will affect how quickly you can get information. A slow-speed modem has a very narrow "pipe" through which information is passed back and forth. The faster the modem (the higher the kilobytes-per-second figure is), the quicker you can download information and flip from page to page in a Web site. The new data transfer services mentioned earlier can help speed up your Internet access.

After you log on, you will generally land on the home page of your Internet service provider. Bigger companies offer their members all sorts of niceties on this home page, such as access to chat groups, customer service, on-line technical support, games, prizes, and more. You can use the home page as a starting point for accessing the rest of the Internet through direct address selection.

Your Internet provider makes money by charging you an hourly or monthly rate, perhaps both. Revenue is also generated from advertisements that flash at you from time to

time and from any database information acquired through your subscription information.

Better software includes search engines that help you sort through information on the Internet to find specifically what you're looking for. Search engines function using keywords, and your success depends upon the power of the search engine software and your selection of keywords. If you have several choices for search engines, try them all with the same keywords. You'll be amazed at how varied their retrievals are.

A large company may opt to act as its own service provider, providing round-the-clock access to the Internet from any computer on the network. This also enables the company to create its own *intranet,* accessible only to employees.

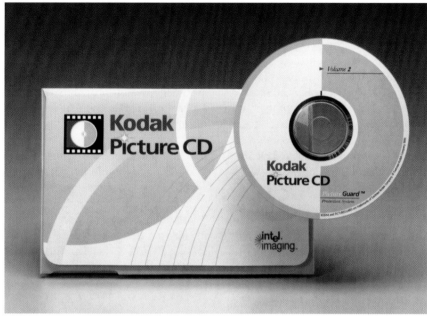

Kodak picture CD provides the benefits of digital pictures without the need for a digital camera—you simply check the picture CD box on your photofinisher's envelope when you drop off a roll of film for processing. Photo courtesy of Eastman Kodak Company.

Bandwidth Problems

How you access the Internet will affect how quickly you can get information. A slow-speed modem has a very narrow "pipe" through which information is passed back and forth. The faster the modem (the higher the kilobytes-per-second figure is), the quicker you can download information and flip from page to page in a Web site.

Many people in the industry predict that the bandwidth problem for the home user is going to disappear in the very near future as cable modems, direct broadcast satellites, and other high-speed options come into play. In the meantime, buy the fastest modem you can.

E-mail

Probably the most often used function of the Internet is e-mail. Letters, data, spreadsheets, and documents of all types can be attached to e-mail, in addition to photographs. It's faster than mail or overnight couriers, and it might be a lot cheaper. Plus, you can indicate multiple recipients to send one e-mail to dozens of people simultaneously.

If you decide to attach pictures to e-mail, you'll need to think ahead as to how the photos will be used. If your recipient is only interested in soft viewing, then attach a low-resolution version of the picture. This will keep the frustration level low when the recipient is accessing the picture, since downloading times for higher-resolution images can take minutes or even hours with a slow modem.

If you think the recipient might want to print the picture, you'll have to check on the type of printer and size to which it will be printed to determine how high a resolution to send—unless you're using a multi-resolution format like FlashPix.

Internet Photofinishing

If you don't own a digital camera, scanner, or printer, you can still take part in digital imaging with one of the new Internet lab services available. The lab will process your conventional film, provide you with prints, and post digitized versions of your images on their

private Web site. Using a password, you can access the photos via the Internet and order reprints via e-mail.

You can also provide family and friends with the Web site information and your password. They can then review the photos at their leisure and order their own reprints directly.

If your printer is down or does not produce satisfactory results, you can use Microsoft software to automatically order reprints from Kodak by e-mail. The user-friendly interface helps you fill out an order form and then automatically sends the information to Kodak via your modem. The prints are then delivered to your home or to the gift recipient's address.

Photos and the Internet

Photography and the Internet are natural partners. You'll find photos attached to e-mail messages or on Web pages. The important considerations for Internet photography are whether the photos are only for soft viewing on a monitor or for downloading to print.

The higher the resolution and larger the picture file, the larger and better you can print the image. (See the chapters in Part IV for more information on printing.) However, larger files take much longer to send and receive, and you could be tying up your modem or network for minutes or hours.

Image compression is one way to decrease transmission and access time. How much compression, however, becomes a give-and-take between quality and transmission times. Some compression methods are better than others, providing less loss and fewer artifacts. All require decompression software of some sort to decipher them. This software is often available for free through the Internet or invisibly integrated in common photo-editing and graphic page design programs.

Your Web Page

Whether you're an amateur or a professional photographer, having your own Web page can be a rewarding experience. To post a Web site, you must work through an Internet server (or become one yourself, if you're a large operation). Generally, you pay a monthly fee to post your site, the price of which depends on the site size in terms of file size.

If you've browsed through the Web, you know that there is great diversity in the caliber, quality, and design of Web pages. Some are incredible with interactive segments, mini-movies, and games you can play. Others seem like "Stone Age" text pages, with perhaps a photo or two unartistically dropped in. The caliber of a Web page depends on a complex mixture of technological know-how, imagination, and most importantly, design. Thought must be given to the pathways that interconnect Web pages within one site, leading the net surfer from page to page according to their individual needs and interests.

Web design used to be an extremely

specialized field. It required learning HTML code to program a site. Today, you don't need to understand programming unless you're doing state-of-the-art work. There are dozens of Web page design programs that hide all of the HTML code and just make it simple.

The best Web design software packages work very similarly to graphic page design programs like QuarkXPress. You create a page grid for text columns and running graphics. These programs not only let you write the text but design it in different fonts and sizes. You create picture boxes and then drop in photos. Success depends not on your understanding of HTML code and HTTP protocol, but on your graphic design capabilities, your copywriting flair, and your ability to design the page flow through your site.

If you want to go beyond this, especially with an interactive site, you'll need to learn the code or work with one of the many Web design firms. Not only are these professionals trained at producing and maintaining the sites, but they are constantly monitoring current trends and technological innovations.

Professional Applications

All the major manufacturers have Web sites, many of which offer new product information, purchasing and technical support, and photo galleries and contests. Kodak's Web site (http://www.kodak.com) has a lot to offer. You can find product and technical information, study conventional or digital photography in interactive classrooms, or simply contact customer service.

Creative professional photographers are finding nice advertising and marketing niches via their Web pages. It becomes their electronic corporate headquarters, where interested potential clients can get information about their services.

Wedding photographers have begun showing their proofs on file servers accessed through the Internet, enabling the bride and groom to purchase prints from the comfort of their home. The bride and groom can also share their password with friends and family members, so they can order their own reprints directly, with or without glamorizing retouching.

A few travel photographers post their itineraries, hoping to get extra work from clients who need photographs from their destinations. Others sell prints to consumers through virtual photo galleries.

Stock Agencies

Huge stock agencies are using the Web, mainly to make life easier for their customers. Stock is an interesting phenomenon that helps clients shop for photos at a "library" that holds the work of hundreds of photographers. The traditional, pre-Web model has the client call or stop by a stock agency and ask for a certain type of picture by keywords—a subject, mood, emotion, color, or just about anything. The agency goes through their files and shows the client potential photographs. If the client decides to use an image, he or she is charged a usage fee, which the agency and photographer split. The fee is dependent on how the photo is used. For example, it would cost less to use a picture as an editorial illustration in a book or small magazine than as a national advertisement.

Clients love the system for two major reasons. The stock price is often much less than the cost of having an original image shot, such as sending a photographer to Alaska for a grizzly bear photo. Secondly, it saves a lot of time. Instead of calling one hundred photographers to find out if they have any bear photos, clients can make one call to an agency that has the work of one hundred photographers on hand.

Photographers like the system, because for a percentage of the profits, they are relieved of many of the business aspects of selling their pictures. They let the agency find the clients, do the paperwork, and negotiate the sales, while they're off taking more pictures.

Now with the Internet, clients gain the ability to browse for images at their leisure, 24 hours a day, without the added cost of shipping potential photos back and forth. Images are, of course, encrypted or watermarked for security until usage has been negotiated.

Buying stock photos is still generally a professional phenomenon. Minimum usage prices (often starting at $250) charged by the agencies put it well out of the range of most consumers. But companies are now researching creative practices that will allow the home user who has no commercial aspirations to access pictures from their files at much lower prices, for inclusion in art, homework, and Christmas cards, for example.

In the meantime, amateur photographers and digital artists must make due with the numerous clip art (royalty-free) photos and artwork available through computer software companies. Or better yet, take the photos themselves.

THE PLUMBING

Telecommunication speed is all about bandwidth, which refers to the system's capacity to transfer information. It can be visualized as a pipe, with a wider pipe allowing more information to flow through it. This explains the origin of the slang lament about the need for "better plumbing" when your data transfers seem to crawl.

Bandwidth is expressed in bits per second (bps), so 28,800bps is also 28.8Kbps. The following are common abbreviations:

(K) Kilo refers to one thousand
(M) Mega refers to one million
(G) Giga refers to one billion
(T) Tera refers to one trillion
(P) Peta refers to one quadrillion
(E) Exa refers to one quintillion

Glossary

A

Algorithm: A set of mathematical rules used to solve a particular problem.

Area Array: A digital imaging sensor that reads a rectangular area rather than one line at a time. Area arrays generally allow quicker scanning times than linear arrays.

Asymmetrical Digital Subscriber Line (ADSL): A service that uses telephone wires to transmit data at rates much higher than conventional modems.

Auto-Exposure: A camera operation mode in which the camera automatically chooses the best possible exposure according to its internal programming.

Auto-Flash: A camera operation in which the camera automatically fires its flash when its programming suggests flash is needed, such as in low-light situations.

Autofocusing: A camera operation in which the camera automatically focuses on what it deems the main subject, which in many cameras is at the center of the frame.

B

Bandwidth: A measure of the amount of information transmitted between points within a certain period of time.

Beam Splitter: An optical device on some scanners and digital cameras that splits light into red, green, and blue (RGB) components, eliminating the need to make separate RGB exposures that are later combined to create a full-color image.

Bit: The smallest unit of computer information. One bit can provide two variables of information, such as yes/no, on/off, or black/white. Eight bits make up one byte.

Bit Depth: A measure of the amount of information each pixel contains. A one-bit pixel sees black or white (not gray). A 24-bit system sees 16.7 million colors. Sometimes referred to as color depth.

Bitmap: A grid of pixel elements, each with its own assigned color and tonal values. Very similar in concept to a conventional film negative, in which individual grains make up the picture.

BPS: (Bits Per Second): A measure of the speed of information transmission.

Byte: Eight bits of information, enough for 256 variables (2x2x2x2x2x2x2x2=256).

C

Capture: Acquiring information, such as with a digital camera or scanner.

CCD (Charge-Coupled Device): A device that converts light into an electrical charge that is then converted to voltage to create a digital image. How many light-sampling points a CCD makes determines the pixel resolution it is able to create.

CFA (Color Filter Array): Tri-color filters (RGB) that allow a CCD or other imaging sensor to divide light into red, blue, and green components for color output.

Charge-Coupled Device: See CCD.

CIS (Contact Imaging Sensor) module: An alternate image-sensing device to CCDs.

Clip Art: Photos and artwork that once purchased can be used without royalty payments.

CMOS (Complementary Metal Oxide Semiconductor): An imaging sensor that is used in some digital cameras and scanners instead of the more common CCD imaging sensors.

CMYK: An acronym for cyan, magenta, yellow, and black, the four inks that make up conventional four-color printing used to produce most magazines and books.

Color Depth: See Bit Depth.

Color Gamut: The range of colors a digital camera, scanner, printer, or other peripherals can capture or create. A color that is "out of gamut" is beyond the capabilities of that equipment.

Color Management System: A combination of hardware and software that works to calibrate your input and output devices to their respective specifications. This helps insure that what you see on your computer monitor is what you will get on the printed output.

Copyright Law: An international law that is designed to protect photographs (and other creations) from being used without the permission, knowledge, and/or compensation of the creator.

D

Depth of Field: The plane of sharp focus—how much from foreground to background is recorded in sharp focus.

Desktop Publishing: Creating documents using a personal computer, printer, and layout program that integrates text and graphics.

Digital: Represented by numerical values based on a binary coding system (1 or 0).

Dithering: A technique in which colored dots are placed very closely to each other to simulate the gradation of colors. For example, a tiny yellow dot next to a cyan dot can appear as green if viewed from a distance.

Dither Pattern: A pattern of uniform-sized dots used by some home printers to create black-and-white or color prints.

Dot Matrix Printer: An output device that uses tiny metal pins to strike an inked ribbon to print text and graphics.

DPI (Dots Per Inch): A measure of the resolution of a printer or scanner. In general, the more dots per inch, the better the detail reproduction.

Driver: Software that allows a peripheral device, such as a printer or scanner, to communicate with the computer.

DSL (Digital Subscriber Loop): A method of Internet access that uses phone wires, without interfering with phone, fax, or modem operation.

Dye Sublimation Printer: An output device that uses gaseous dyes to form near-photographic-quality images.

Dynamic Range: A measure of the ability of a scanner or digital camera to differentiate between subtle gradations of tones. Higher dynamic range figures are exponentially better than lower figures.

E

Encryption: The scrambling of a digital file to protect photographs from being copied without permission.

EPS (Encapsulated PostScript): A graphics file format developed by Adobe.

External Memory: Removable storage media, such as PCMCIA cards.

F

File Format: The particular arrangement or structure of digital information stored from an application program.

Fill-Flash: A feature that fires the flash to add some front lighting to the subject.

Film Recorder: An output device that records digital files onto film.

Film Scanner: A scanner designed specifically for 35mm film, although a few accept medium format. These scanners tend to be expensive but can scan at a high resolution and offer high dynamic range.

Filter: In computer software terms, a software function that performs a certain task, such as blurring a photograph. In photography, a filter is a glass or plastic accessory that is placed in front of the camera lens to modify the light before it enters the lens and records on film (or the CCD sensor).

FITS (Functional Interpolating Transformational System) Technology: A technology that facilitates the editing of large image files by accessing only the data being edited.

FlashPix: An image file format that uses FITS technology to handle large image files.

Flatbed Scanner: A scanner that uses CCD linear arrays that move across the material being scanned.

FPO (For Placement Only): A term used for low-resolution images used to help the designer and others visualize the layout. This allows the designer to work with smaller file sizes while designing the page on the computer monitor.

Frame Grabber: See Video Frame Grabber.

G

GIF (Graphics Interchange Format): A graphics file format used to minimize file size for use on online services.

Gigabyte: About one billion bytes. (To be exact, 1,073,741,824 bytes.)

Graphic Stylus: A direct graphic input device that looks like a pen. It is used to draw on a special touch screen that converts the pressure from the pen into lines on the computer.

Gray Component Replacement: An advanced software correction that helps improve printed output by reducing equal amounts of CMY and replacing them with black. This results in crisper, less muddy blacks.

H

Halftone Screen: A printing method that uses a specific dot grid. Tonal values are lightened or darkened by the size of these dots, without changing their actual placement on the grid. The halftone screen is common in newspaper photographs.

Hard Copy: Any printout of a photograph or document.

High Resolution (Hi-Res): A relative term that denotes a more detailed photograph with a large file size.

HTML (Hypertext Markup Language): A computer language and format often used in Web page design.

I

Image Stabilization: Technology that reduces the blur caused by camera shake. Usually achieved with a computer algorithm that makes the correction in the digital files.

Ink-Jet Printer: An output device that sprays ink droplets to print onto paper.

Interface: The ability for one piece of hardware to communicate with another.

Interface Port: A receptacle that enables you to connect compatible peripherals to your equipment.

Internal Memory: Memory in a digital camera that lets you store picture information until you are able to download to a computer or other storage media.

Interpolated Resolution (Enhanced Resolution): The *guess* that software makes to augment the resolution *after* a scan or digital picture has been made. Do not confuse with optical resolution.

ISDN (Integrated Services Digital Network): Digital phone lines that can move data at a faster speed than conventional phone lines.

J

Jaggies: A term for the rough, "stair-stepped" edges that sometimes appear in bitmapped images. Also called aliasing.

JPEG (Joint Photographic Experts Group): A graphics file format that compresses to reduce file size; this can cause some loss in image quality.

K

Kilobyte: 1,024 bytes.

L

LAN (Local Area Network): A group of computers that are linked together (usually by cables) to efficiently share printers, scanners, software, internal e-mail, and other files.

Laser Printer: An output device that uses small dots blended together cleanly to produce professional-looking documents.

LCD (Liquid Crystal Display) Viewfinder: A very convenient monitor on which to review your digital images on your camera. The larger the LCD viewfinder, the easier it is to review your images.

Linear Array: A digital imaging sensor that reads one line, repositions itself to read another, and so on. More time-consuming than an area array, but linear arrays can create extremely high-resolution scans in certain scanners.

Line Art: Black-and-white photographs or drawings. Your signature is an example of line art.

Line Screen: A term used to define the density of the screen. A higher line screen results in a more detailed image.

Local Area Network: See LAN.

Low Resolution (Low-Res): A relative term that denotes a less detailed photograph with a small file size.

LPI (Lines Per Inch): See Line Screen.

M

Magneto-Optical Disk: A removable storage medium that utilizes both magnetic and laser technology.

Megabyte: 1,024 kilobytes or 1,048,576 bytes.

Modem: A device that lets you transmit computer file data over ordinary telephone lines, either directly to another computer or via the Internet.

O

OCR (Optical Character Recognition): A technology that enables you to convert a page of text into a word processing file.

OLE (Object Linking and Embedding): A technology that allows software developers or end users to permanently link information to a photograph without affecting the picture file itself.

Optical Character Recognition: See OCR.

Optical Resolution: The true resolution of a scanner, measured in terms of the actual number of readings per inch a scanner makes. Do not confuse with interpolated or enhanced resolution.

Out of Gamut: See Color Gamut.

P

Page Description Language: Computer software such as Adobe PostScript, which helps translate vector typefaces, page layouts, and bitmapped photographs into a file that the printer can understand.

Parallax: Cameras with separate viewing and picture-taking lenses often have a problem called parallax. If your subject is very close, the two lens angles see slightly (and sometimes radically)

different views of the scene. This explains why you sometimes get pictures with the subject's head cut off, even though the view looked great through the viewfinder. With SLR cameras, you are looking though the same lens shared by the film (with conventional cameras) or imaging array (with digital cameras).

Parallel Interface: The ability of hardware to connect and communicate with another piece of hardware. A 16-bit parallel interface provides a "wider pipe" for information than an 8-bit system, since twice as many bits can be swapped at any instant.

PCMCIA (Personal Computer Memory Card International Association) Cards: Removable memory cards that hold digital, audio, and other information received from the camera. They can be used like film, allowing you to change cards (as you would change film) to continue taking pictures before stopping to download the images.

PDF (Portable Document Format): A format that enables digital files to be distributed and displayed as originally designed, with the formatting, typography, and graphics remaining intact, by using software such as Adobe Acrobat.

Peripheral: A hardware device connected to a computer and not a part of the computer's CPU (central processing unit), such as a printer or scanner.

PICT: Apple's graphics file format for the Macintosh computer; it has the capability of holding both bitmapped sections and vector graphics.

Pixel: The smallest picture element of a digitized image; it contains color and tonal information. Pixels can be compared to grain in conventional photographic films.

Pixel Resolution: A measure of the number of pixels (picture elements) that make up an individual digital photograph. The higher the pixel resolution, the more detail you see in the picture and the better it can be enlarged. It is a fixed number, not a per-inch ratio. Often pixel resolution figures denote the horizontal side times the vertical size, such as 1152x864.

Plug-In: A software addition that allows certain equipment to work within a computer software program or vice versa.

PMT (Photomultiplier Tube) Drum Scanner: A scanner with a high dynamic range designed to produce high-quality, high-dpi scans of transparencies.

Point-and-Shoot Camera: A colloquial term for a lens-shutter camera. They are usually small and compact, offering "point-and-shoot" simplicity.

Port: A receptacle on computers and peripherals for connecting hardware (usually with cables).

Posterization: A printing method that reduces a continuous tone to a limited number of tones (usually three to five).

PostScript: A high-level page description language created by Adobe and used on many printers. It helps translate complex graphics and page designs into information that the printer can use.

PPI (Pixels Per Inch): A measure of the spatial resolution of a scanned image.

Print-Fed Scanner: A generally inexpensive scanner into which photographs are fed to be passed in front of a stationary linear CCD array, which scans the image line by line. These scanners usually offer only low-resolution scans.

Printing Kiosk: A small "do-it-yourself" stand, often found at a mall, where one can make reprints, enlargements, or other customized photos.

Print Server: Software that queues up printing jobs in order of receipt or priority. It can free up your computer when waiting for something to print, which is especially important in a Local Area Network (LAN) when several computer workstations share one printer.

Processing Speed: The time it takes for a digital camera to process image data and prepare for the next shot. This can be compared to the film advance or motordrive time in conventional cameras.

Q

Quality Factor (Printing): A mathematical quality factor used to improve output. Usually this means multiplying

the minimum pixel resolution necessary by 1.5 to insure satisfactory results.

R

RAM (Random Access Memory): Temporary memory held on chips for use in current applications. RAM is necessary to run software programs and manipulate pictures on the computer.

Raster Image: See Bitmap.

Reflective Scan: The scanning of an opaque picture or document. The scanner works by reflecting light off the subject.

Removable Storage Media: Any device that can be used by computers or digital cameras to record and share digital imaging or computer file information with compatible media. Examples include PCMCIA cards, Kodak Photo CD discs, floppy disks, and Iomega Zip, Iomega Jaz, and SyQuest cartridges.

Resolution: A measure of the clarity and sharpness of an image on screen or in print.

RGB: An acronym for red, green, and blue, the three additive primary colors used to create screen images on a color monitor.

RIP (Raster Image Processor): A processor used to translate graphics data into raster data for printing.

S

Scan: The process of converting an image into digital information.

SCSI Port: A receptacle that allows you to connect SCSI peripherals to your computer for communication at a fairly rapid speed.

Service Provider: Any vendor or business that offers imaging services, including photofinishing and scanning.

Sheet-Fed Scanner: A document scanner designed for OCR (optical character recognition).

Silver Halide Printer: An output device using precision lasers to expose photographic papers.

SLR Camera: A single-lens-reflex conventional film or digital camera, generally considered an advanced amateur or professional camera. Differs from a point-and-shoot camera in that the scene is viewed through the picture-taking lens. Generally SLR cameras offer interchangeable lenses and advanced accessories like flash units and filters.

Soft Viewing: Looking at a digital picture on the computer monitor instead of the printed output. Also called soft proofing.

Spatial Resolution: See Pixel Resolution.

Still Video Camera: A camera that records still images on magnetic media. This magnetic information is then converted to digital information for use on a computer.

Stochastic Screen: A printing screen with a random dot pattern that alters the tonal values by varying the number and location of dots per inch (rather than their size, as in halftone printing).

Stock Photography: Photographs that can be purchased for use that fill the photo buyer's specific needs, saving the time and expense of having to specially create desired photos.

T

TARGA: A multimedia and video picture file format.

Template: An original document file that contains the specifications and formatting (the pattern) from which you can produce other documents.

Thermal Dye-Incorporated Paper Printer: An output device that uses special paper containing microencapsulated dyes; the dye units are broken when exposed to varying amounts of light or heat.

Thermal Wax Printer: An output device that uses wax ribbons; a thermal head melts the wax onto the paper, where it is fused with heat.

TIFF (Tagged Image File Format): A file format used in graphic page design software.

Transparency Adapter: An accessory that converts a flatbed reflective scanner into a transparency scanner. Usually it consists of a new lid with its own built-in light source.

True DPI: See Optical Resolution.

U

USB (Universal Serial Bus) Port: A type of digital port for connecting peripherals that allows considerably faster data transfer than conventional ports (40 times faster than a serial port). Digital video teleconferencing and digital camera downloading benefit from the speed of a USB port.

V

Vector Image: A mathematical description of how a digital image should look; equations describe what a curved line looks like or how a box is filled with color. Vector files can be enlarged to any size without affecting quality.

Video Frame Grabber: A device that allows you to "grab" still images off of a videotape, television screen, or console game to save as digital photographs that you can use on your computer.

View Camera: A conventional photography large-format camera (generally using film sizes 4x5-inch and larger). These cameras are most often used by studio photographers. Most offer lens board and film plane movements that allow incredible control over depth of field and optical distortions/corrections of the image. Large-format digital cameras are a hybrid of this camera, often with a digital back/imaging sensor that replaces the sheet film holder.

W

Watermark: A visible or invisible mark or logo placed over your digital photograph to protect it from unlawful usage. It can be removed with a special device or password.

World Wide Web (WWW): The commercial sector of the Internet. Individuals and companies can post Web sites to disseminate information. The pages can be simple text or include complex photos and graphics with multiple pages linked.

Writable CD: A compact disc on which digital pictures and computer files can be recorded.

Index